AMAZING

MOUNTAIN

CABINS

Architecture Worth the Hike

Agata Toromanoff

LUSTER

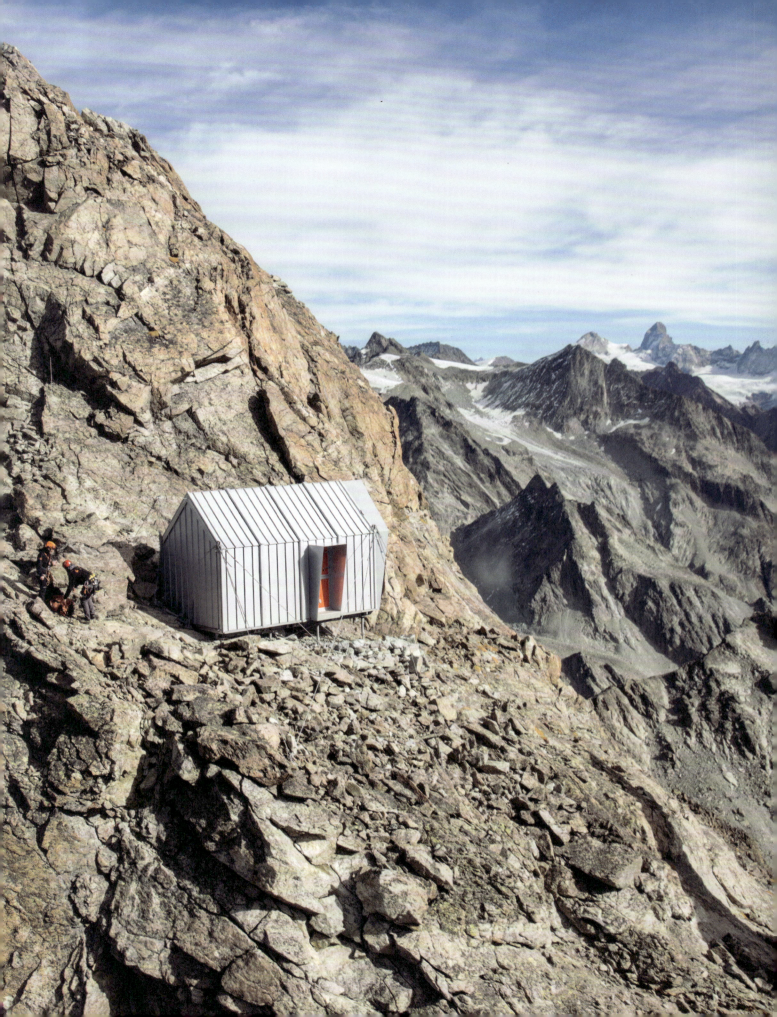

High altitudes are not the most obvious place to find architecture, yet hikers and climbers around the world can enjoy more and more inventive refuges that complement the adventure of conquering peaks. Surrounded by dramatic landscapes, whether cabins with just a few beds or huts that can accommodate larger groups, they are not merely shelters but also spaces that offer an entirely new way of experiencing mountains. The main objective is of course to provide a safe hide-out to rest or overnight, but contemporary architects pay no less attention to creating a special relationship with the spectacular natural context. This can be achieved through a playful shape or installation – some cabins seem to be suspended in the air or literally stick out into the void, which puts the mountaineer guests in the middle of the landscape. Meditation on the views is often enabled by generous openings that act as a passage between the majestic outside and the shelter provided inside. Made of reinforced glass, these connections allow for observation and open to the horizon while keeping hikers protected from the elements.

There are several essential aspects in mountain cabin design. The first and most important is that of limiting the environmental impact of the architecture to a minimum. Even if the volumes are quite distinctive and durable, they should be easily reversible and fixed to the usually rugged terrain with the smallest possible intervention into the site. Given the speedily changing weather conditions at high altitudes, elements of cabins are usually prefabricated and brought to the sites by helicopter. It is extremely important that they can be assembled in a short time, so the structures have to be thoughtfully considered in every single detail. To be able to transport them by air, architects make very conscious material choices. The lightness is obviously only part of the task, while the other, and biggest, endeavour is to create structures that will stand up to the elements, usually including in the winter. Advanced technologies offer the possibility of equipping new cabins with self-sufficient solutions, which are not limited to solar panels. Many examples featured in this selection demonstrate inventive approaches that lead to uncompromising architecture built in the most challenging of locations. At the same time, comfort is never neglected. Many of the interiors feature a wood-panelled envelope with natural colour and texture, creating an atmosphere of nest-like cosiness for visiting mountaineers. This unpretentious aesthetic is obviously in line with the character of the remote locations but it also further highlights the striking contrast between the human scale and the vastness of nature.

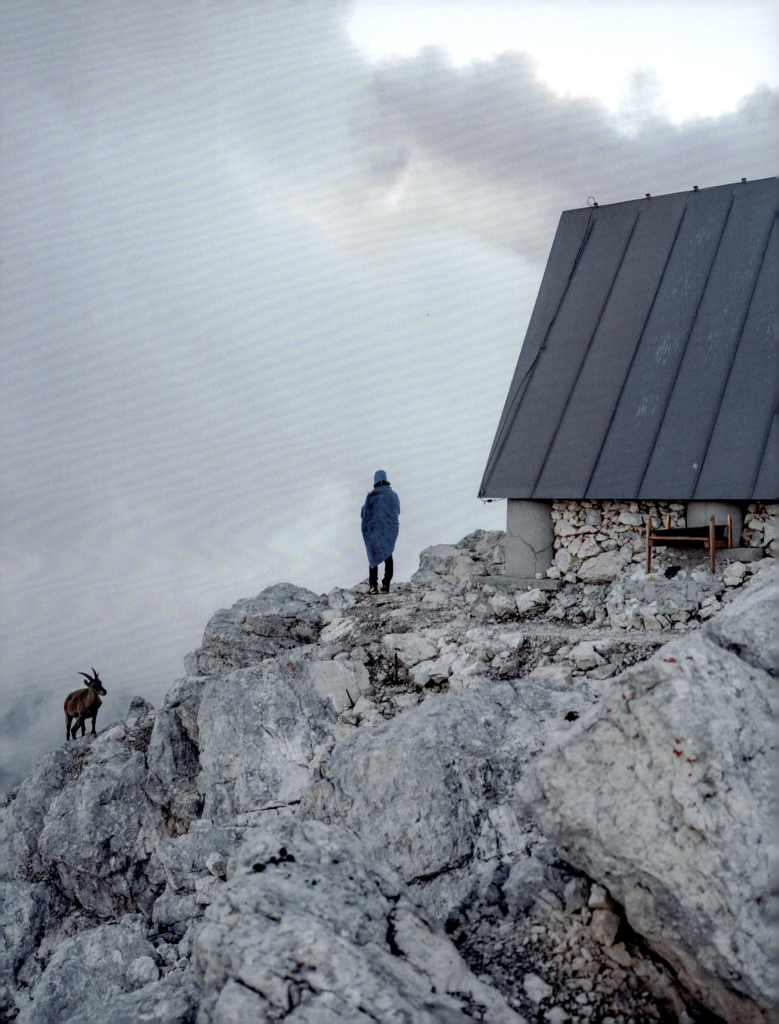

BIVOUAC
FANTON
P6

ALPINE
SHELTER
P14

NEW
TRACUIT
HUT
P22

TUNGESTØLEN
HIKING
CABIN
P28

BIVACCO
BRÉDY
P36

HAMMERFEST
HIKING
CABINS
P42

WINTER
BIVOUAC
AT PRADIDALI
P48

BIVOUAC
UNDER GRINTOVEC,
A MOUNTAIN SHELTER
P56

CABANE
DE MOIRY
P64

FUGLEMYRHYTTA
P72

BIVAK II
NA JEZERIH
P80

PREHODAVCI
BIVOUAC
P88

RABOT
TOURIST
CABIN
P94

MONTE
ROSA
HÜTTE
P102

GRAMPIANS
PEAKS
TRAIL
P108

CAMPING
LUCA
VUERICH
P114

SHELDON
MOUNTAIN
HOUSE
P122

RIFUGIO
VAL DI
TOGNO
P126

ECOCAMP
PATAGONIA
P134

BIVACCO
CITTÀ DI
CLUSONE
P142

BIVACCO
FELTRE
& WALTER
BODO
P148

RIFUGIO
GUGLIELMO
MIGLIORERO
P152

BIVOUAC
ZORAN
ŠIMIĆ CABIN
P158

BIVOUAC
HANNIBAL
P168

BIVOUAC
LUCA
PASQUALETTI
P174

THE
BOLDER
P182

BIRDBOX
P188

REFUGE
DU GOÛTER
P196

MOUNTAIN &
CLOUD CABINS
P202

FAROUCHE
TREMBLANT
P208

48° NORD
LANDSCAPE
HOTEL
P214

MALLARD
MOUNTAIN
LODGE
P220

PLATEAU
HUT
P226

NEW
GERVASUTTI
BIVOUAC
P230

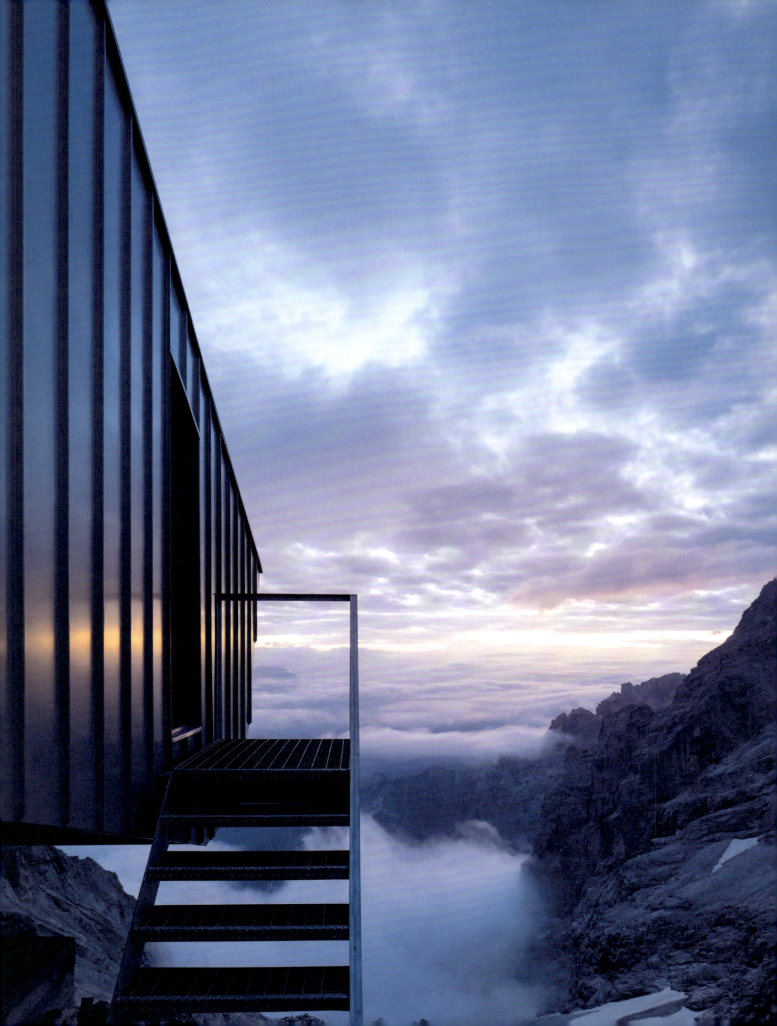

BIVOUAC FANTON
DOLOMITES, ITALY

In the martian-like landscape of the Italian Dolomites, the geometric body of Bivouac Fanton is striking, as it stretches out into the void of the majestic and barely accessible mountain range. At an altitude of 2667 metres above sea level, the building seems to be effortlessly suspended above the ground as it generates an axis that connects the spot with the Auronzo Valley. Inspired by nature, the volume's distinctive shape and its inclined position have been created to adjust to the topography of the Marmarole. Like a piece of rock, on the one hand it blurs easily into the scenic context, while on the other it offers an exceptional hide-out for hikers who can admire the stunning vistas. Designed by the studio DEMOGO, the cabin makes a cosy shelter in an environment defined by extreme wind and snow. The structure, anchored to the rugged foundations, is made of fiberglass and clad in titanium zinc, the metallic coating of which will change with the passing seasons, "allowing the bivouac to find the right intonation with the context and to be influenced by the light reflected by the walls of dolomite rock of the surrounding landscape," as the studio emphasises. The architects opted for technologies that allowed for an exceptionally light volume in relation to its dimensions, which as a result facilitated both the transportation and installation of the volume.

The 30-square-metre building has been planned in a very efficient as well as minimalist way. The interior is broken into three parts with bunk beds on each side. These zones, marked with small stairs, are divided by a system of vertical shelving that offers practical storage. The basic character of the space is softened by the use of naturally hued wood, which welcomes visitors with a comfortable atmosphere, much needed in the rough wilderness of the spot. The biggest highlight of the interior is a full-wall panoramic window placed at the end of the cabin that frames the stunning view and enhances the illusion of floating above the rocky mountain range. Sitting on one of the benches placed along each side wall and looking out into the absolute landscape is an immersive experience. Hikers can feel safe enveloped by this comfortable shelter, and at the same time, the structure turns into a sort of telescope to admire the vast mountains in the heart of the Dolomites. Observing the power of the dominating natural surroundings reveals the stark contrast in dimensions and the impossibility of the cabin's location.

ACCESSIBILITY
The cabin is inhabitable all year round but it is relatively hard to access without the marked paths to the Forcella Marmarole notch. This is a destination recommended for experienced mountaineers, not climbers. The season lasts between the end of June through the end of September.

ARCHITECTURE
DEMOGO, 2021
LOCATION
Forcella Marmarole (The Marmole Arc), Dolomites, Italy (the Province of Belluno)

ALTITUDE
2667 m
NUMBER OF BEDS
12

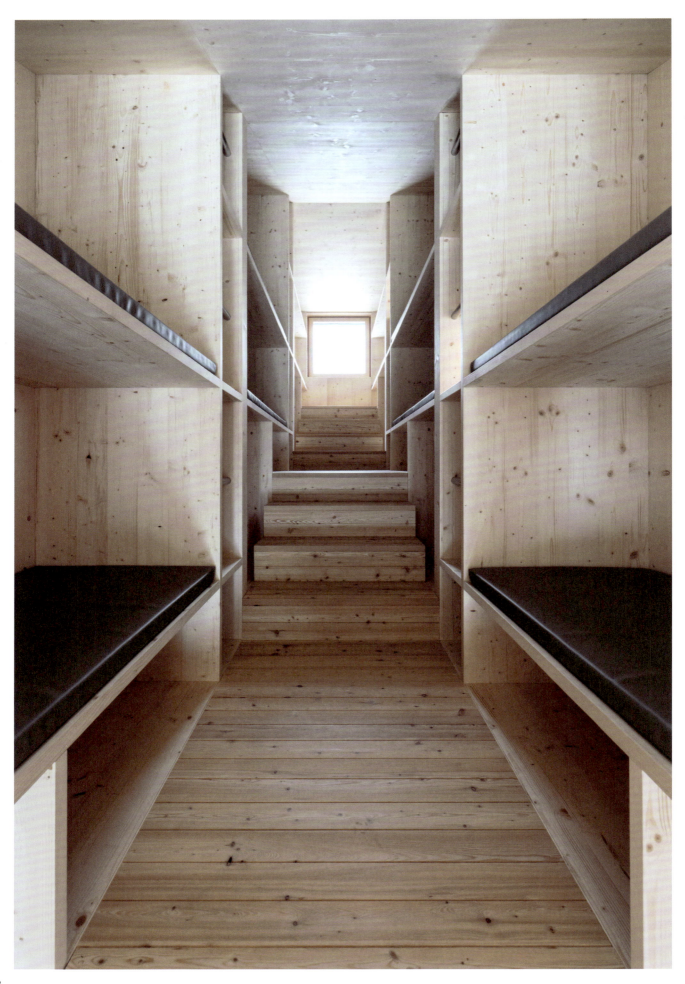

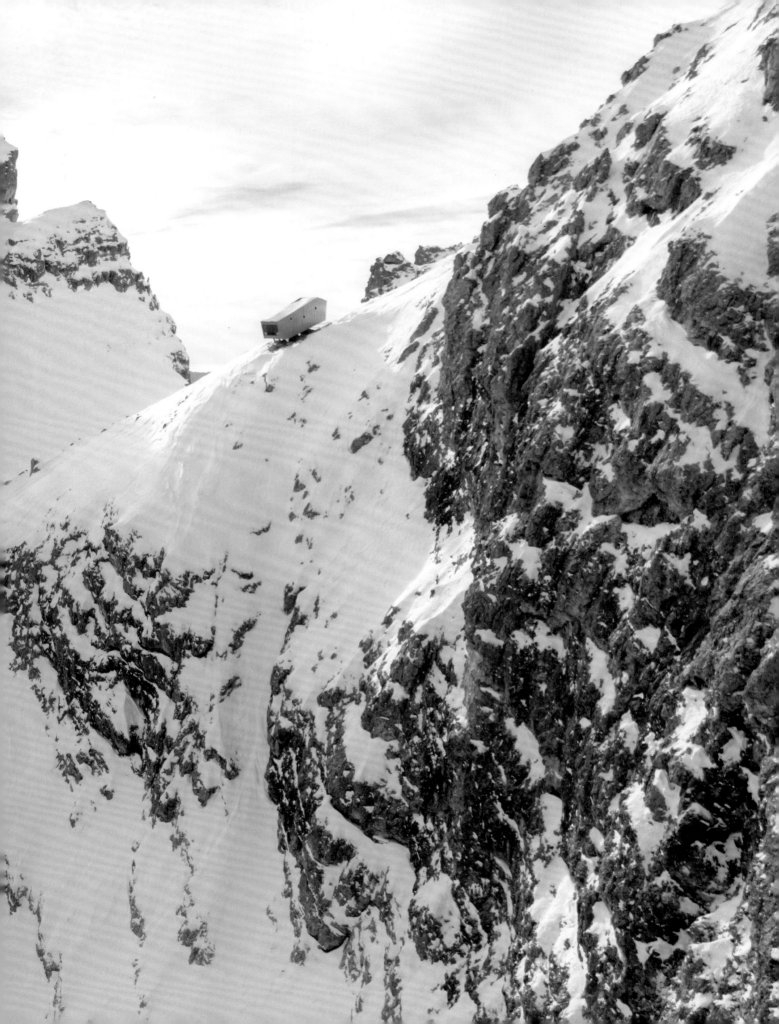

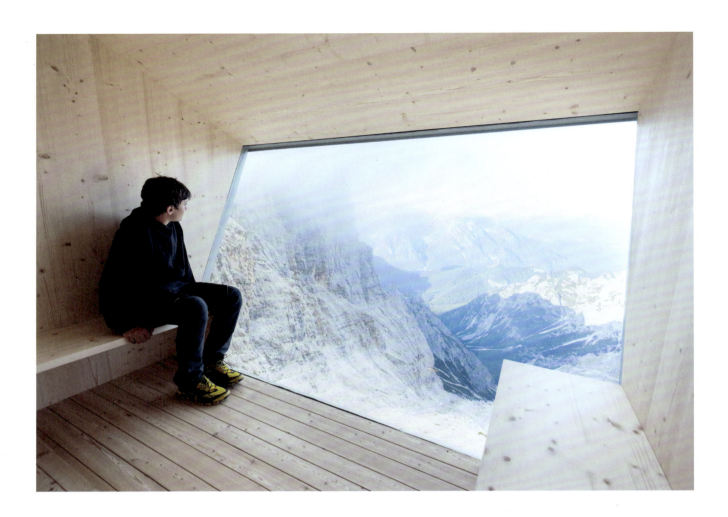

The cabin turns into a sort of telescope to admire the vast mountains in the heart of the Dolomites.

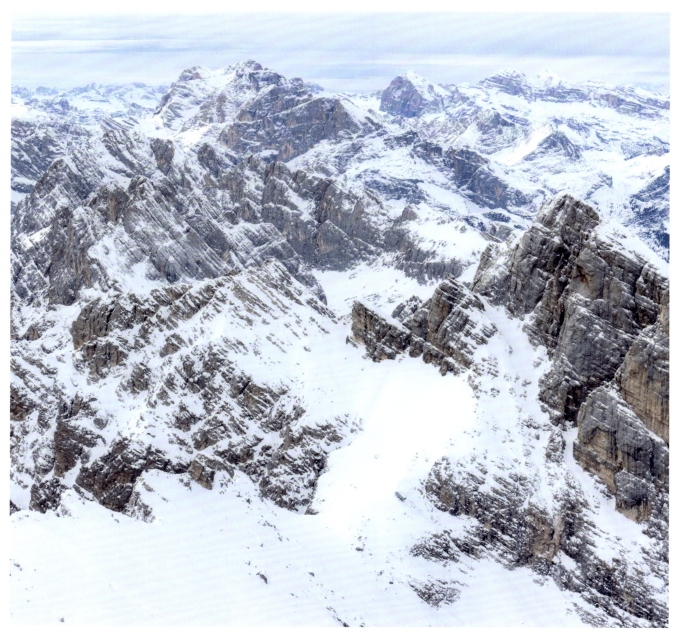

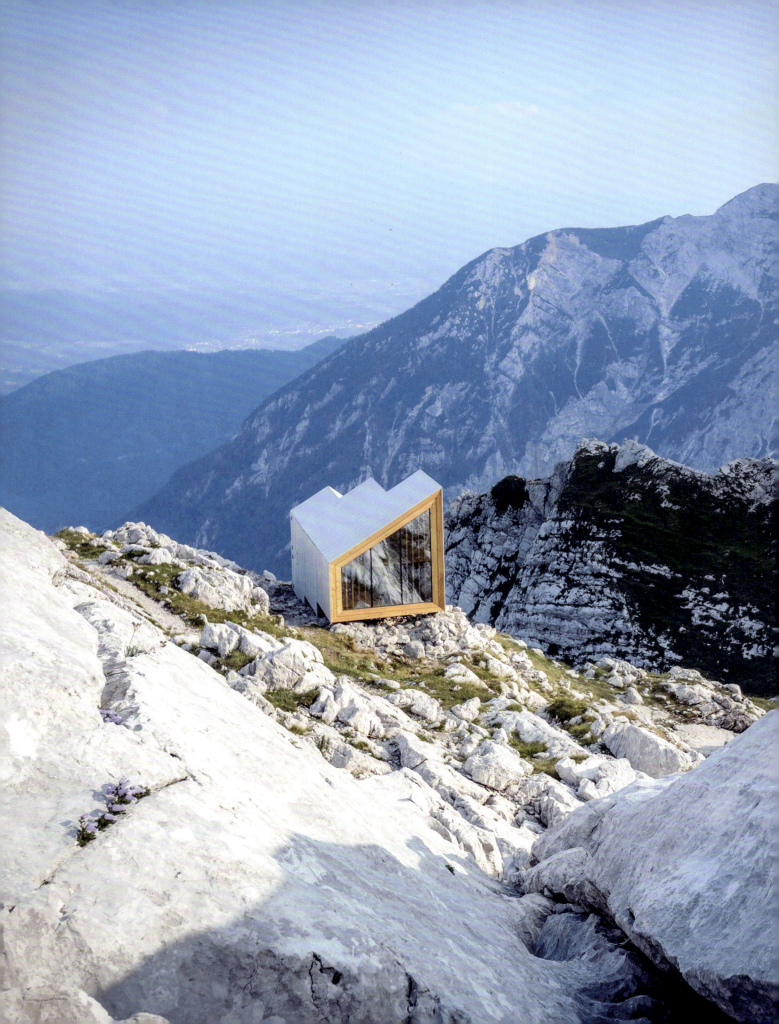

ALPINE SHELTER
KAMNIK ALPS, SLOVENIA

The shelter is the work of an architectural design studio led by Rok Oman and Špela Videčnik of OFIS Architects at the Harvard Graduate School of Design. The task was to come up with an innovative as well as practical shelter that would best respond to the extreme mountain conditions. To ensure that the structure could withstand radical temperature shifts (these can vary between plus and minus 30 degrees Celsius), snow loads, and strong winds, the architects chose a triple pane system of glazing, wood construction, and thermal wool insulation using about 97% mineral materials. "The production process for this particular stone wool is a technological replica of the inside of a volcano that spins and cools lava in a controlled environment, that makes the product naturally durable and stable over the lifetime of a building," they explain. This choice is perfect for the constant condensation in the climate, as tiny pockets of air trapped within the physical structure of the stone wool create perfect insulation. It also reduces the need to keep the building warm in the winter, while providing a cool interior temperature during the summer.

The shape was on the one hand inspired by the vernacular architecture of Slovenia and the country's rich heritage. On the other, it relates visually to the shape of the surrounding mountains (this design scheme is by students Frederick Kim, Katie MacDonald, and Erin Pellegrino). Designed for a high altitude, and for a plot with very limited accessibility, the shelter was prefabricated. All structural components, envisioned together with the team of AKT II responsible for the structural engineering, were easy to transport in parts via helicopter. The lightweight modules planned as a series of robust frames were then assembled on site. In the 12-square-metre shelter, made entirely of larch wood, there are three functional zones – an entrance with a storage area and a small space for preparing meals, a second module with a bedroom and space for socialising, and the last part with bunk beds. The shelter is strongly anchored to the rugged terrain, yet in a way that has a minimal impact on the ground and a non-invasive foundation, achieved through strategically placed pin connections. The visitors can also enjoy striking views of the rocky peaks of the Slovenian Kamnik Alps, particularly the impressive Skuta Mountain in the range of the Triglav Glacier (the highest mountain in Slovenia) and the valley, through full-wall glazing on each end of the building.

ACCESSIBILITY
While only one challenging and unmarked path leads to it through Žmavčarji Valley, the cabin is additionally difficult to find in the fog. The hiking and climbing season with the most suitable and stable weather conditions lasts from June to October. Hiking in the winter can be dangerous and demanding of special experience.

ARCHITECTURE
OFIS Architects / Harvard GSD / Akt II, 2013
LOCATION
Mountain Skuta, Kamnik Alps, Slovenia

ALTITUDE
2045 m
NUMBER OF BEDS
10

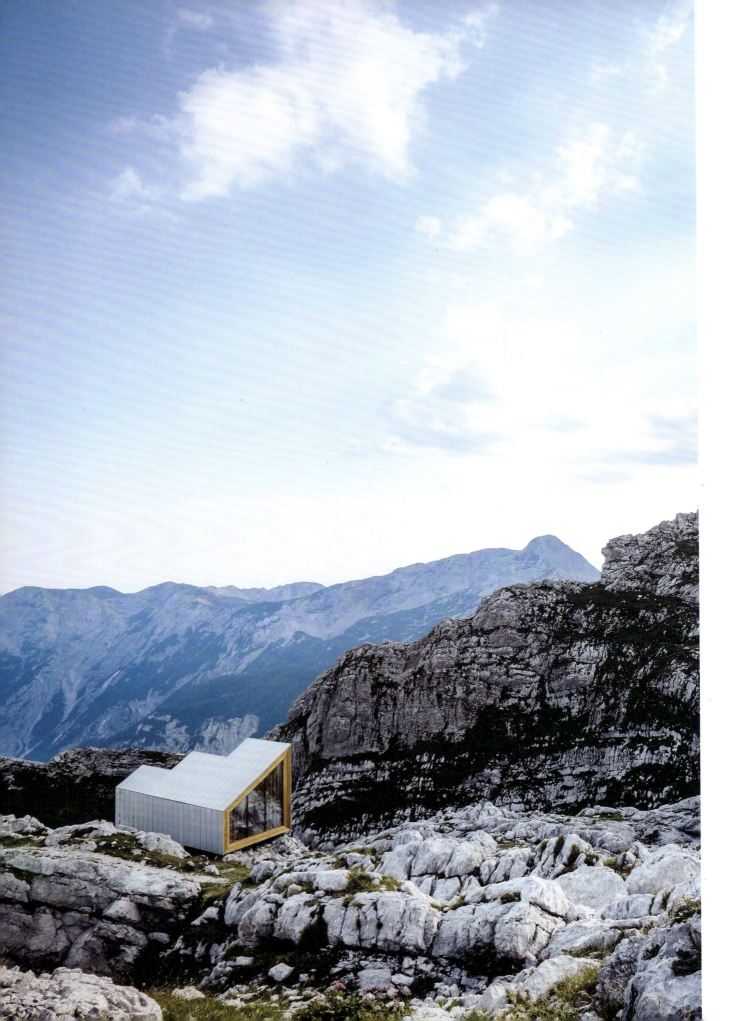

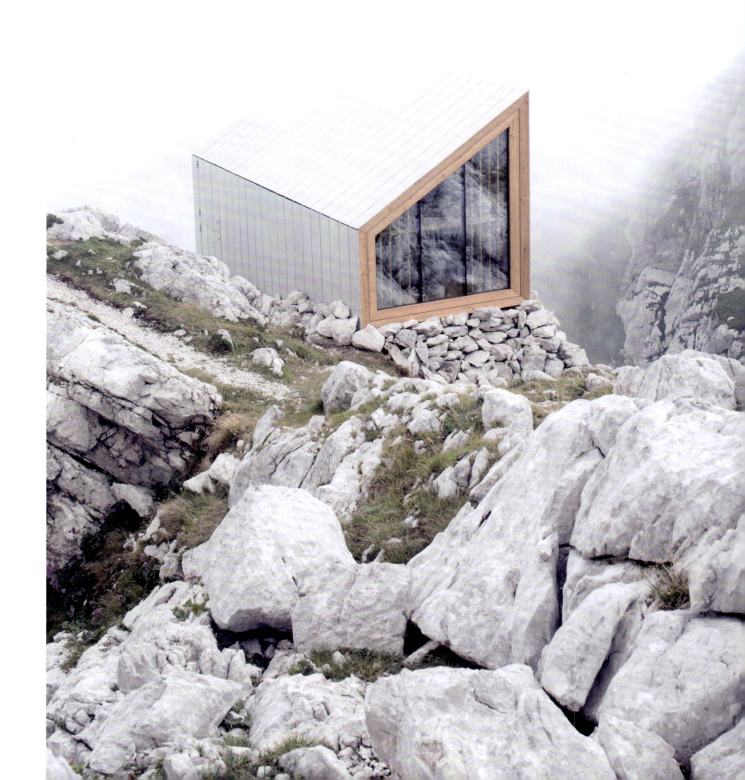

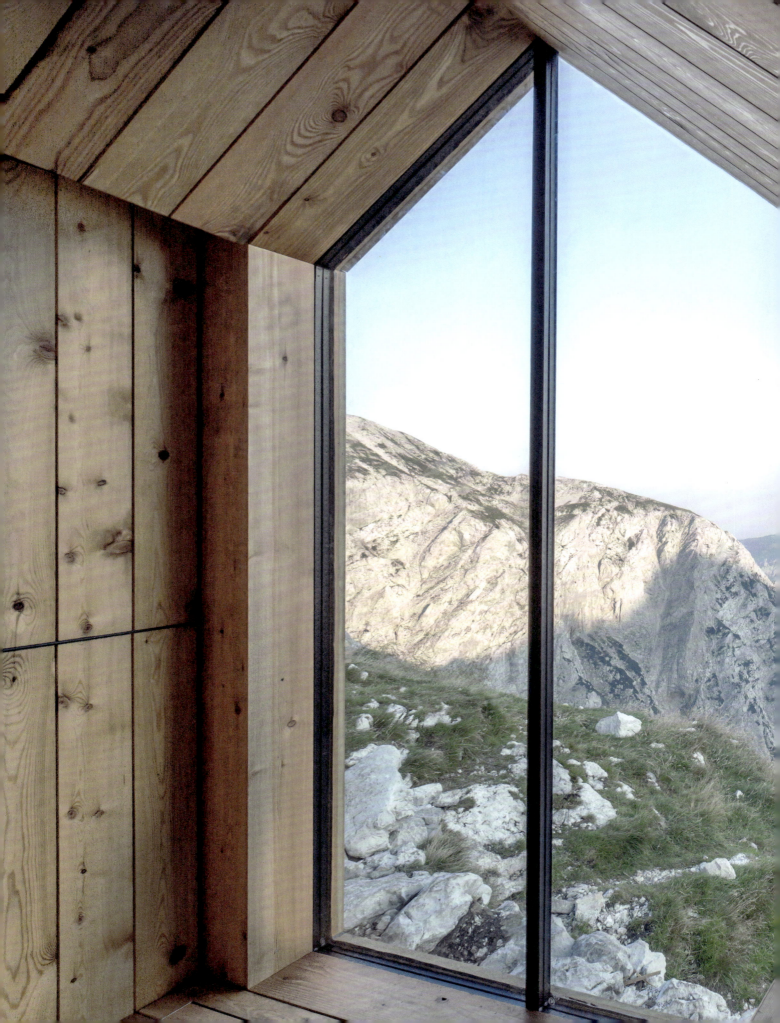

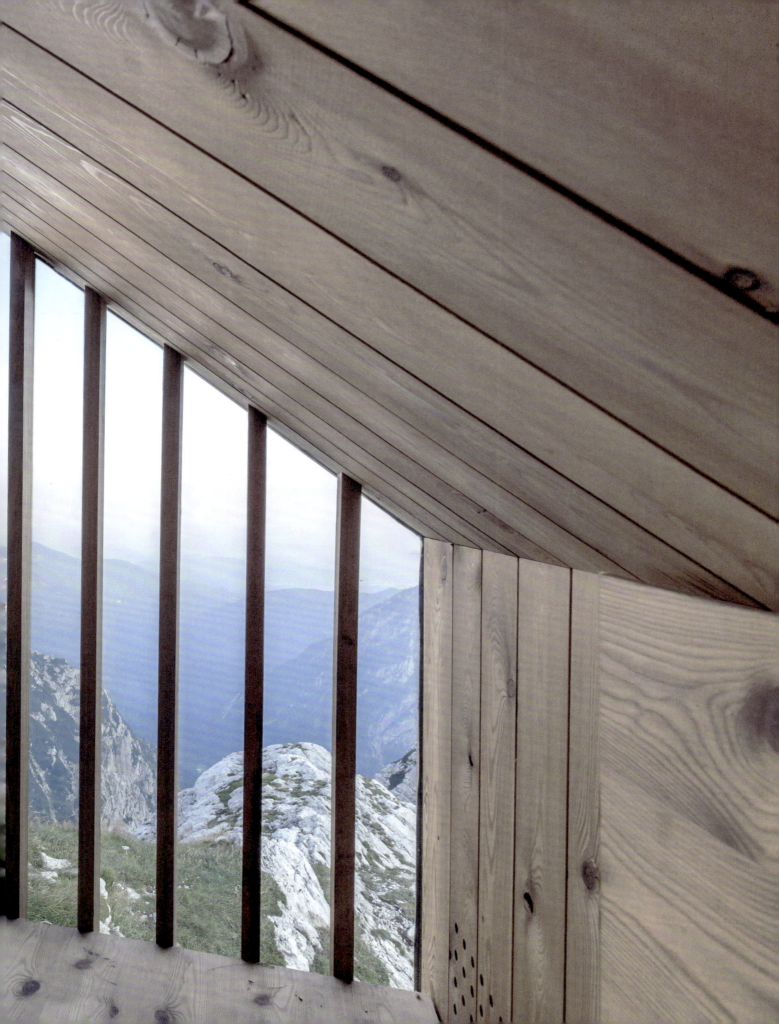

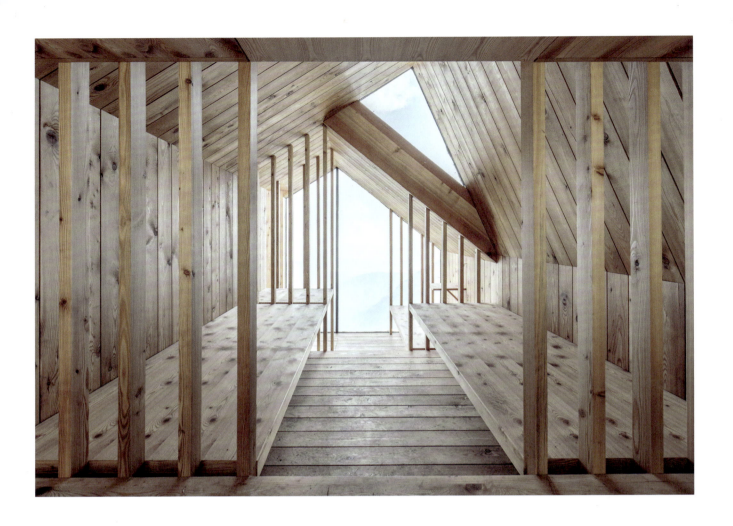

The visitors can enjoy striking views of the rocky peaks of the Slovenian Kamnik Alps, particularly the impressive Skuta Mountain.

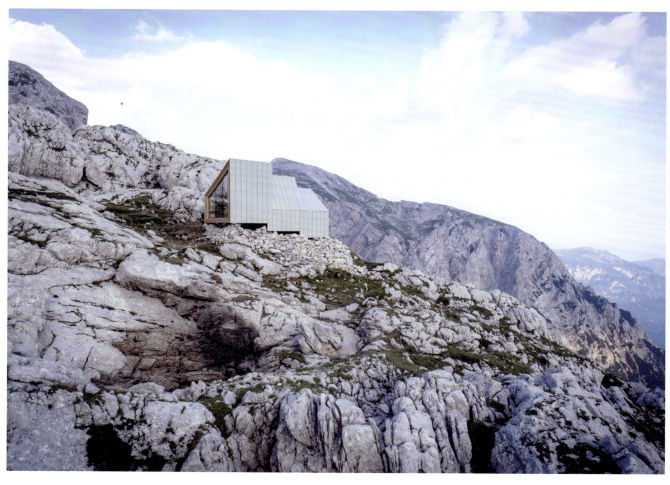

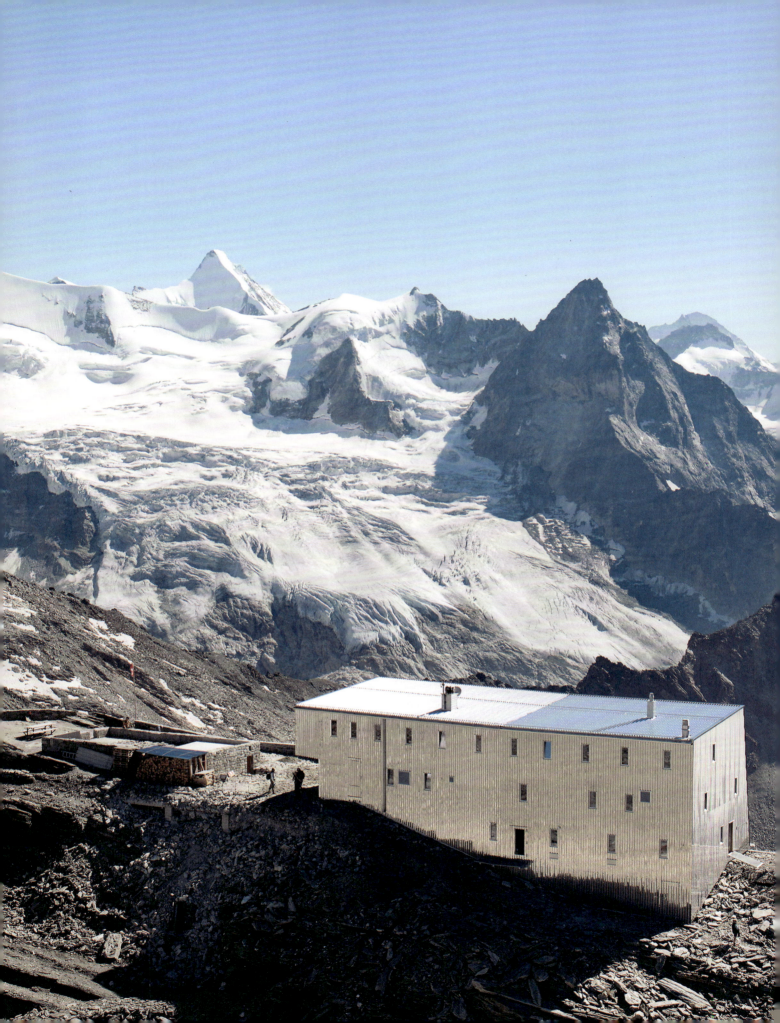

NEW TRACUIT HUT
ZINAL, SWITZERLAND

The story of this cabin goes back to 1929. Extended and developed several times in the past century, it was finally replaced by a brand new hut designed by Savioz Fabrizzi Architectes to meet the standards of mountaineers and hikers of the 21st century. The latest technologies allow for comfort for the guests but also ensure that the building respects the striking natural environment of the Val d'Anniviers in the heart of the Valais Alps. The building offers comfortable dormitories (for 4, 12 and 24 guests) on the top floor as well as a refectory on the ground floor, filled with natural light and open to spectacular views over the Val de Zinal. The below-ground level houses lavatories and technical rooms. As it sits between a cliff and a glacier, both the placement and the shape were perfectly adjusted to fit the site's topography – the building literally becomes an extension of the rugged rocks. The most striking element of the volume is the south façade: envisioned to extend from the cliff, it acts as an extensive sun radiation collector through generous openings and solar panels, which profit from exposure to the sun. The other sides were planned with only a few and relatively small openings to reduce heat loss, which is also achieved through the compact shape and efficient wall insulation.

To optimise the construction, the architects limited the use of concrete, which can be found only in the foundations, while the structural frame of the building is made entirely of wood. All other elements like the wall and floor components were prefabricated and brought to the site by helicopter. To adapt the building to adverse weather conditions, the architects wrapped the volume in protective stainless steel cladding. Low-tech ventilation is used to cope with the heat emitted by the guests and prevent excess humidity during the months the hut is closed. The interiors are entirely lined with light wood and are furnished in a minimalist but comfortable manner. New Tracuit Hut is open from March to September, but a spare room remains open in the off-season with a wood-burning stove both to heat the room and to cook. A dormitory with room for 24 guests is also available. It is used as a perfect 'base camp' to attack several neighbouring peaks including the Bishorn and the Weisshorn.

ACCESSIBILITY
A path from the village of Zinal is said to be of average difficulty, but it is a relatively long route of nearly five hours and with a 1500-metre difference in altitude.

ARCHITECTURE
Savioz Fabrizzi Architectes, 2013
LOCATION
Zinal, Switzerland

ALTITUDE
3256 m
NUMBER OF BEDS
120
INFO
www.tracuit.ch

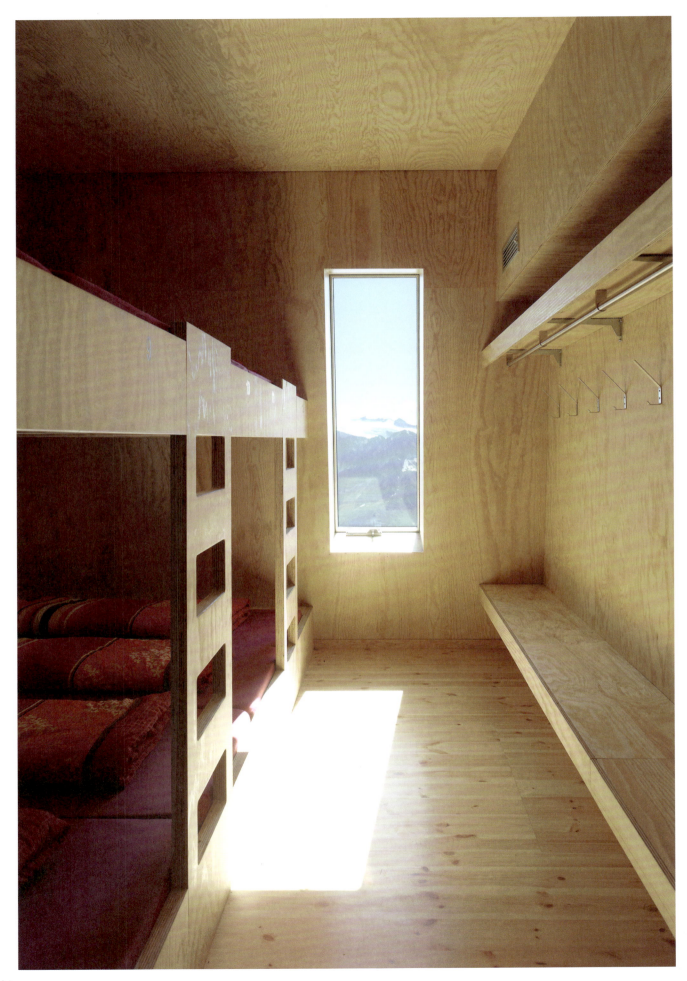

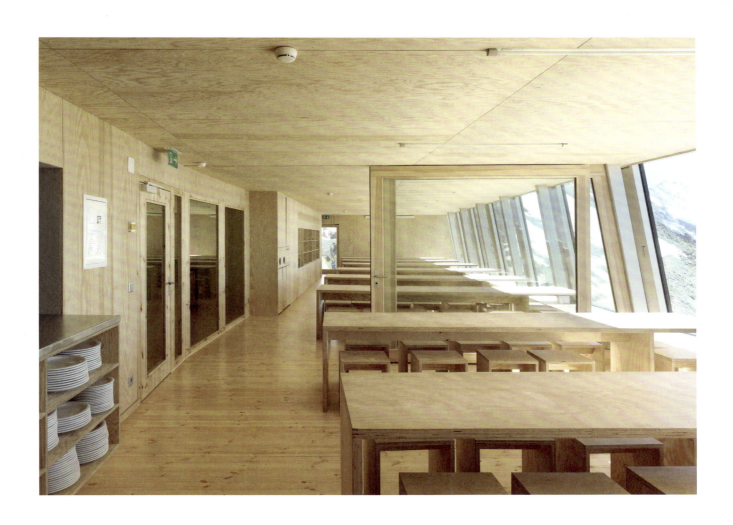

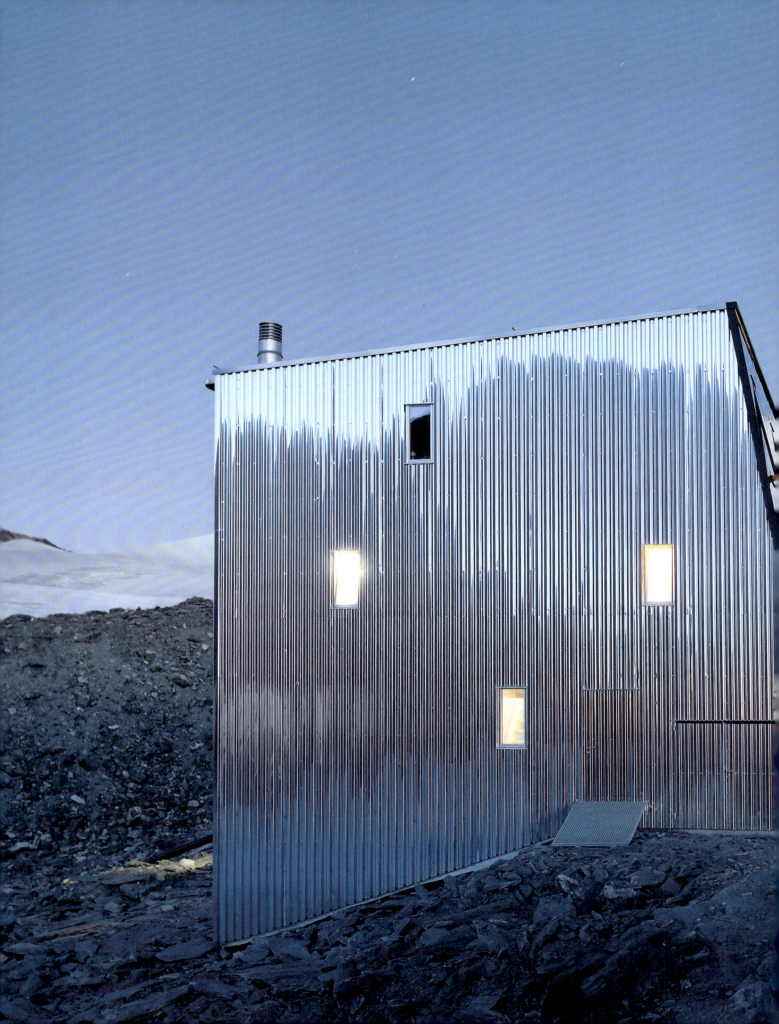

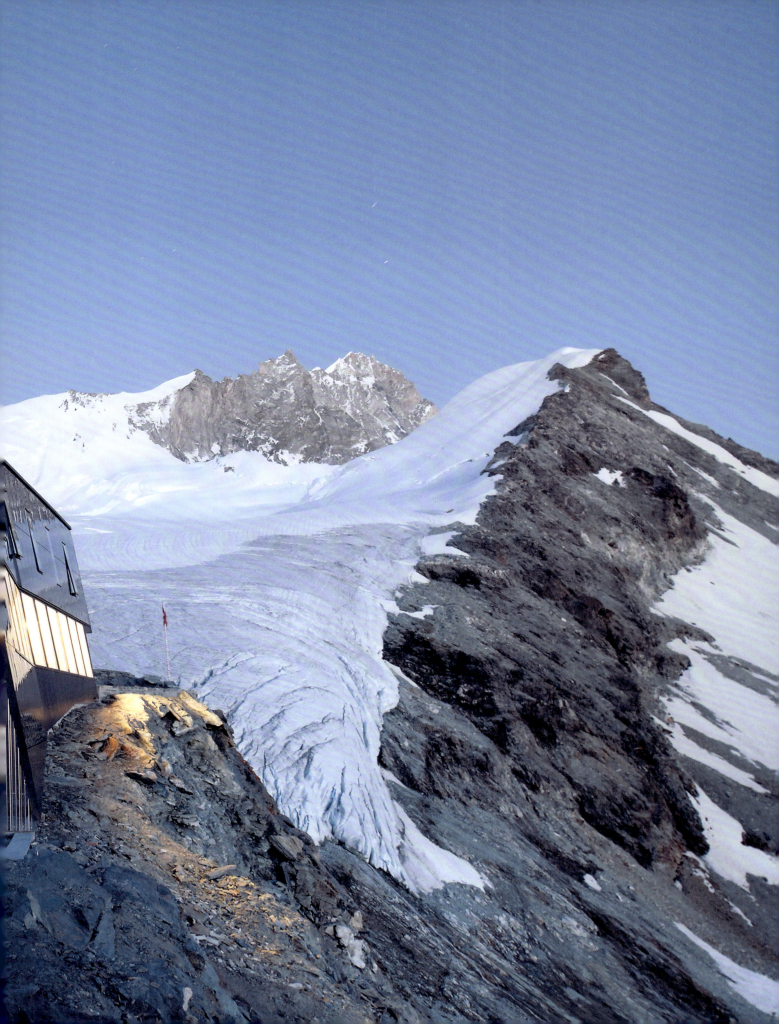

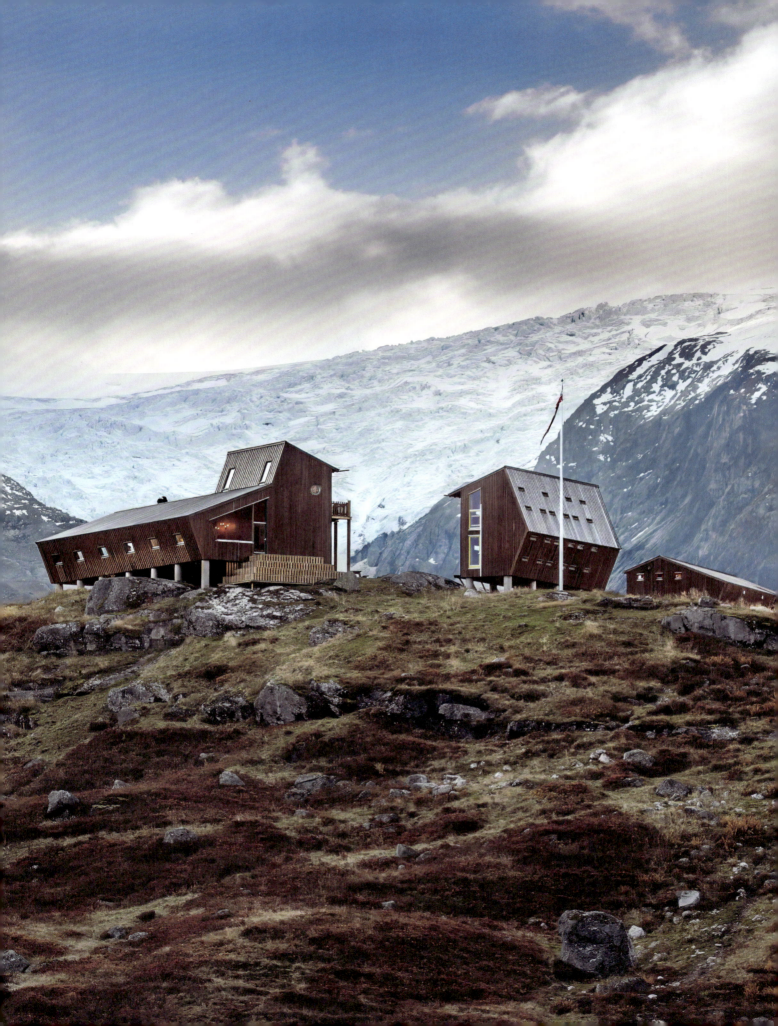

TUNGESTØLEN HIKING CABIN
LUSTER, NORWAY

Commissioned by Luster Turlag, the local branch of the Norwegian National Trekking Association, a complex of timber cabins occupies the perfect spot – a small plateau with a stunning view overlooking the Jostedalen Glacier. The buildings, surrounded by the dramatic scenery of the steep mountains, form a quiet retreat. Through the selected natural materials as well as thanks to the playful shaping, the architects achieved a well-balanced relation between the natural beauty of the location and the architecture, which blends into the context instead of visually dominating it. Furthermore, the hues of the wooden outer shells of the buildings will change with time under diverse weather conditions and thus further alter the colour palette of the mountainous panorama. Nine pentagonal volumes have been envisioned with a structure using wooden glue-laminated frames, covered with sheets of CLT, and clad in ore pine. "The outward-facing walls of the cabins have been given a beak-like shape to slow down strong winds sweeping up from the valley floor," explain the architects, who took into consideration the changing weather conditions of the site – the original cabin was completely destroyed by the cyclone Dagmar in 2011. The unusual forms were also an opportunity to frame views of the dramatic landscapes in all directions, with playful panoramic windows that provide illumination of the wood-clad interiors.

While extensive in the common areas, the windows are much smaller in the dormitories to create a cosy atmosphere. All rooms have been arranged in a simple yet very comfortable way.

The main cabin houses a collective meal space and is equipped with large tables. The irregular ceiling is in some places up to four metres high, which opens up the generous and dynamic socialising area, enhanced by the vistas, onto its surroundings. A large stone-clad fireplace in the lounge offers a comfortable, relaxing space for colder times. Among the realised buildings is a dormitory volume with space for 30 guests, as well as one smaller cabin with four beds. When the ambitious programme of the nine cabins is completed, there will be room for up to 50 guests. Tungestølen Hiking Cabin is not only perfect as a base for advanced hikers who plan to climb the local glaciers, but it can also welcome families with small children, who can enjoy shorter and far less-challenging hikes in the area around the cabins. The cabins are open during the summer and autumn months.

ACCESSIBILITY
Relatively easy with numerous hiking trails in the surrounding area accessible for families with small children.

ARCHITECTURE
Snøhetta, 2019
LOCATION
Luster, Norway

ALTITUDE
1478 m
NUMBER OF BEDS
30

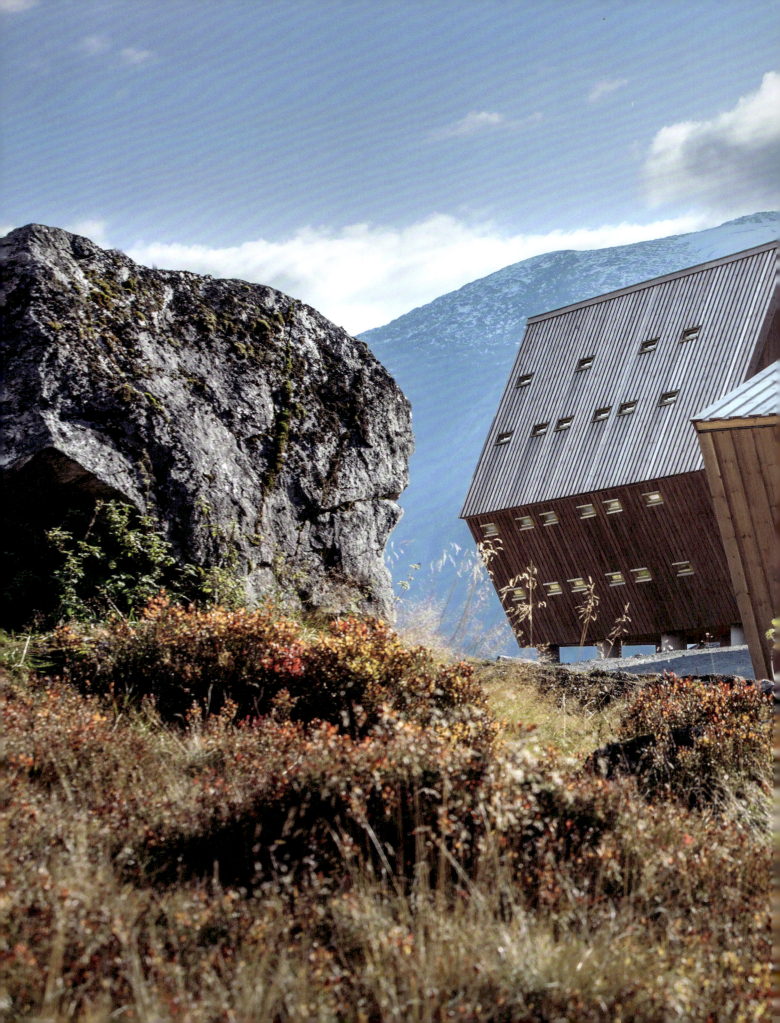

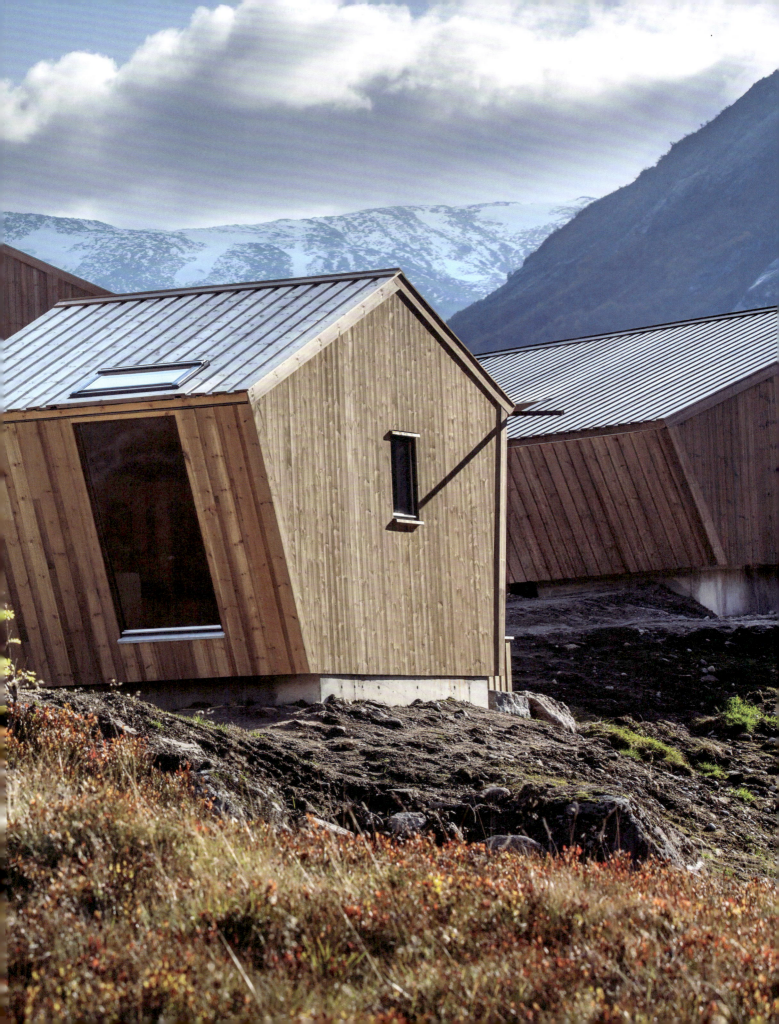

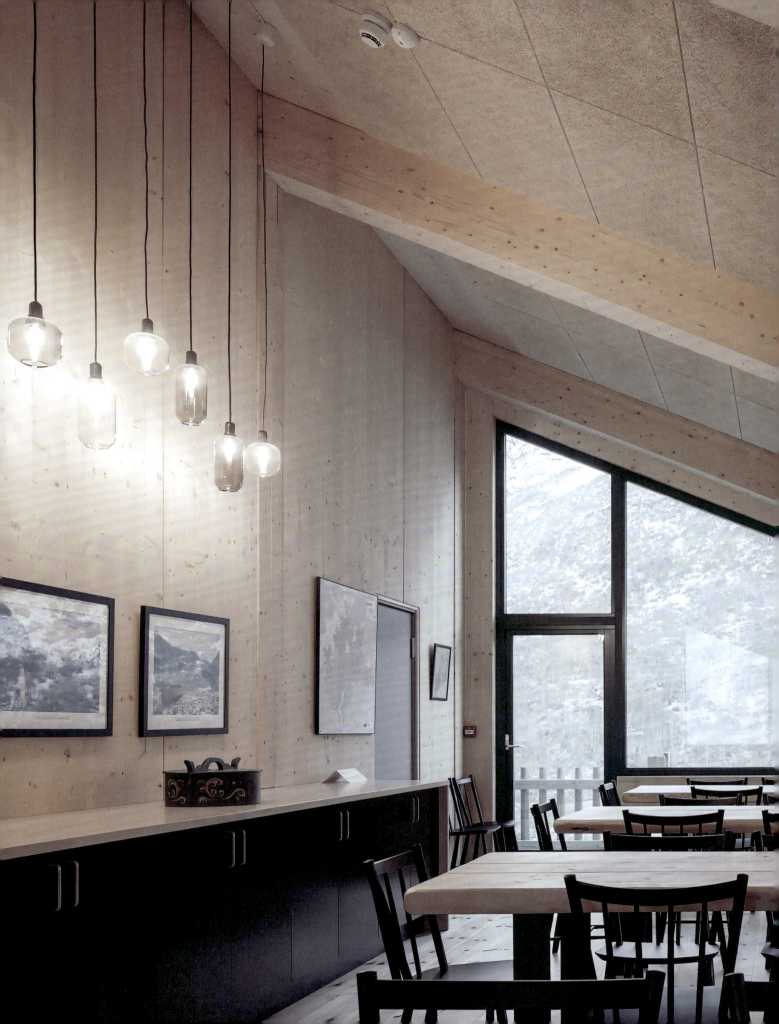

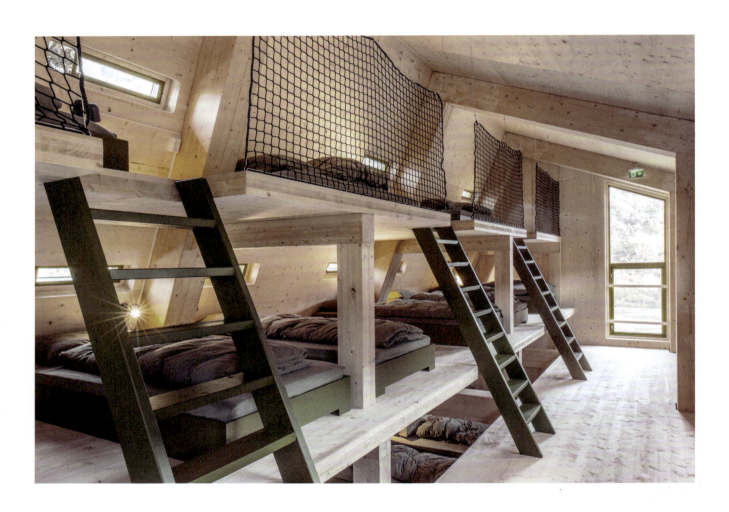

Tungestølen Hiking Cabin caters to both experienced hikers tackling local glaciers and families with young children.

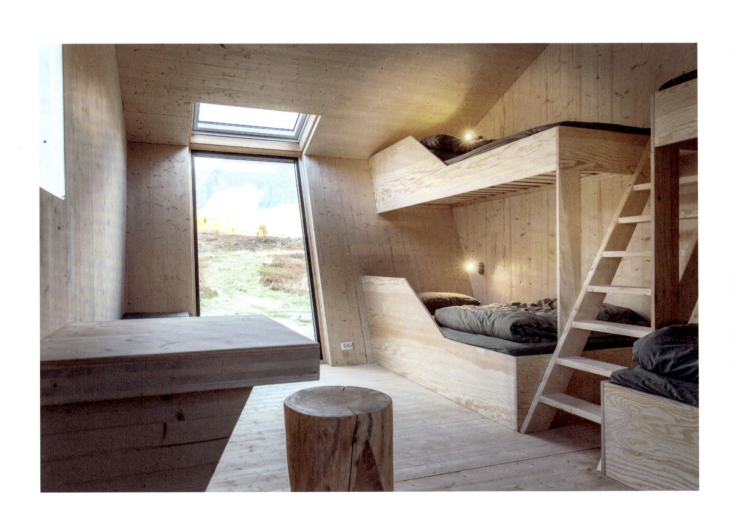

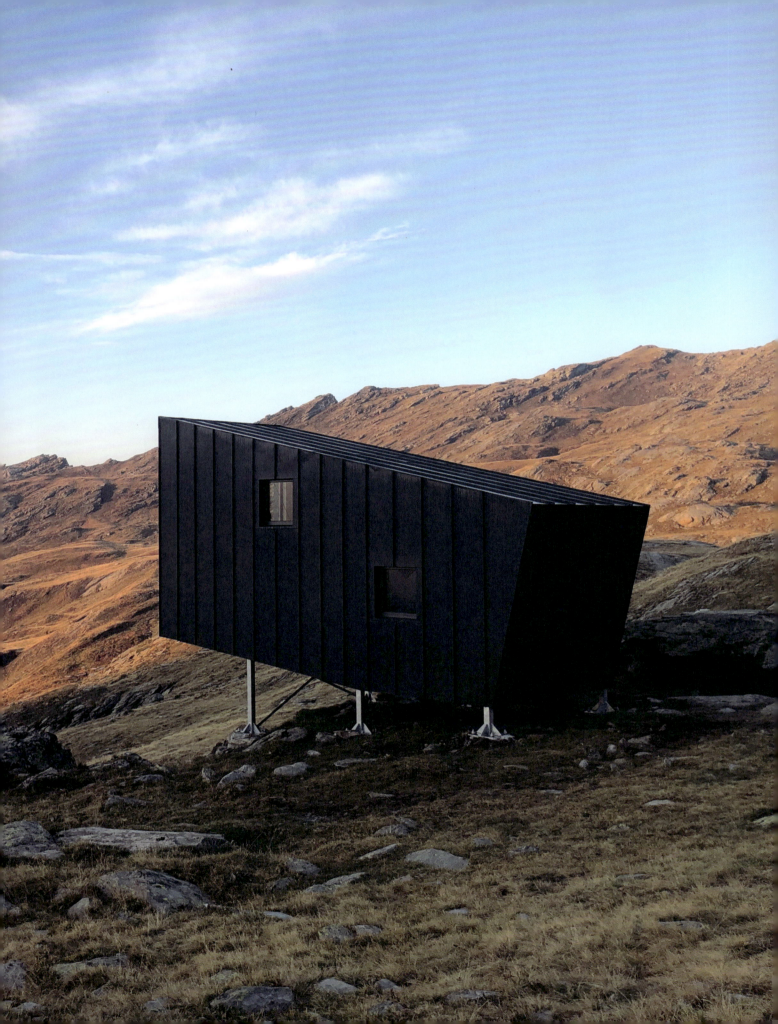

BIVACCO BRÉDY
AOSTA VALLEY, ITALY

BCW Collective, founded by Chiara Tessarollo, Skye Sturm, and Facundo Arboit, specialises in architecture for extreme weather conditions and landscapes. The realisation of this hikers' cabin was initiated by the Brédy family to commemorate Claudio Brédy, an alpinist and politician who lost his life in a hiking excursion five years earlier. The cabin was prefabricated in the valley and carried by a helicopter to the picturesque spot with a view of the two alpine Dzioule Lakes. Its silhouette has become a reference point recognisable from afar. However, while the building is distinctive, it can be easily removed. Its light yet durable structure is envisioned to reduce the footprint to a minimum, and the manner of anchoring it to the rock allows for the easy removal of the structure, practically without leaving a trace. The dramatic cantilever is symbolic: directed into the void, the shape is intended to evoke the absence of a person. But it also has a practical aspect – this way the volume can take maximum advantage of the solar gain to warm the interior, particularly in the winter time. From a bird's-eye view the geometric volume looks like a stone, in part thanks to the dark grey hue of the zinc cladding, which not only resists the elements and absorbs heat, but also acts like a camouflage, immersing the curious shape into the rocky context.

Inside, hikers will find six beds, some of which, interestingly, are folding bunks that have been fabricated from climbing robe and fixed to the wall with carabiniers. Apart from the vestibule entrance, which offers storage space and protects the interiors from the elements, inside is a common open space with a striking culmination in the form of an extensive opening that frames the Grivola peak and Gran Paradiso. A sitting area at the window offers hikers a contemplative observation point, while the beds are located further back in the volume and sandwiched between more solid walls, which still feature some openings. The interior of the volume is based on wood-frame walls with efficient insulation. The architects envisioned basic furnishings to use the small space in a practical way. The envelope in light wood creates a striking contrast between the cosy inside and vast outside. Bivacco Brédy was realised in collaboration with YACademy, Cantieri d'Alta Quota, the Municipality of Avise, and the Architects' Order of Valle d'Aosta.

ACCESSIBILITY
The new bivouac can be reached from Jovençan in the Vertosan Valley of the Valle d'Aosta region of Italy. In the snow-free months Bivacco Brédy is reachable by approximately three hours of hiking. Although the terrain is steep in places, there are no technical or exposed passages so it is accessible for most hikers. The hut is open and can be visited all year round, but in the winter, due to avalanche risk in the Vertosan Valley, it must be approached from a more technical route and is thus accessible only to experienced mountaineers.

ARCHITECTURE
BCW Collective, 2021
LOCATION
Vertosan Valley, Aosta Valley, Italy

ALTITUDE
2528 m
NUMBER OF BEDS
6

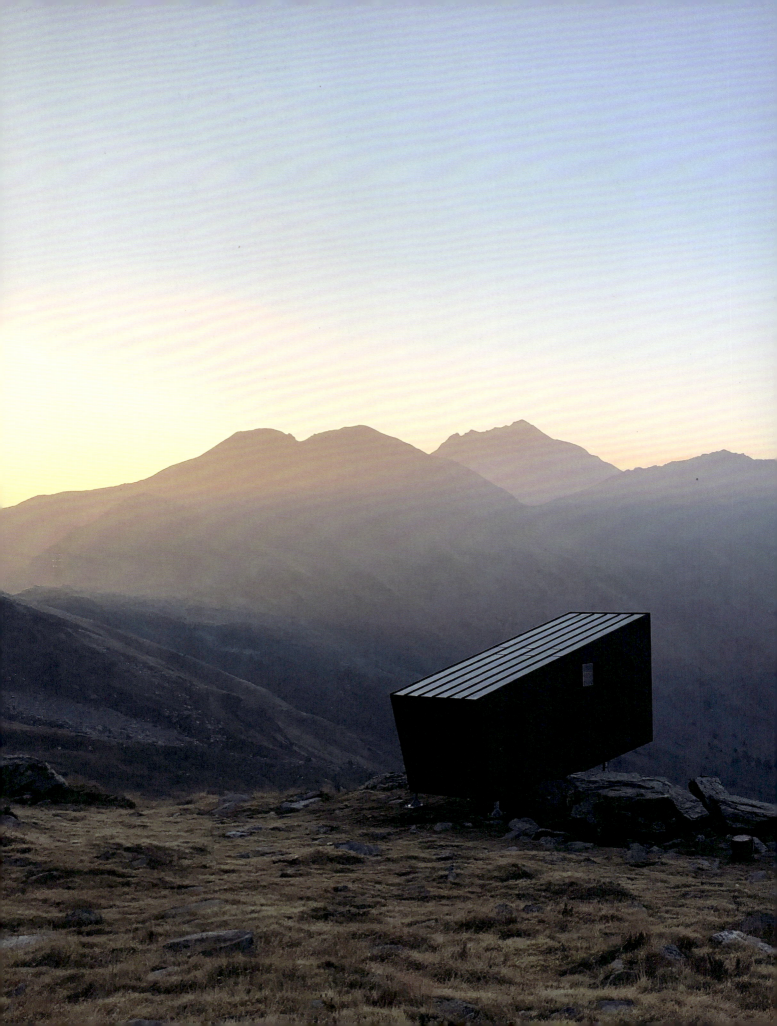

From a bird's-eye view the geometric volume looks like a stone, in part thanks to the dark grey hue of the zinc cladding.

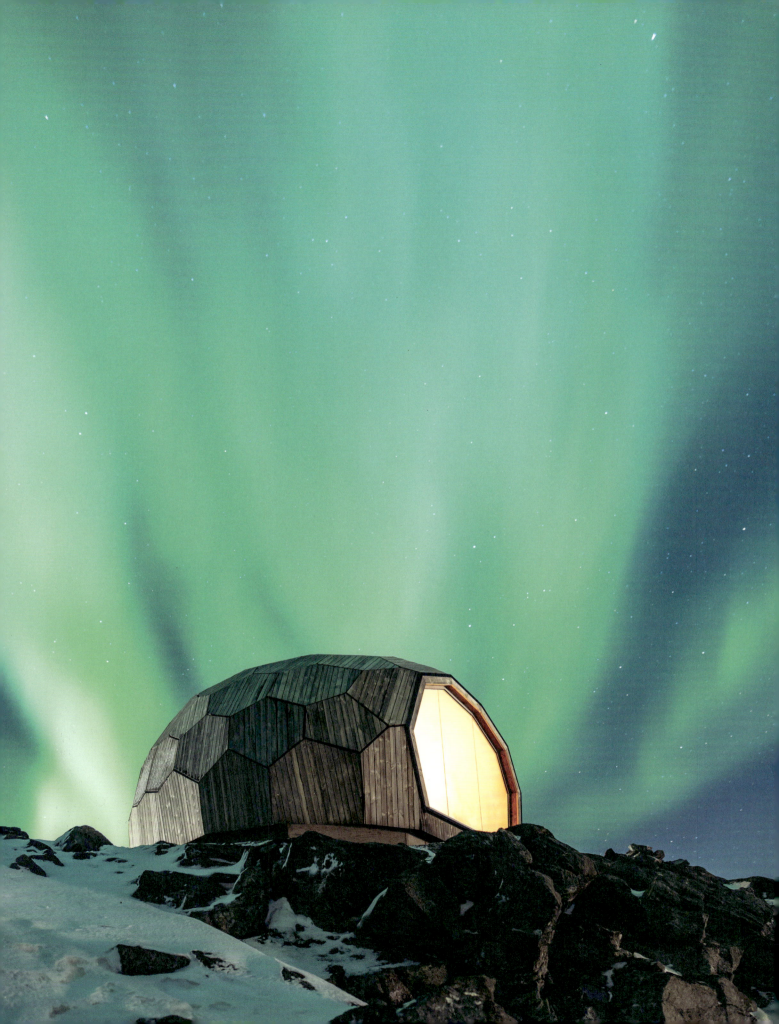

HAMMERFEST HIKING CABINS
HAMMERFEST, NORWAY

One of Norway's oldest cities, Hammerfest, is a strikingly beautiful arctic spot surrounded by mountains, white beaches, and panoramic views of the scenic coast. With gentle ascents, it is also a perfect destination for hikers, even for less-experienced ones. In order to promote hiking, the Norwegian Trekking Association commissioned the construction of two huts. Their brief was straightforward – they were to have a wood burning stove, simple benches and good windows, while their design was to initiate a dialogue with the terrain. "The sites were mapped in 3D using a drone and photogrammetry software to give a detailed map of the surface which was used as a baseline for form-finding," explains the Norwegian studio SPINN Arkitekter, who teamed up with British firm Format Engineers. The initial shapes envisioned by the architects were optimised by the engineers to make it possible to assemble the structures on top of a mountain by a non-professional team. It was essential to select the correct types of screws and fasteners. The rock-like wooden volume has been made of 77 unique panels designed to fit together like a 3D puzzle – the creators used 3D printing to determine how the construction would fit together and also to test out cladding options for the exterior. The organic shape is made of cross-laminated timber that softens the interior even more. Most impressive are the carved walls seamlessly turning into the ceiling. Hikers who take a break from the trail or spend more time to admire the midnight sun or Northern Lights can enjoy this cave-like hide-out that is comfy and opens onto the stunning arctic vistas of Hammerfest.

The cabins were first built in a controlled warehouse environment and tested to be partially demounted for the lorry transport, then placed on the foundations prepared at the sites. The window, fireplace and ramp as well as interior furniture were all installed on site, too. The routes to both Tyven and Storfjellet are easy walks that take approximately one hour to the very top. Access in the winter is much more challenging due to the snow, but the cabins were both conceived to withstand the harsh polar winter conditions, in particular storms and extreme wind, which is possible thanks to the two-layer bitumen water-resistant shell. With a series of snow simulations, the architects made sure that the cabins can cope even with heavy snowfall.

ACCESSIBILITY
Easy walks of approximately one hour each – via the sherpa stone stairway to Tyven (there are also other, more difficult ways), and via a gravel road going up to the Storfjellet mountain top. In the winter months, the routes are more challenging due to the snow.

ARCHITECTURE
SPINN Arkitekter, 2018/2019
ENGINEERS
Format Engineers
LOCATION
Storfjellet and Tyven, Hammerfest, Norway

ALTITUDE
660 m and 418 m
NUMBER OF BEDS
Overnight stay possible only on the floor

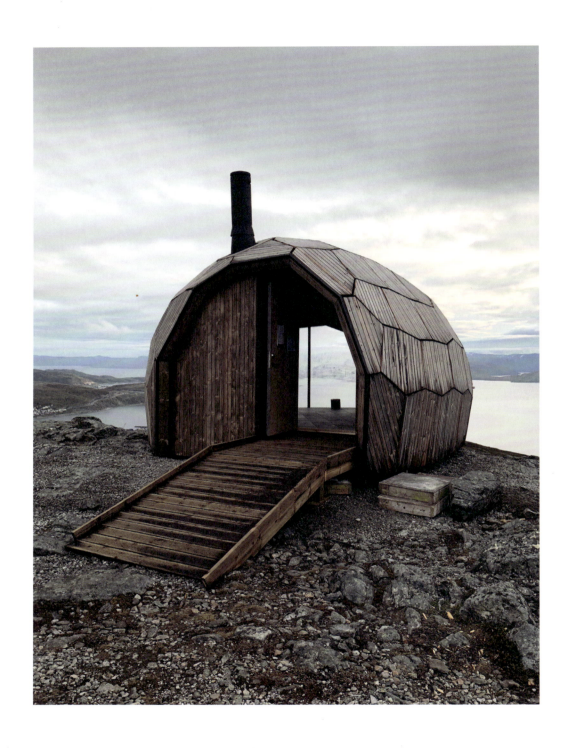

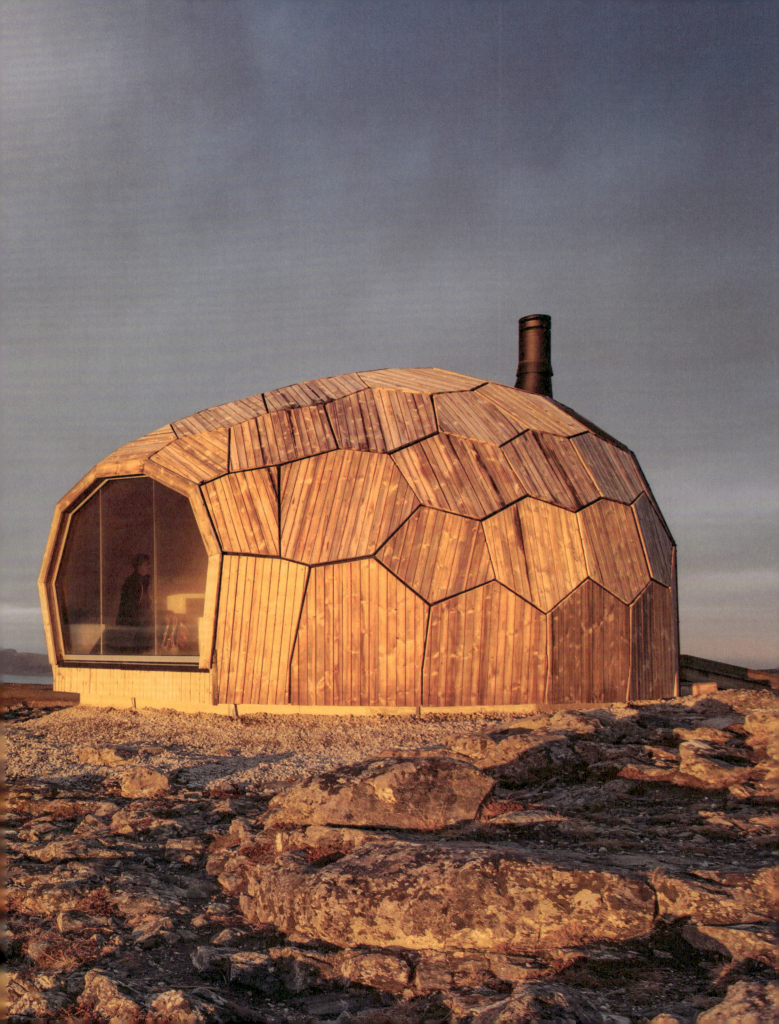

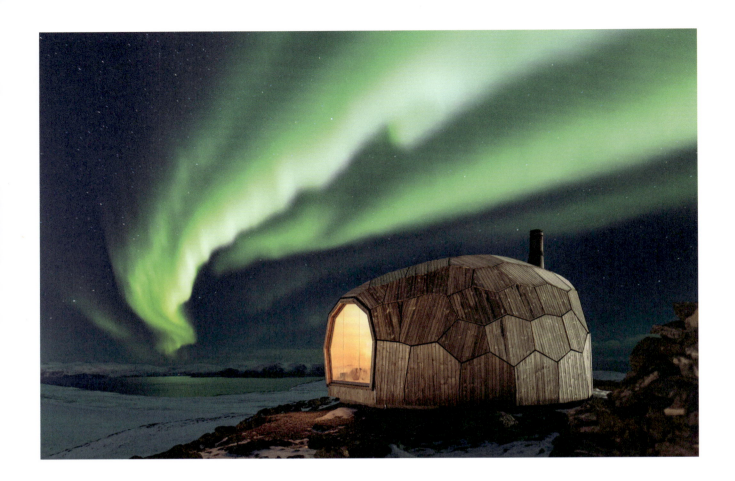

Hikers who take a break from the trail or spend more time to admire the midnight sun or northern lights can enjoy this cave-like hide-out.

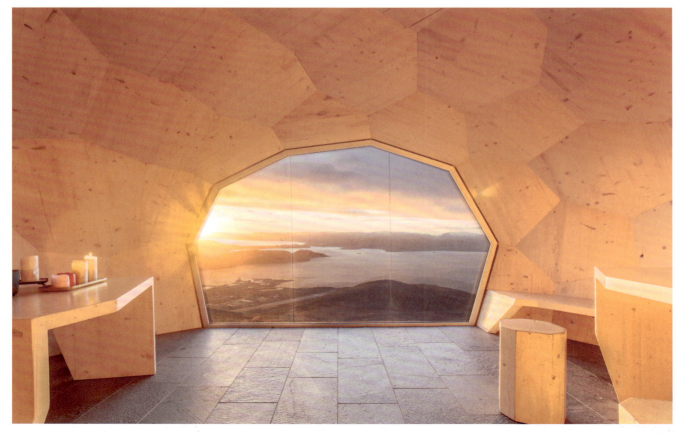

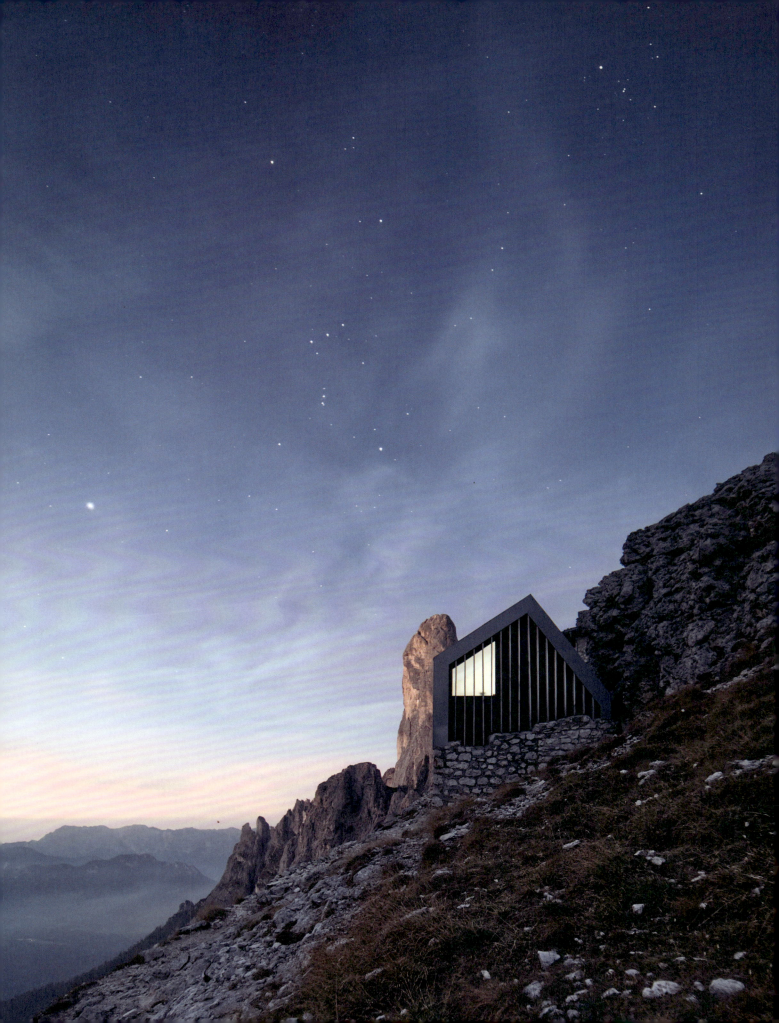

WINTER BIVOUAC AT PRADIDALI
DOLOMITES, ITALY

Giacomo Longo, Lucia Pradel, and Andrea Simon of Mimeus Architettura envisioned a spectacular refurbishment of a cabin located at the Rifugio Pradidali, which for many climbers is the starting point for excursions in the Pala group of the Dolomites. Surrounded by a rocky landscape, the refuge sits at the very edge of the rugged slope. While the large refuge is open only over the summer months, usually June to September (the exact dates may vary), mountaineers can use the refurbished old winter bivouac during winter time, as it remains open all year round.

The structure was originally built by volunteers belonging to the Treviso branch of the Italian Alpine Club; the refurbishment preserved the original basement made of stone. This traditional building material, just like in the Pradidali building, helps blend the architecture into the context and reduces its visual impact in the spectacular mountain landscape. The architects decided to cover it with a pitched-roof structure, which is made of weather-resistant metal. Significantly enlarging the interior in comparison to its original shape, the roof also protects the structure from accumulating snow in the winter. Both its shape and colour act like camouflage. One interesting element is the vertical cut at the entrance to the hut, which leads up to the gabled roof and is entirely glazed; it acts as a source of natural light and provides breathtaking views. Throughout the whole cabin, the architects made sure to create a good balance between the solid protective walls and openings, allowing natural light and views of the surroundings. Despite the compact shape, the interior is efficiently arranged across three levels. The designers' objectives were to make the best use of the height and create a functional subdivision of the space. Offering space for up to seven hikers, the interior they envisioned is entirely lined in timber – the walls, stairs, ceilings, and floors create a box-like environment. Comfortable and evoking warmth, the interiors are in stark contrast to the outer shell. The combination of the ability to withstand the elements on the outside and the embracing effect of the inside makes it an exemplary refuge. The Mimeus Architettura team also demonstrates how existing elements can be playfully juxtaposed with contemporary materials and forms, which do not disturb the natural beauty of the location. Authentic and modern at the same time, as well as discreet and comfortable, the Winter Bivouac at Pradidali disappears into its context.

ACCESSIBILITY
The pathway leading to the Pradidali bivouac begins at the Cavalli Valley and is a relatively easy walk of two to three hours. The level of difficulty changes with snow in the winter.

ARCHITECTURE
Mimeus Architettura, 2017
LOCATION
Pale di San Martino, Tonadico, Dolomites, Italy (the province of Trentino)

ALTITUDE
2278 m
NUMBER OF BEDS
7
INFO
www.rifugiopradidali.com

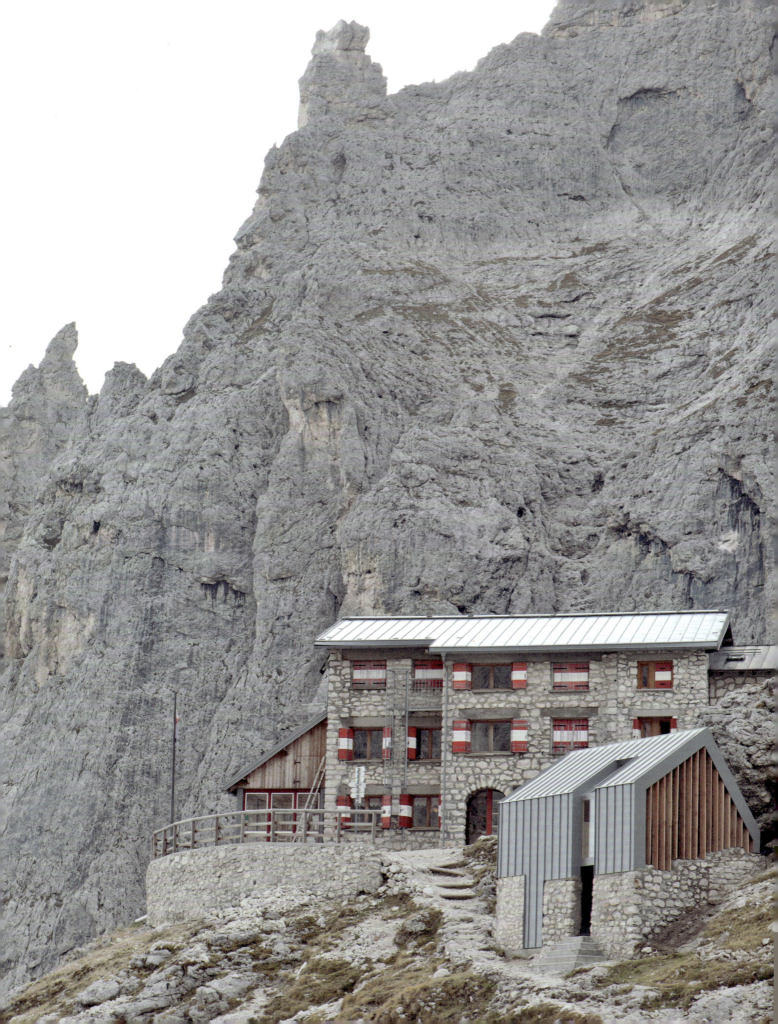

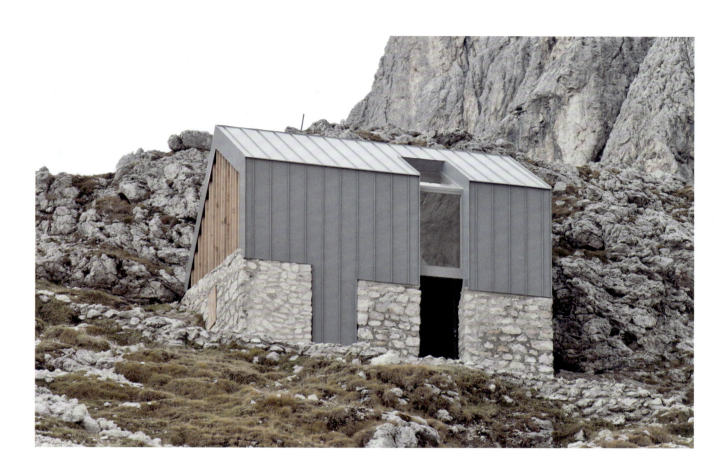

The roof protects the structure from accumulating snow in the winter. Both its shape and colour act like camouflage.

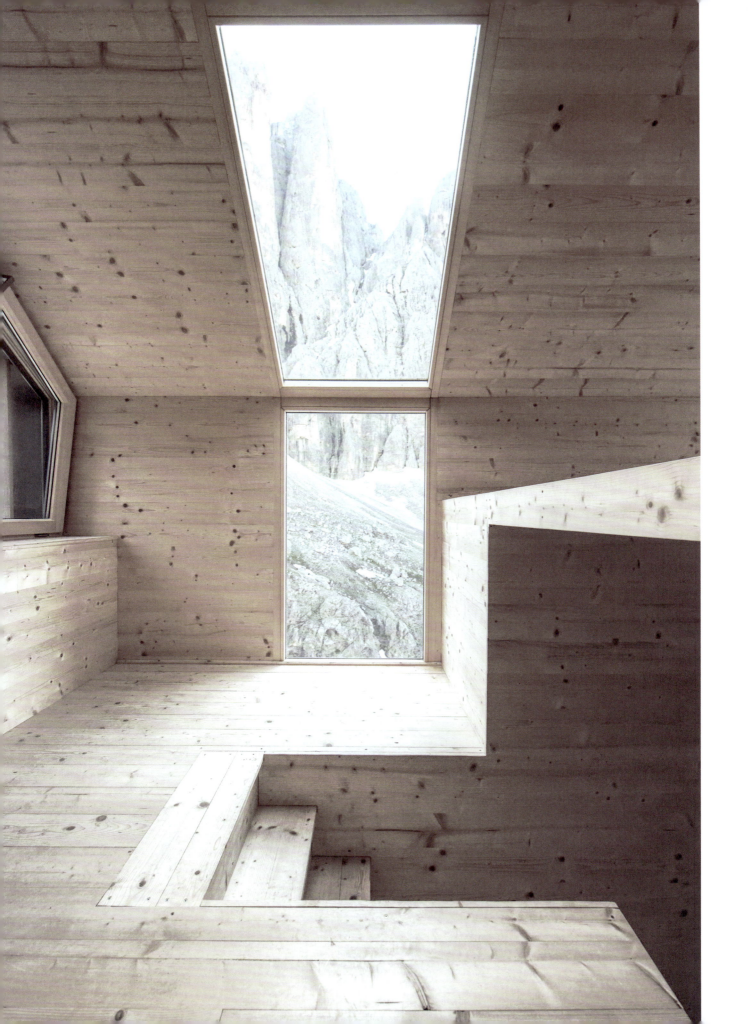

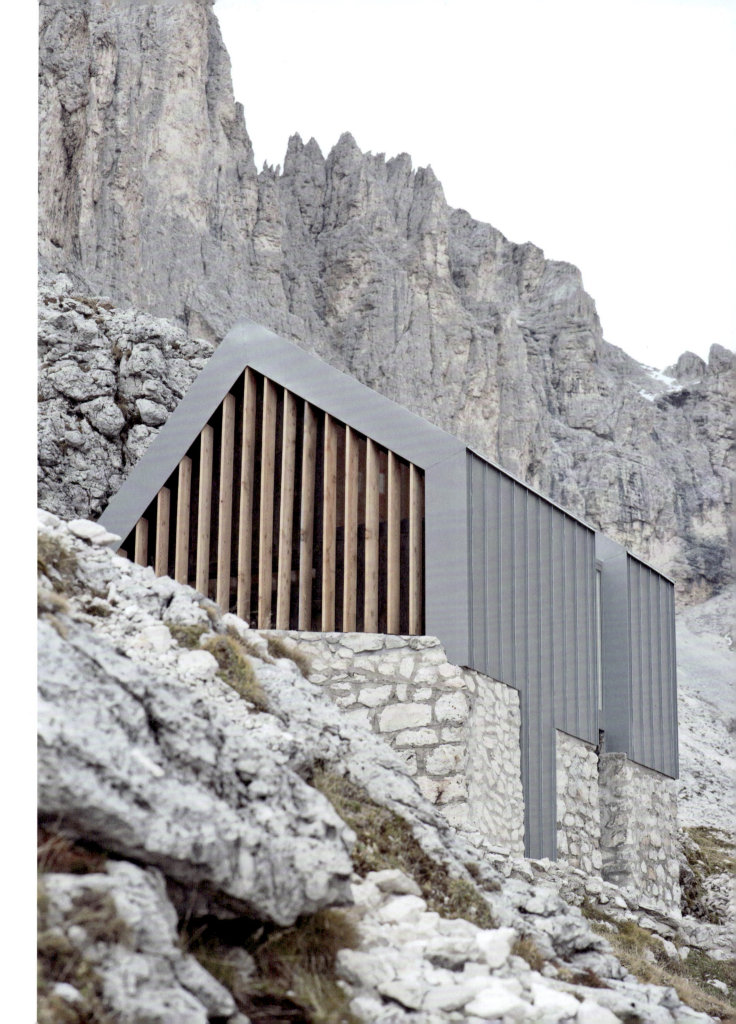

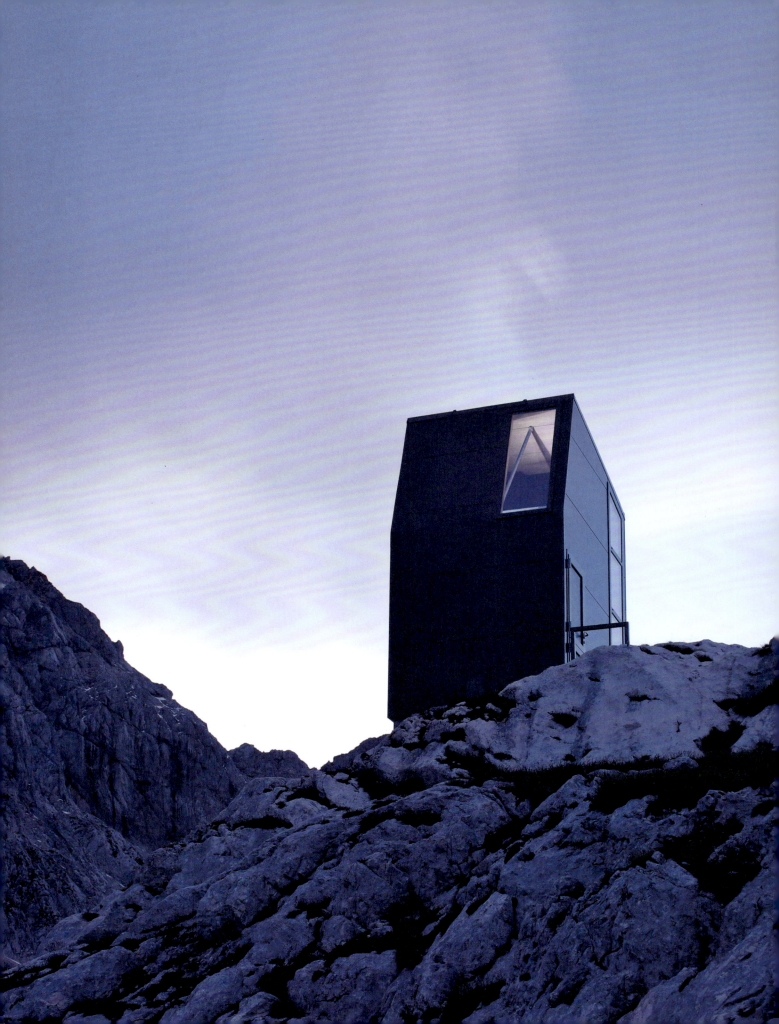

BIVOUAC UNDER GRINTOVEC, A MOUNTAIN SHELTER
KAMNIK ALPS, SLOVENIA

On a surface area of only 14 square metres, Miha Kajzelj designed a spacious vertical volume that is visible from afar yet visually attuned with the rocky setting. Its dark colour is an orientation point especially during the winter time, when it stands out against the snow. The structure has replaced the previous bivouac built back in the 1970s. Situated between the valley and Skuta Mountain, the cabin stands on a wide plateau. Its impact on the ground is minimal as the structure sits on a small concrete basement that is anchored to a rock and partly suspended in the air. "It is placed in a part of mountains where it is very difficult and dangerous to escape in the valley when caught by bad weather," explains the studio. Completed in the valley, the structure with windows and all inside elements was brought to the spot via helicopter.

The main idea is to provide a temporary shelter for waiting out sudden meteorological changes, but higher levels of the cabin have been designed as bed units to accommodate two to three people for the night. The architect designed the interior as a monovolume – a vertical open space with three levels creating a void and connected with a ladder that allows access to upper floors. The ground floor has a dining and living space that can be transformed into a sleeping area for the night. Some of the most striking elements of this curiously shaped cabin are the large openings arranged irregularly on all sides. Providing natural light and striking vistas, they also add lightness to the thus semi-transparent structure. The idea was to create a shelter that would be open to the context so that while sitting inside, guests can really feel they are part of the natural surroundings. Additionally, as the architects remark, "the verticality of the windows creates the feeling that the sleeping levels are floating in the air above the mountain scenery." The building is not heated, but the outer shell of the bivouac is made of isolated panels of aluminium, which are intended to keep in the heat produced by guests' bodies – the vertical arrangement makes the upper levels warmer. Inside, wooden perforated panels have been used to help body moisture evaporate, to keep the space dry. This original perforation also has a practical use – hooks installed in the holes can be quite useful for hanging clothes. The cabin is open all year round.

ACCESSIBILITY
The bivouac is located on the official path to Skuta Mountain, between Kamniška Bistrica Valley and the peak. The trail is difficult and hence suitable only for experienced climbers.

ARCHITECTURE
Miha Kajzelj, 2009

LOCATION
Kamnik Alps, Slovenia

ALTITUDE
2080 m

NUMBER OF BEDS
6-8

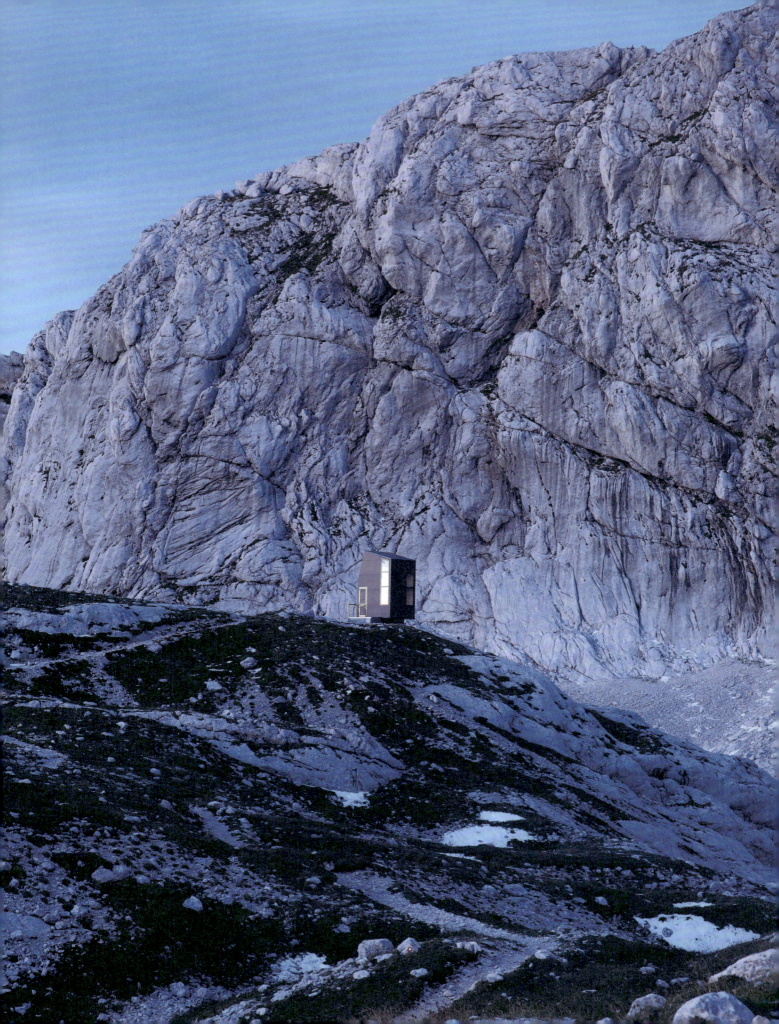

Completed in the valley, the structure with windows and all inside elements was brought to the spot via helicopter.

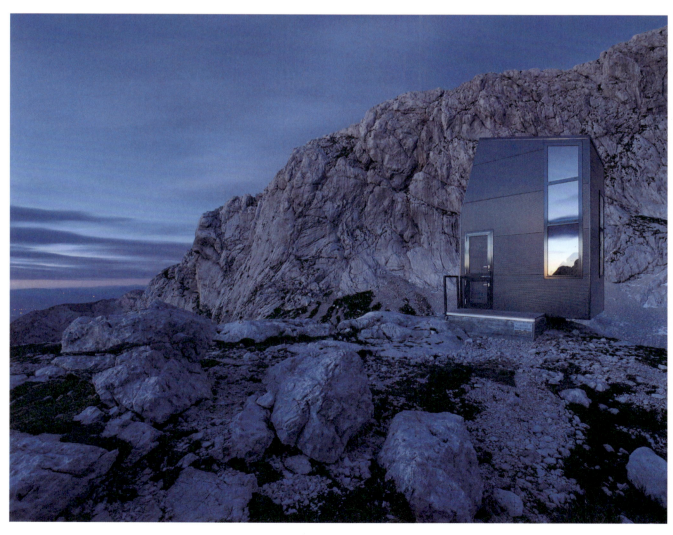

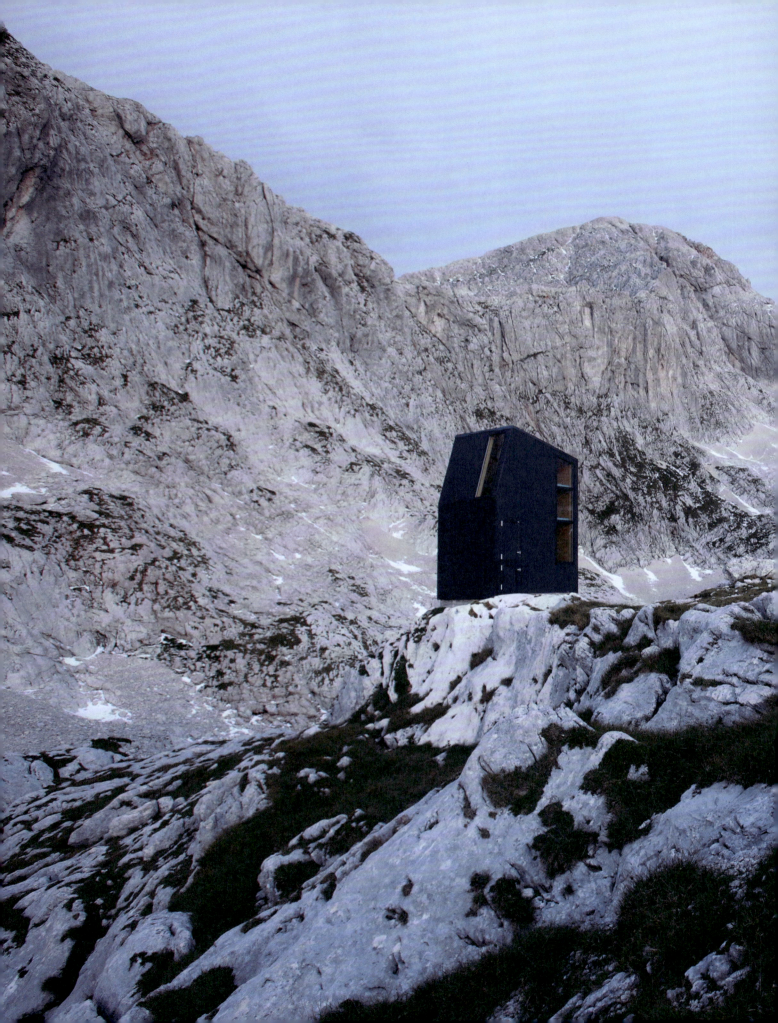

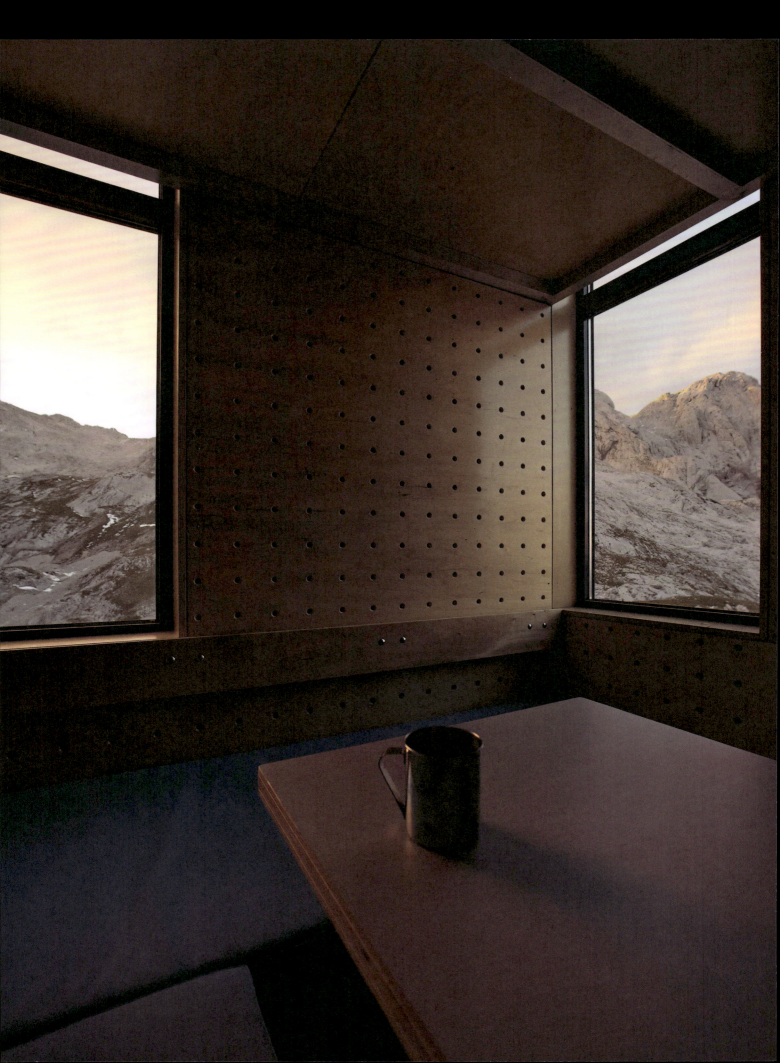

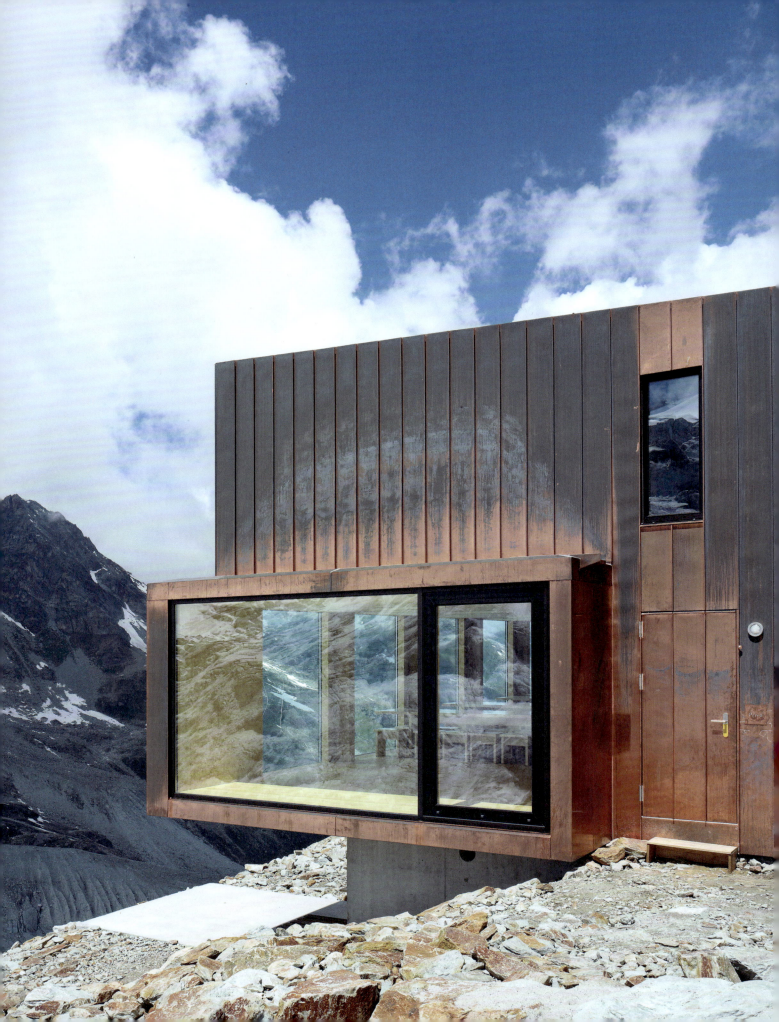

CABANE DE MOIRY
GRIMENTZ, SWITZERLAND

In the heart of the Valais Alps, situated on the trail from Chamonix to Zermatt between the Col du Tsaté, Val d'Hérens, and the Col de Sorebois towards Zinal, Cabane de Moiry has a beautiful view of the Moiry Glacier. As it is located at the very foot of it, many hikers make it a base for glacial peaks and ice climbing or fishing in Lake Moiry – mountain biking and paragliding are other popular activities. The architects baserga mozzetti won the competition to enlarge the capacity of the historical hut. This included adding a new building that consists of a masonry basement and a two-storey wood-frame structure. Inside is a refectory for 120 guests as well as the kitchen, service areas, and a couple of four-bed mini dormitories. While its underground level of reinforced concrete was constructed on site, the wooden walls of the upper floors were prefabricated off site. It took three days to assemble everything at the location. Excavated stone was used for the cladding of the terrace walls, which is in line with the pre-existing building. For the cladding of the façade of the new volume, the architects interestingly selected copper; they explain that this was a response to the type of material used for the roof of the existing hut. Employed on a huge scale, it creates a stark contrast with the pre-existing architecture. However, the modern design sits well in the landscape and somehow resembles a rock on the slope. Despite the visual difference between the two parts of the volume, the fusion of old and new at the high-altitude site is very successful.

At the core of the project was the goal of making an energy-efficient building, which was realised through a good thermal envelope offering protection from the cold temperatures as well as wood-burning stoves that heat the ground floor. Solar panels were placed on the south roof of the existing building. "Energy is produced by photovoltaic roof panels and by a heat and power generator fueled by rapeseed oil," emphasise the architects. The season when the cabin is open lasts from mid-June to mid-September. During this time the hut keepers offer a half-board dinner menu as well as lunch dishes. It is important to bear in mind, however, that the alpine route leading to the refuge is steep and snow can stay on some parts of the path until the end of July, and sometimes even up to the beginning of August.

ACCESSIBILITY
The path to the shelter is alpine and in some places steep. It is recommended to use a rope, especially for children and inexperienced hikers.

ARCHITECTURE
baserga mozzetti architectes, 2009

LOCATION
Grimentz, Valais Alps, Switzerland

ALTITUDE
2825 m

NUMBER OF BEDS
106

INFO
www.cabane-moiry.ch

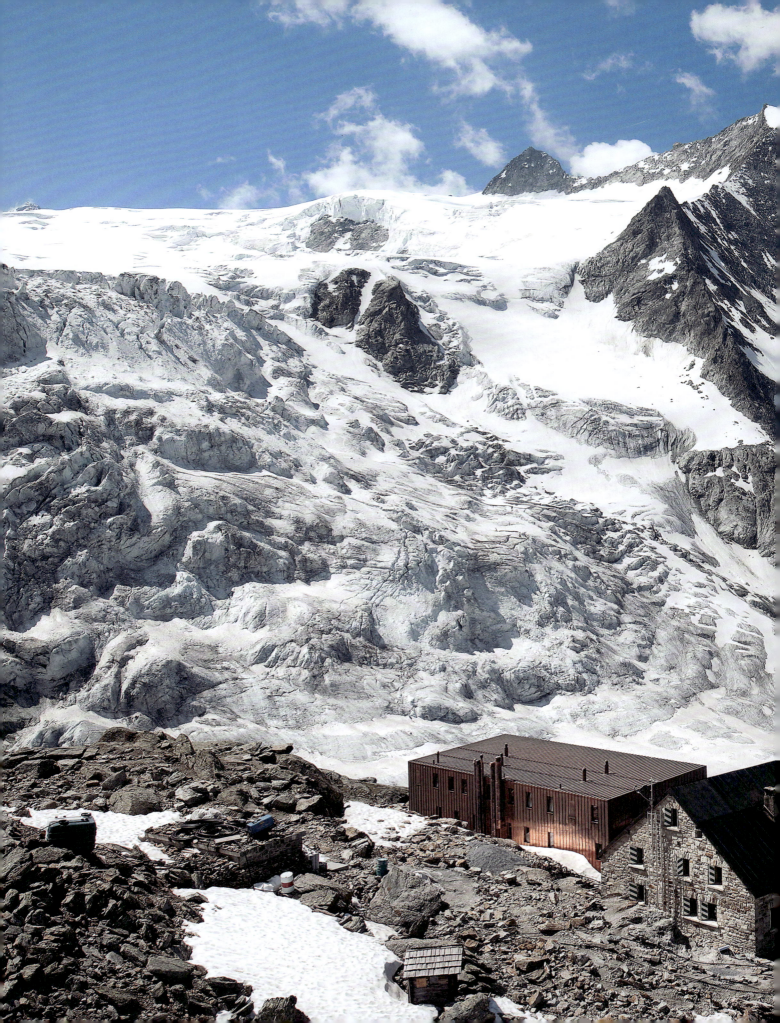

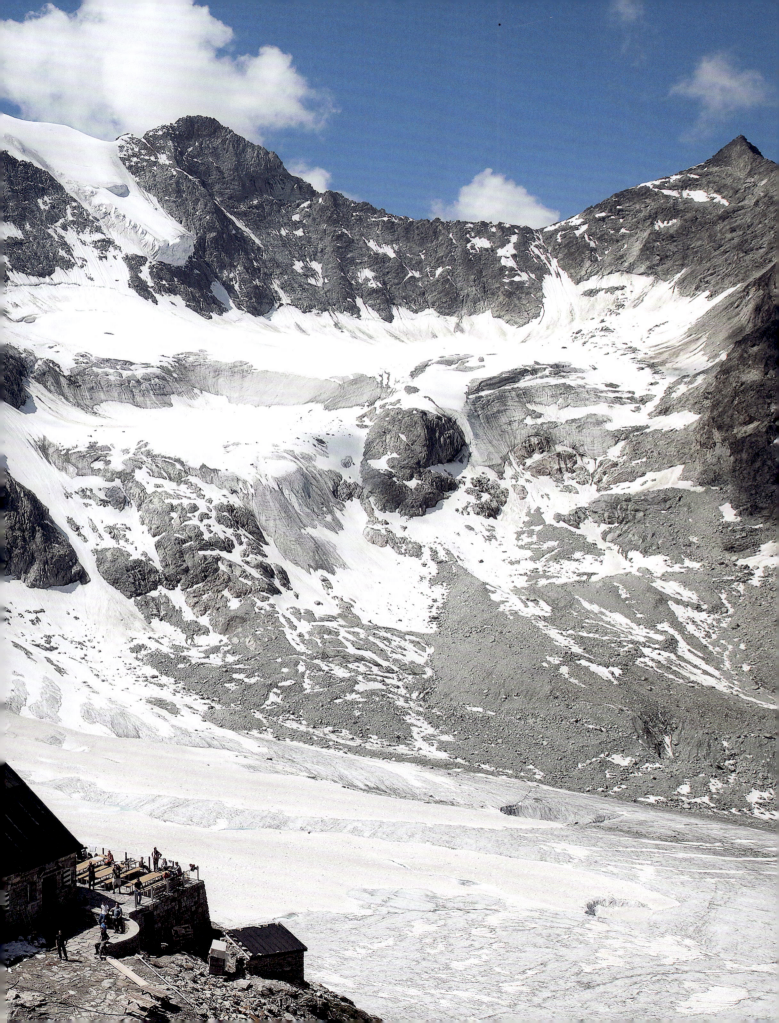

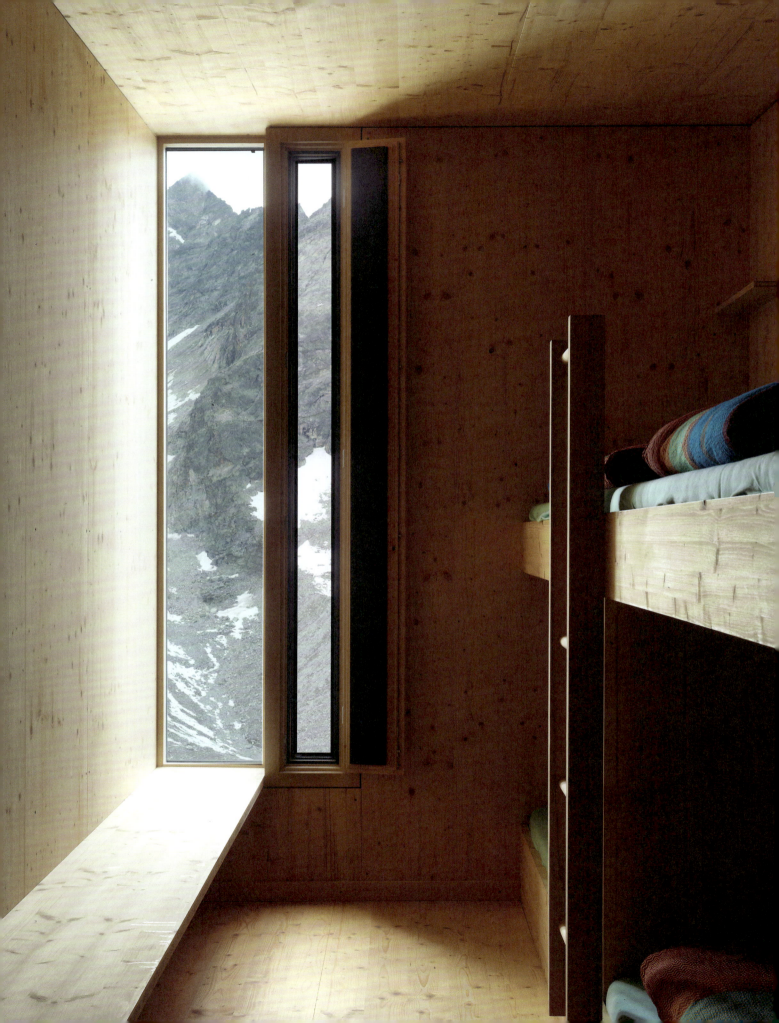

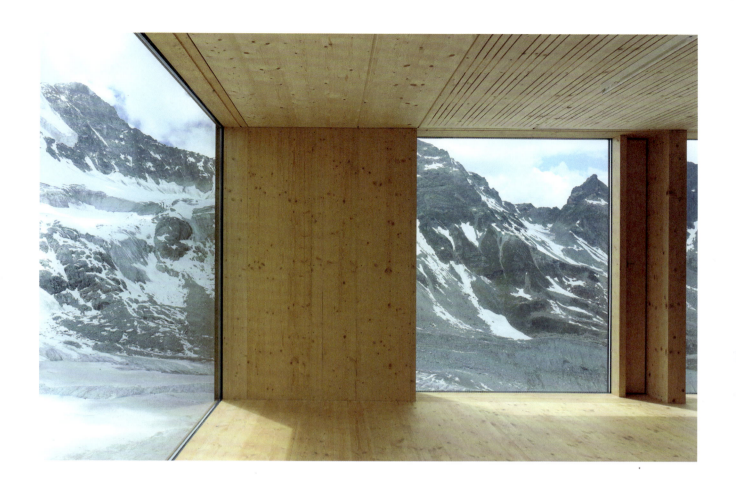

The new building houses a refectory for 120 guests as well as a kitchen, service areas and a couple of four-bed mini dormitories.

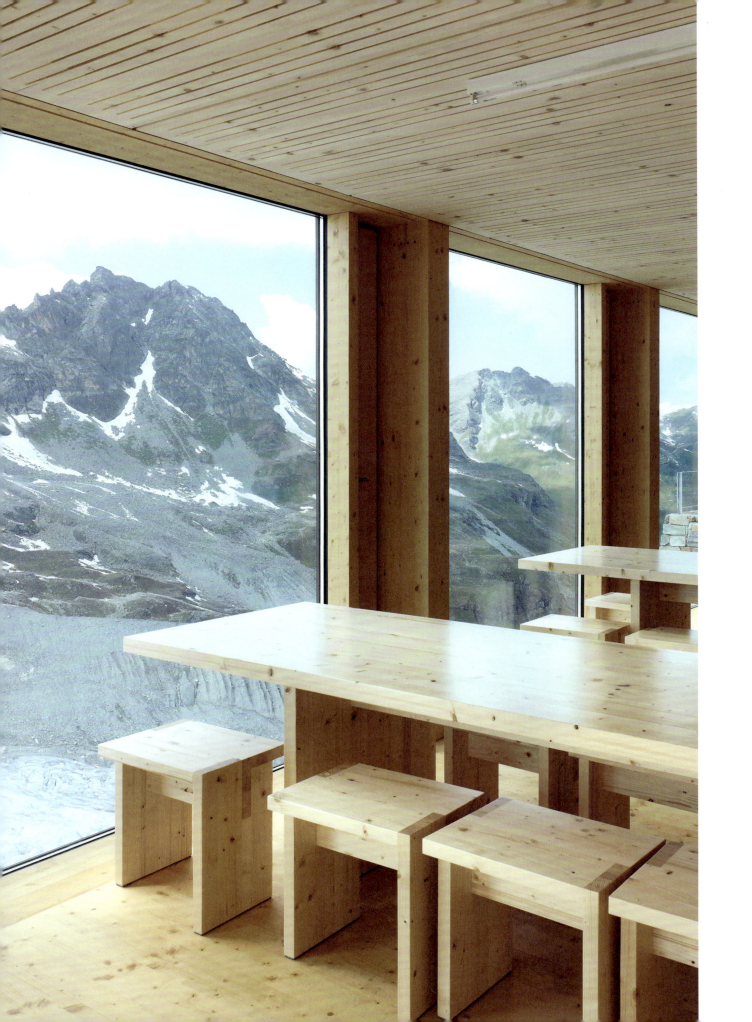

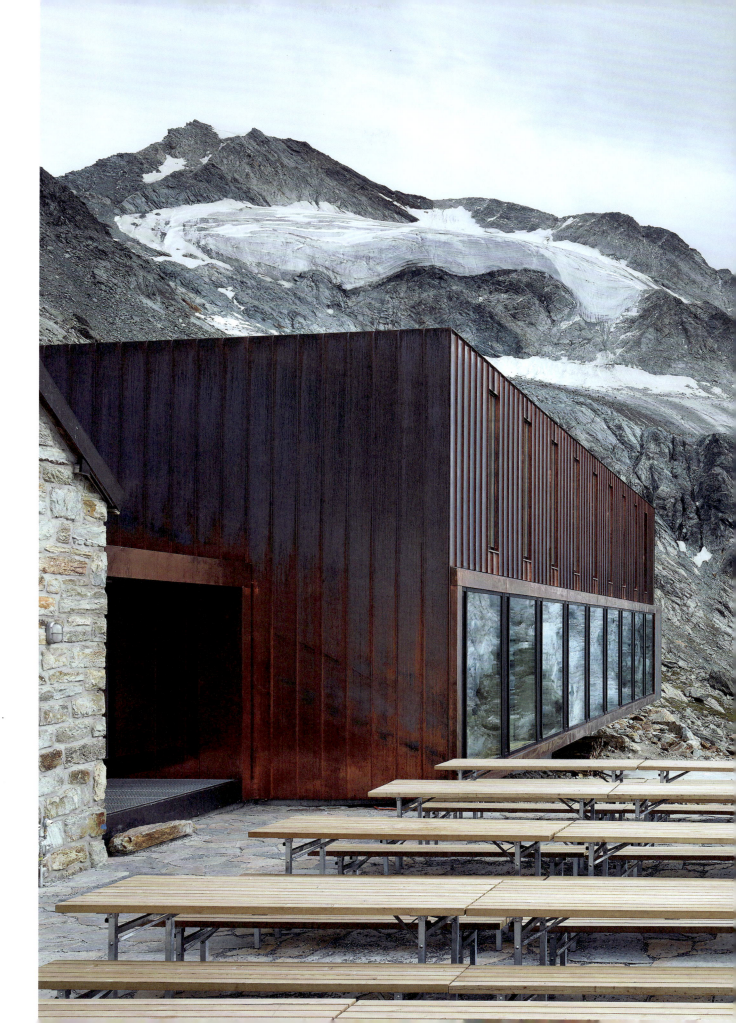

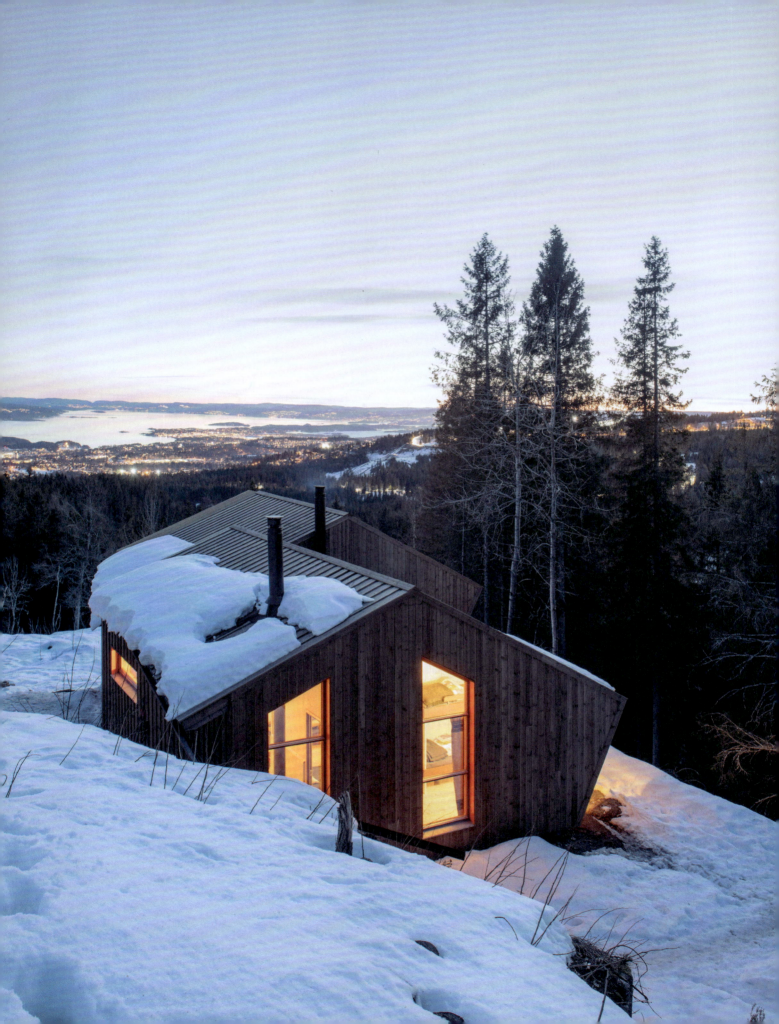

FUGLEMYRHYTTA
OSLO, NORWAY

Placed on the west side of a small hill, this dynamically shaped self-service cabin offers wonderful vistas across the Oslofjord. One of the most popular hiking destinations in the area, Fuglemyrhytta is easily accessible by foot for everyone, including families with small children and school groups. Some visit the cabin during a hike to enjoy the view or hide from a sudden change in the weather, while others come to have a meal in the beautiful scenery, or to spend the night there. Surrounded by the Nordmarka Forest, which also offers numerous hiking trails, the cabin offers panoramic vistas through many playfully located openings. The biggest one, framing the south-facing view, is part of the large common space with tables, an oven, and a stove, enabling visitors to make their own meals. The architects envisioned the hut as two staggered pentagonal volumes. "The shape of the rooms further creates clever sleeping solutions and more interesting views of the surrounding landscape," they explain. The interiors do not lack practical elements – there is a long hall by the entrance for storing shoes and jackets and a special drying room. While social spaces dominate the slope side, the sleeping spaces are located in two bedrooms with bunk beds in the deeper part of the cabin, for more privacy and warmth in the winter months.

The cabin is constructed from cross-laminated timber and two stiffened glulam (glued laminated timber) frames that are clad in ore-pine. The entirely wood-lined interiors, enhanced by timber furnishings, look uniform yet not monotonous due to the hard wax oil treatment on some of the walls to obtain various surface textures. The colour palette, ranging from light gray to burgundy, also adds an interesting twist. All materials selected by the architects are natural and sourced locally to limit the carbon footprint to a minimum. Highlighted by the ample natural light, they create a welcoming atmosphere. Behind the cabin there is a small volume housing a toilet and a woodshed. Visitors can enjoy benches in the area just outside the cabin as well. There is no water or electricity in Fuglemyrhytta. However, it is equipped for self-catering with gas, wood, solar-powered lights, and water available from a nearby stream. Fuglemyrhytta is open year-round. It offers ten beds but can accommodate up to 16 people during the day.

ACCESSIBILITY
Easily accessible – the cabin is located close to the Skådalen and Vettakollen metro stations, which connect the site with Oslo's city centre.

ARCHITECTURE
Snøhetta, 2018

LOCATION
Oslo, Norway

ALTITUDE
401 m

NUMBER OF BEDS
10

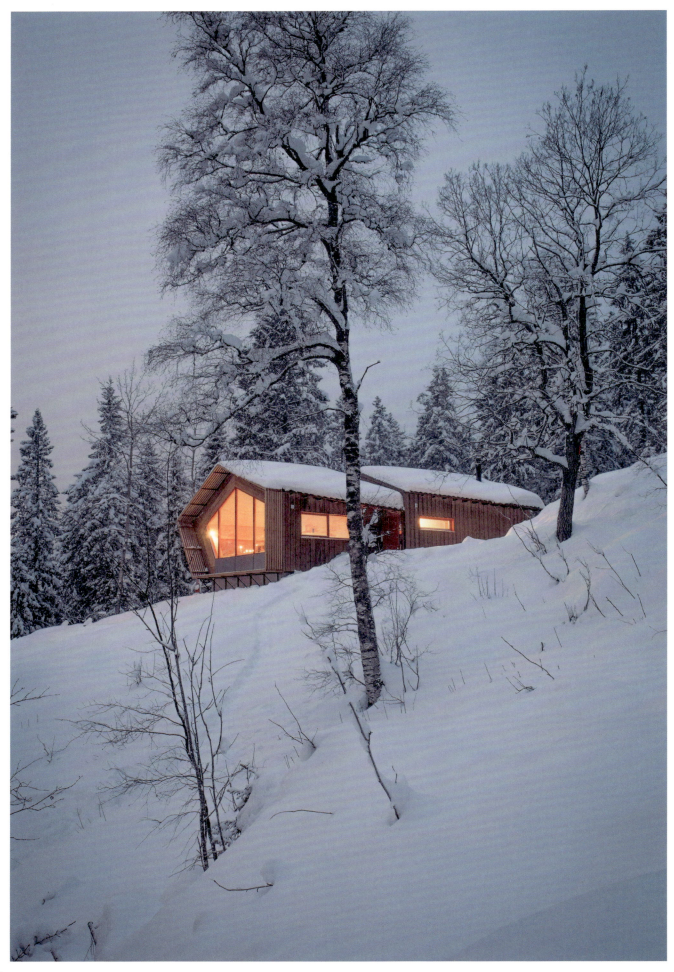

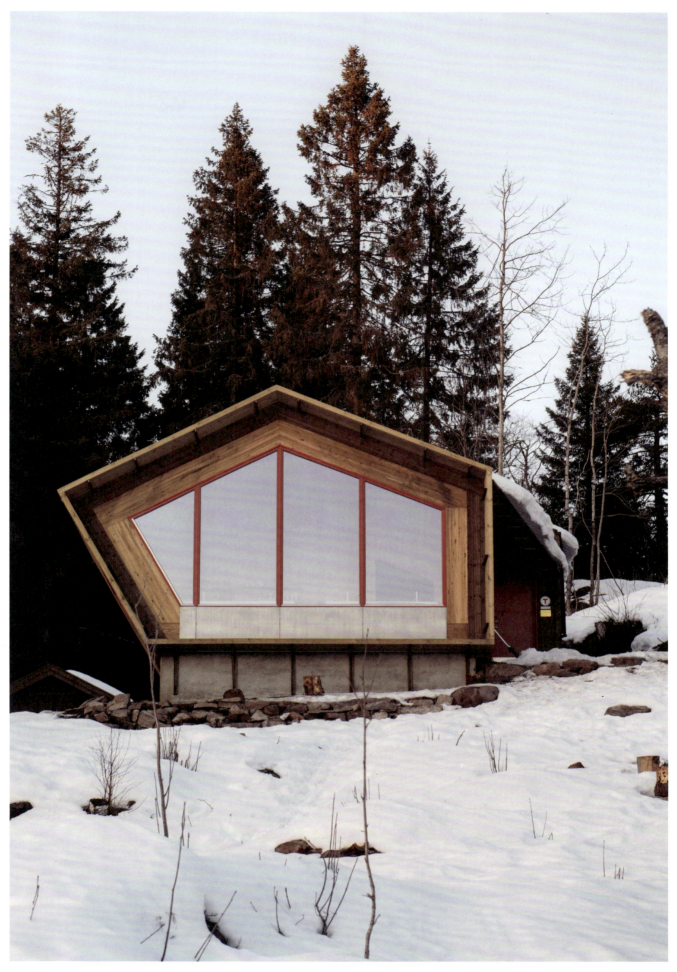

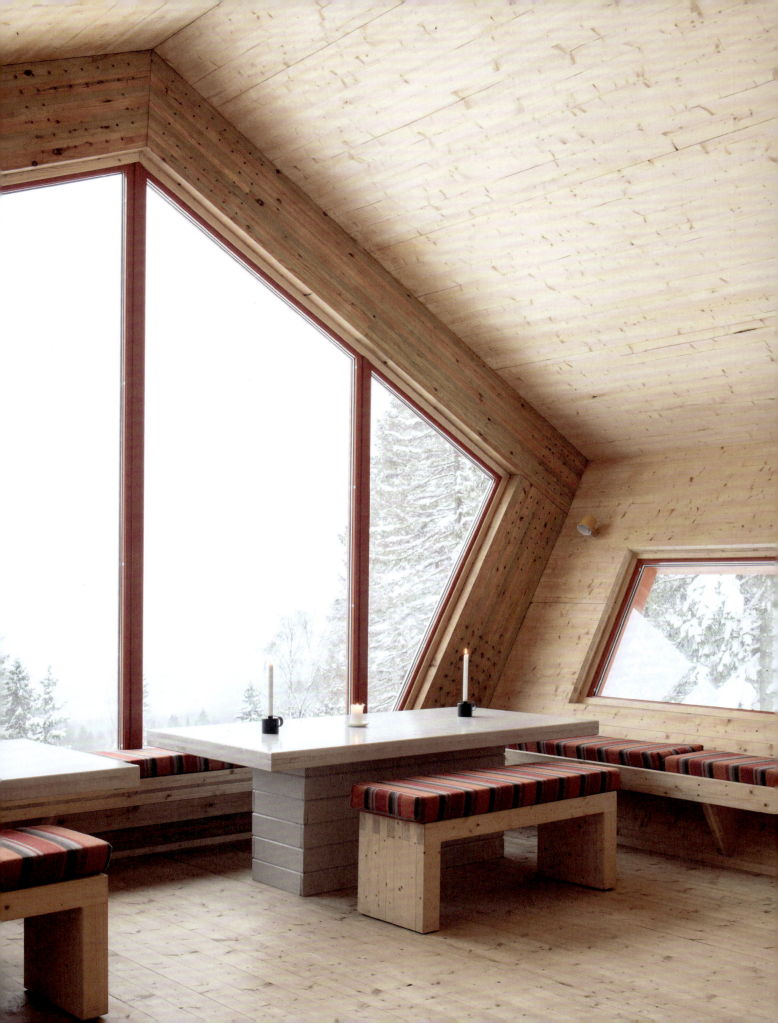

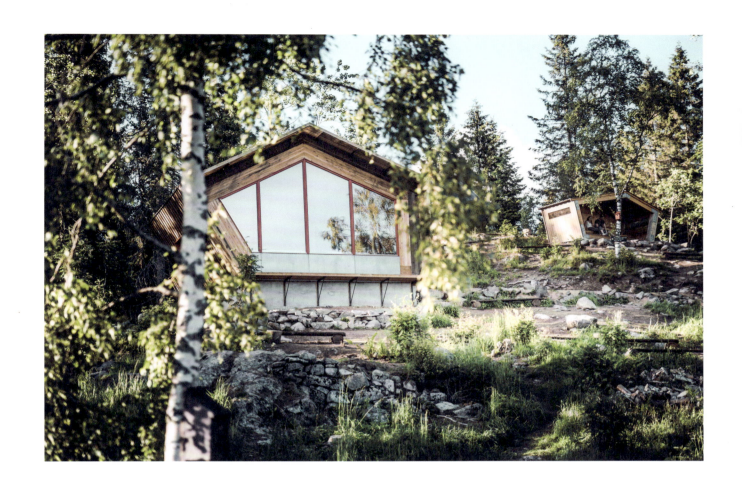

All materials selected by the architects are natural and sourced locally to limit the carbon footprint to a minimum.

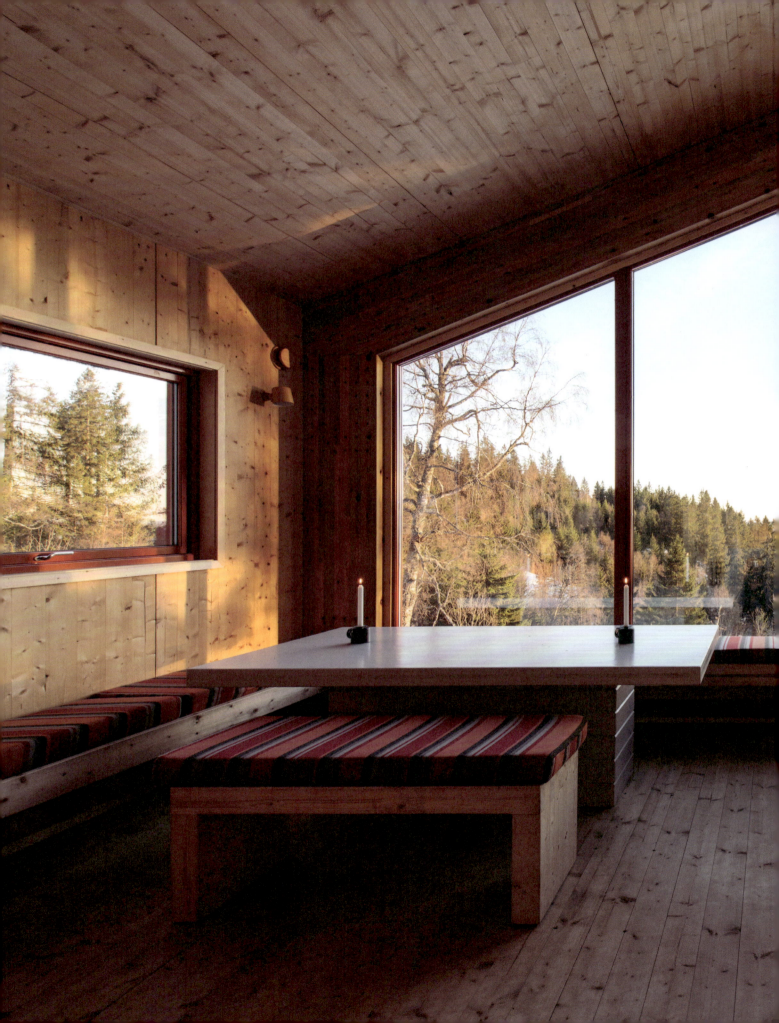

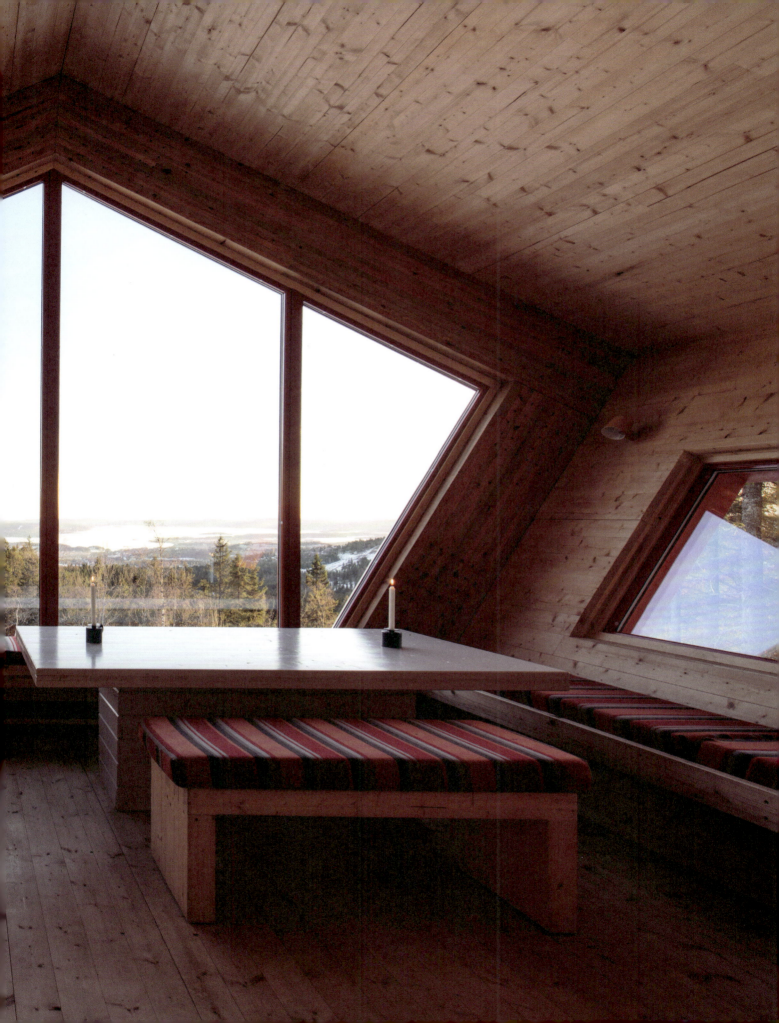

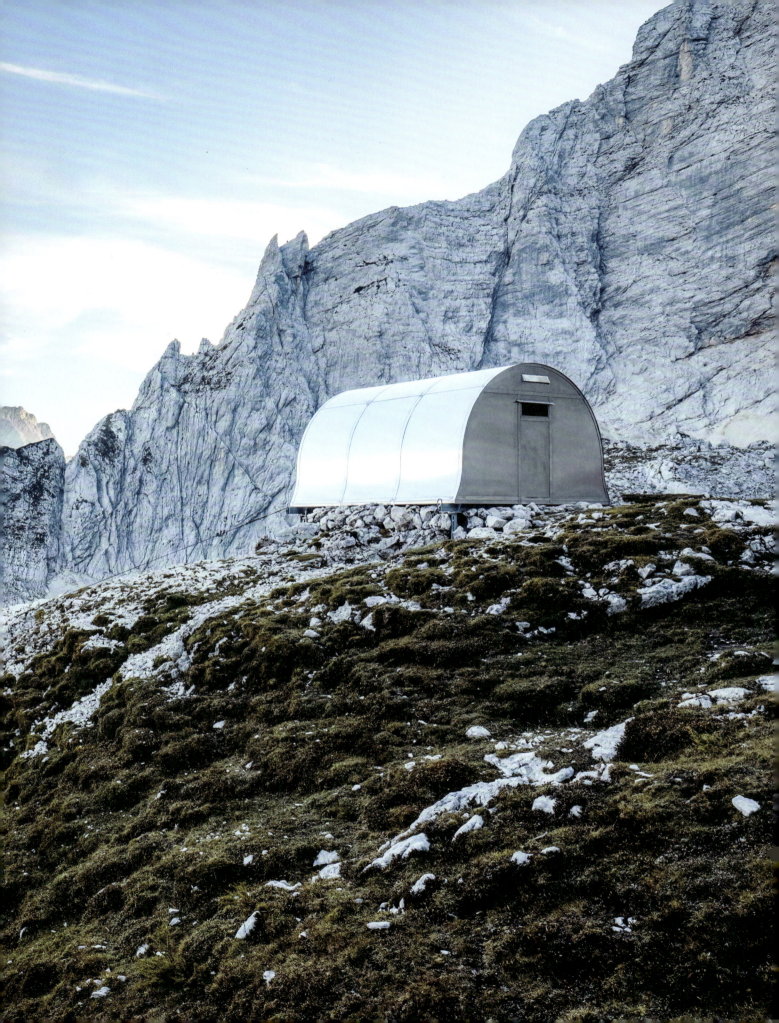

BIVAK II NA JEZERIH
VRATA VALLEY, SLOVENIA

The first, original bivouac at this location, designed by Karel Korenini, was erected back in 1936. The idea was to create a small but functional shelter that would allow for the exploration of the higher parts of the mountain range. Built by the mountaineers in situ – with over a ton of wood and steel that they carried on their backs, the wooden cabin withstood extreme weather for 80 years. Today it is on display at the Slovenian Mountain Museum in Mojstrana. When envisioning the new version, Darko Bernik of AO drew from the original: "In a sensitive environment, where special laws apply, we have learned from our ancestors," he said. The construction was upgraded and improved so that it would continue to be resistant to hurricane-force winds, extreme amounts of snow and low temperatures, but interestingly, there are no special solutions or modern materials used. The biggest challenges were the highly restrictive policies of Triglav National Park and a long list of criteria to be met by the bivouac, like resistance to winds of 200 km/h or the size of the volume remaining close to that of the original cabin.

It was also designed to be easily constructable and then maintained. The priority for the small interior was to find functional solutions that would made the best of the limited space, but the neatly lined wood nevertheless creates a cosy ambiance and is aesthetically pleasing. The aluminum in the outer shell makes the volume robust for the elements; however, the architects also used it for the visual effect of the harmony of its grey hue with the surrounding rocky peaks. The material is not only durable but also low weight, which was essential for the transportation stage (the cabin was brought to the high-altitude site by helicopter). Modern and safe, the bivouac offers a shared sleeping area, bench, folding table, and handy storage area, as well as USB ports supplied by a solar panel for charging mobile phones. The embracing, curved structure is open all year round and can welcome up to six visitors. Placed at the very edge of a slope, it enhances the remoteness of the location and allows guests to fully enjoy the impressive scenery.

ACCESSIBILITY
The cabin is located above the Vrata Valley with a view of the north face of Triglav Mountain and a demanding alpine trail leading to it. The path leading to the bivouac is very steep, unmarked and hardly seen with a very difficult and exposed trail for experienced mountaineers.

ARCHITECTURE
AO, 2016
LOCATION
Vrata Valley, Slovenia

ALTITUDE
2118 m
NUMBER OF BEDS
6

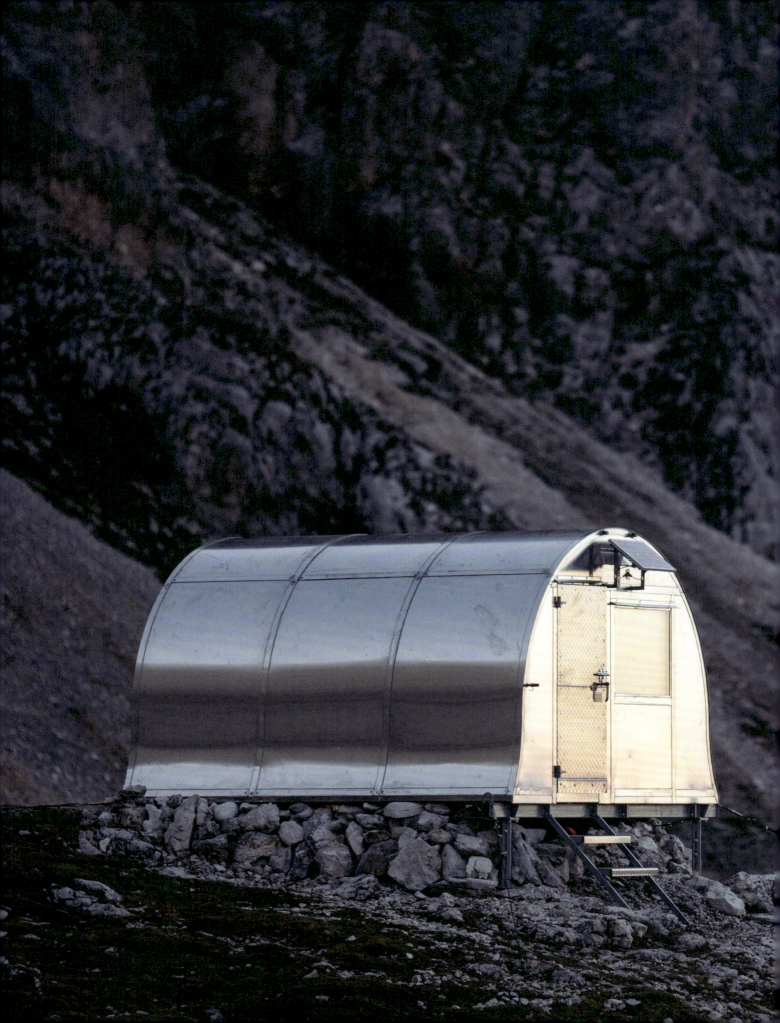

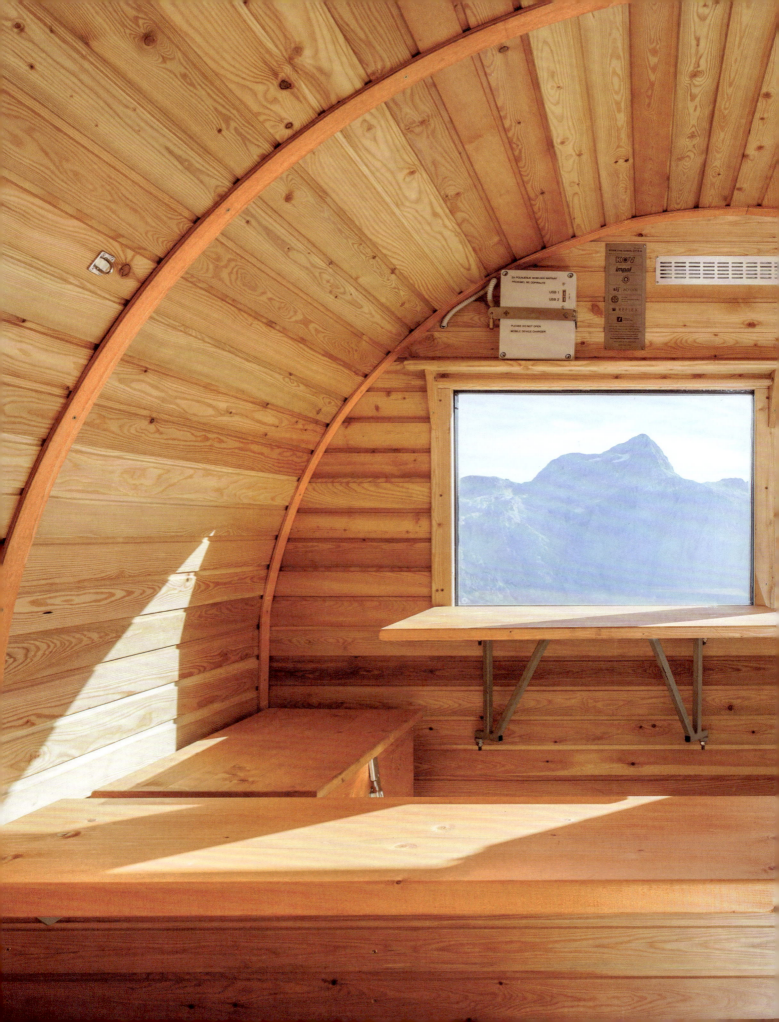

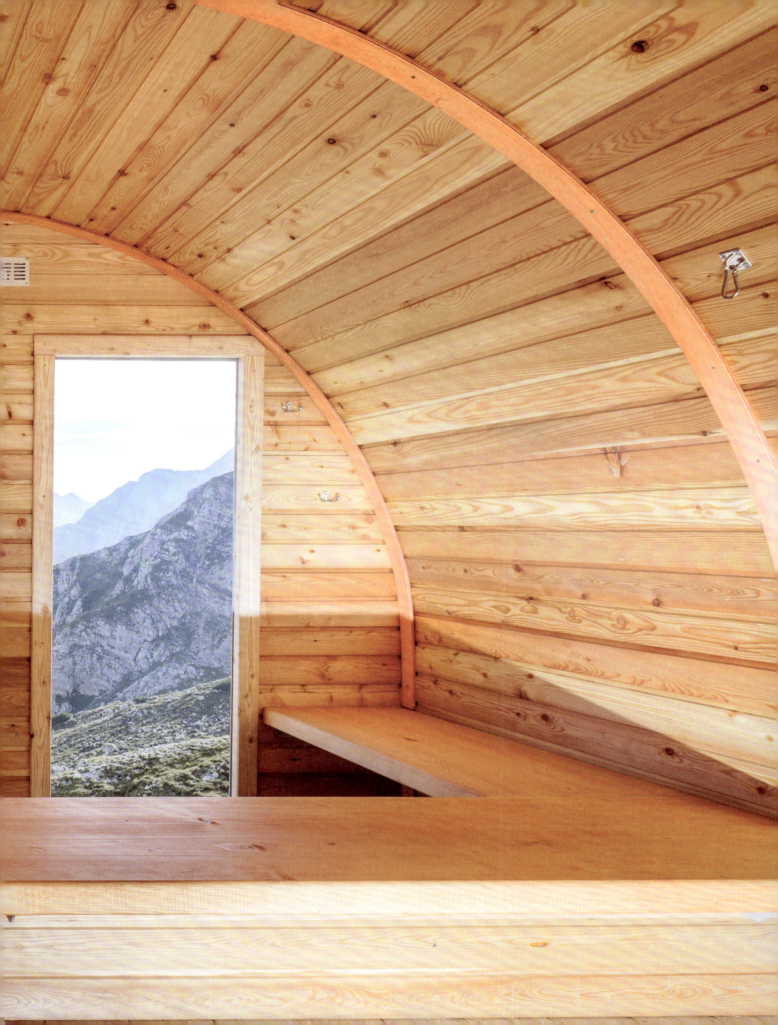

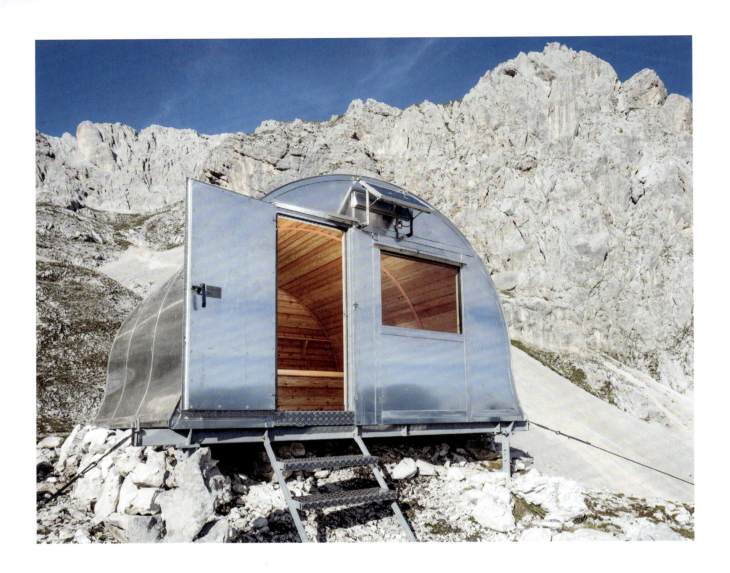

The aluminum in the outer shell makes the volume robust for the elements; the architects also used it for the visual effect of the harmony of its grey hue with the surrounding rocky peaks.

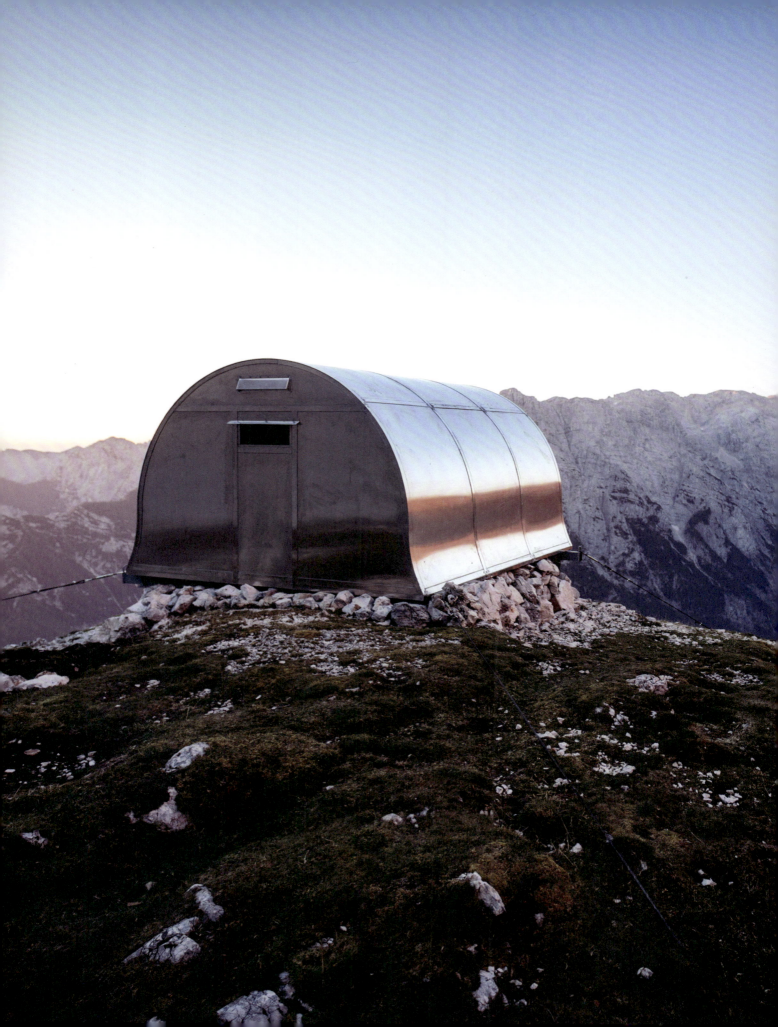

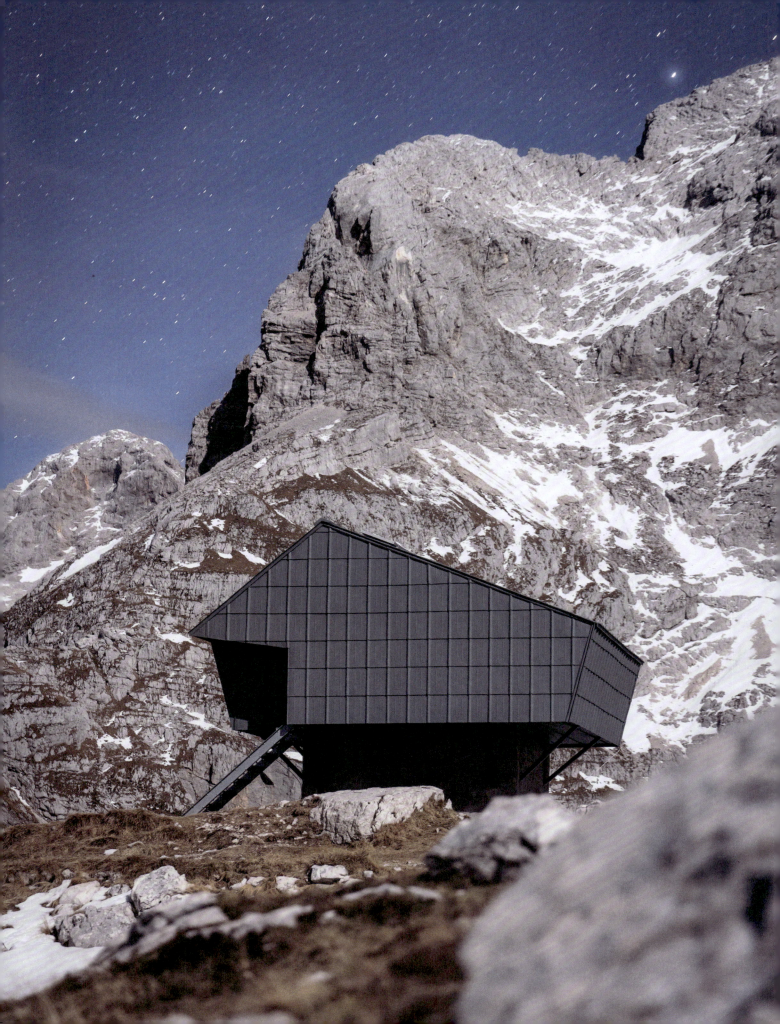

PREHODAVCI BIVOUAC
TRIGLAV NATIONAL PARK, SLOVENIA

To create this distinctive cabin, Slovenian studio Premica Architects transformed the former bunker, which was part of an alpine fortification system created in the 1920s, into a spacious shelter for mountaineers. The intriguing volume has been elevated above the ground and seems to be floating in the air, but is based on much smaller concrete foundations – the remains of the former bunker. The current cabin was envisioned after the previous structure had been damaged during a storm in 2012.

Before transporting the new bivouac to the location, the architects manufactured and preassembled the timber construction and cross-laminated wooden panels of the building in the valley. Wood was chosen for a pleasant and cosy final look for the interiors as well as to create a relation between the inside and outside, as the cabin is located in the stunning natural reserve of Triglav National Park. The wooden core is durable but, given the weather conditions, the building required enhancement through a sturdy envelope. This was done with a PREFA façade and roof panels manufactured from sustainable aluminium. Cladding of this kind is perfect for structures of complex shapes. In this case, the dynamic form also has a practical solution, as the architects made sure to create a wind-resistant shape which would additionally not accumulate snow on the roof. Last but not least, this vernacular architecture with a twist is in line with the contours of the mountain. Interestingly, there is only one opening in the compact building, keeping it protective more than creating observation points. As such, it also relates to the monolithic structure of the bunker it is based on. The generous height of the building enabled the architects to organise the nearly 40-square-metre interior as an open space with a bunk sleeping area settled in the all-wood environment. There is neither water nor electricity inside of the cabin. Only a small solar panel allows for a single wall-light in the interior. Fifty metres from the cabin is another tiny volume housing a toilet.

ACCESSIBILITY
The hut is situated on a lookout point above the Prehodavci Pass, near the trail leading from Trenta to the Triglav Lakes Valley. The bivouac is accessible through marked paths.

ARCHITECTURE
Premica Architects, 2013
LOCATION
Triglav National Park, Bohinjsko jezero/Lake Bohinj, Slovenia

ALTITUDE
2050 m
NUMBER OF BEDS
24

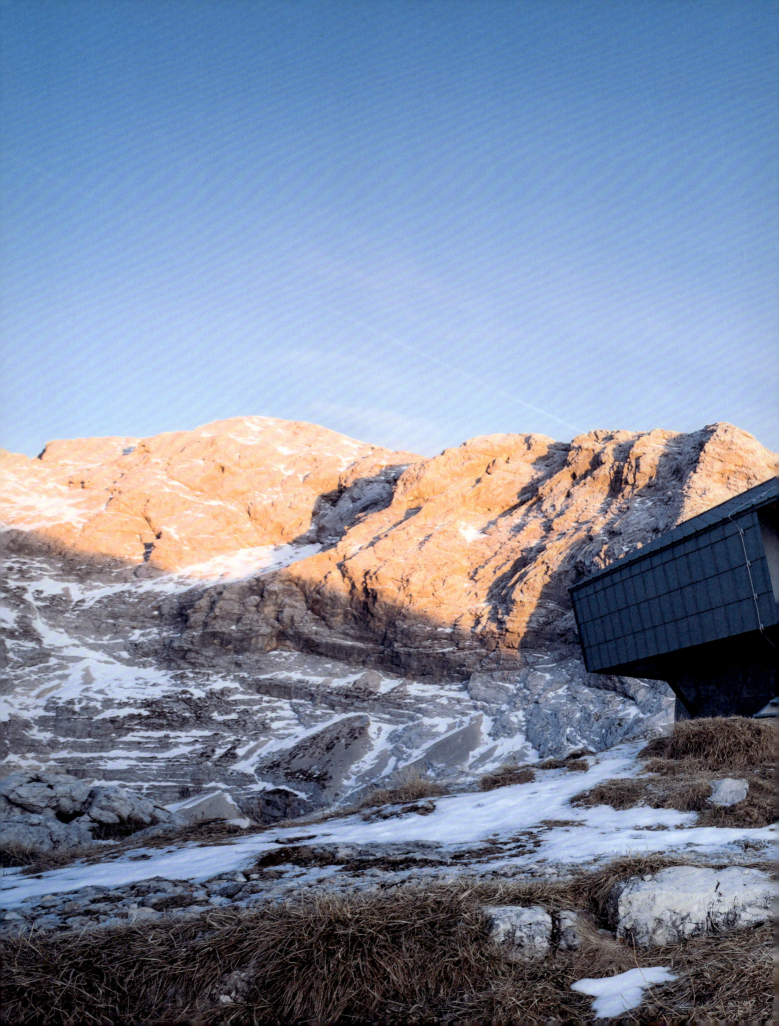

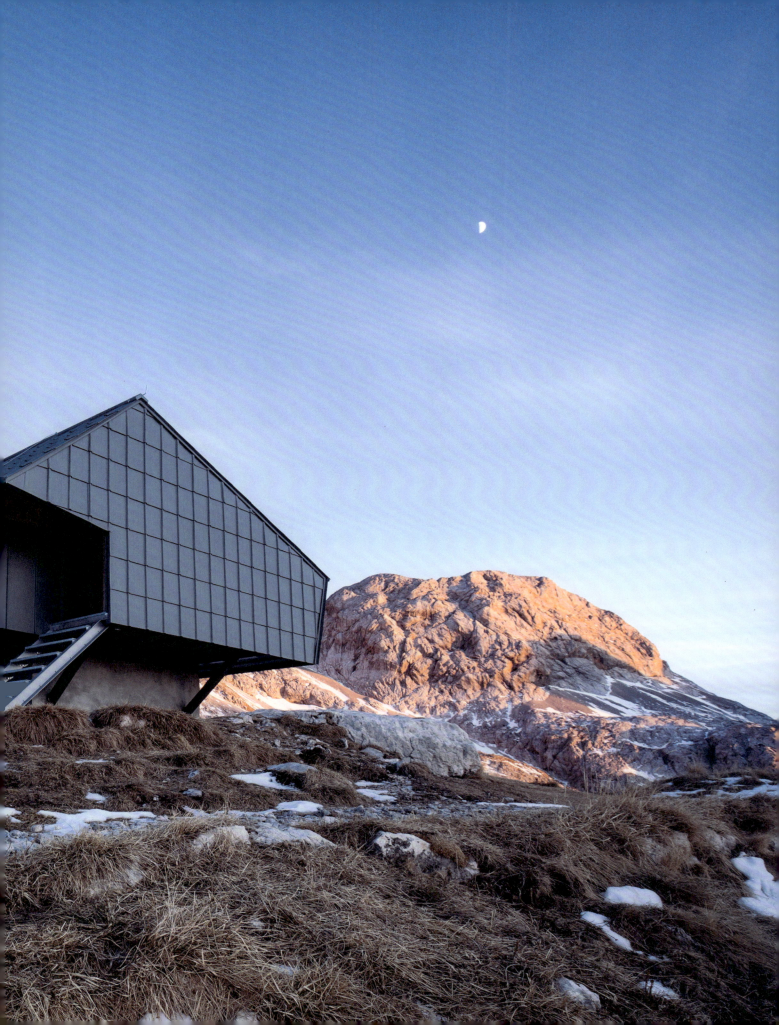

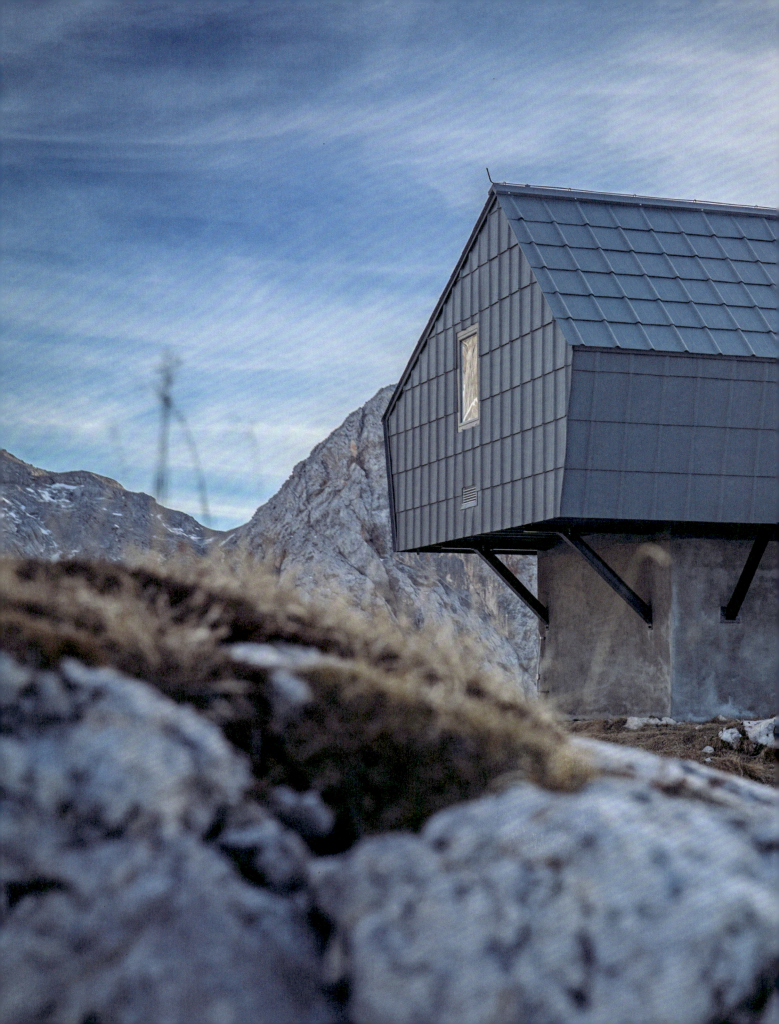

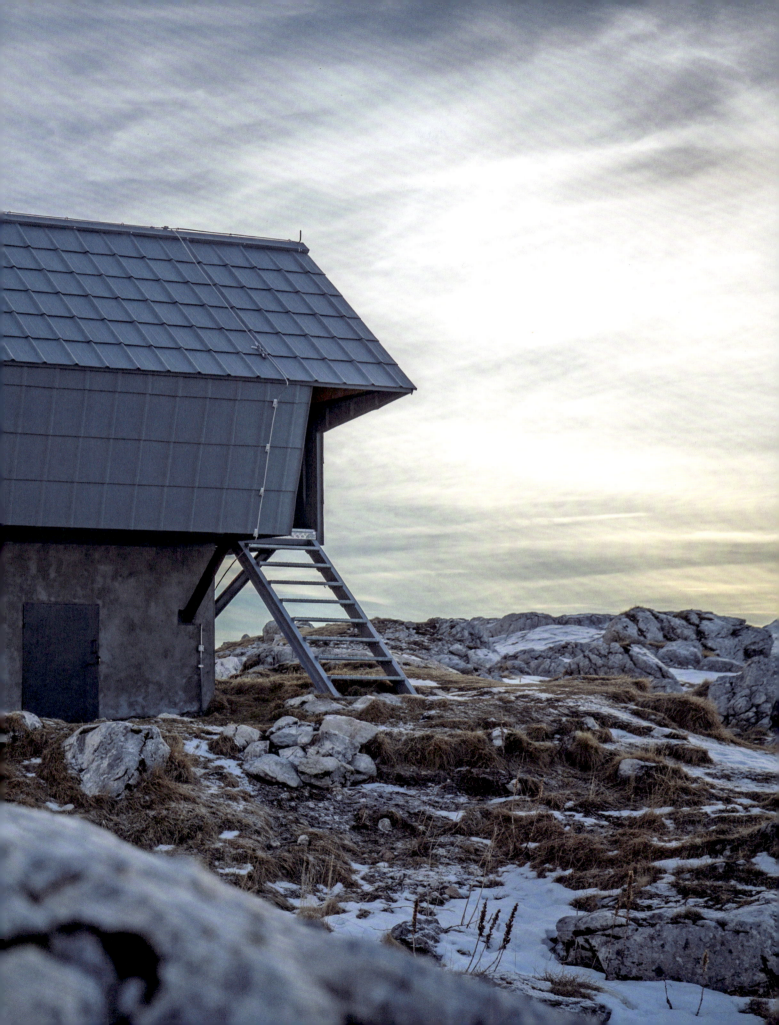

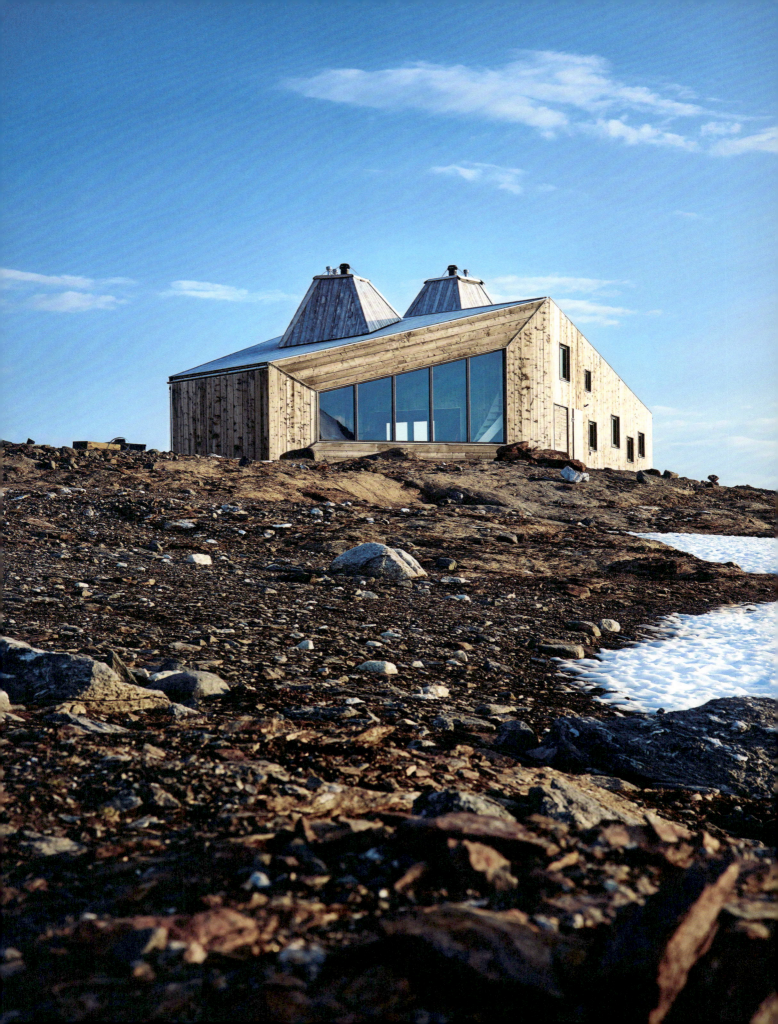

RABOT TOURIST CABIN
OKSTINDAN, NORWAY

Einar Jarmund and Håkon Vigsnæs, the duo who ran the practice JVA (Jarmund/Vigsnaes AS Arkitekter) until 2019, is responsible for this beautifully shaped mountain cabin for trekkers. The Rabot Tourist Cabin is located near the glacier at Okstindan in northern Norway, surrounded by spectacular mountains, especially due to the fact that it occupies a wide plateau. The site can be reached either by foot or on skis. Although the altitude is not that high, the weather at the location can be harsh, so the architects secured the construction for both heavy storms and winds. Built from local materials, the cabin has a multifaceted shape with two chimneys that refer to the forms of the surrounding mountain tops. The thick timber boards of the exterior cladding have a coarse finish and have been treated with ferric sulphate to obtain a natural feel. The hue of the cabin's outer shell stands out nicely against the blue ice forms.

"The behaviour of snow and heavy winds at the site have generated the simple shape of the cabin, without protruding elements," comment the architects. There are two entrances planned on opposite sides with a restroom, and storage for firewood and food.

The common area with a double-height ceiling and distinctive glazing offers vistas in two directions – one towards the mountain range and the other towards the plateau and further the valley. On the other side are a kitchen and dining area with a spacious mezzanine above with bunk beds. Seven bedrooms on the first floor have small, playfully placed windows, which also frame various perspectives of the stunning context. The interior is embraced by the same timber boards as the outer shell in the common areas and with white varnished panels in the bedrooms and spaces of secondary use. The furnishings were made locally from birch plywood. Due to the lack of electricity, solar panels deliver power for the lighting. Two fire stoves in the common areas are used for heating. To make the later more efficient, the cabin may be divided in half with sliding doors when there are just a few guests. In case the main cabin is damaged, there is a secondary rescue hut 50 metres away. The name of the cabin commemorates French glaciologist and geographer Charles Rabot, who explored the mountains in the Nordland province in the 1880s.

ACCESSIBILITY
The route to the cabin is quite long but rather gentle as it leads through large agricultural valleys, asphalt slides, and a final ascent in a more alpine landscape. It is also reachable from a parking lot at Leirbotnet, after a five-kilometre walk.

ARCHITECTURE
JVA, 2014/2015

LOCATION
Okstindan, Nordland, Norway

ALTITUDE
1200 m

NUMBER OF BEDS
30

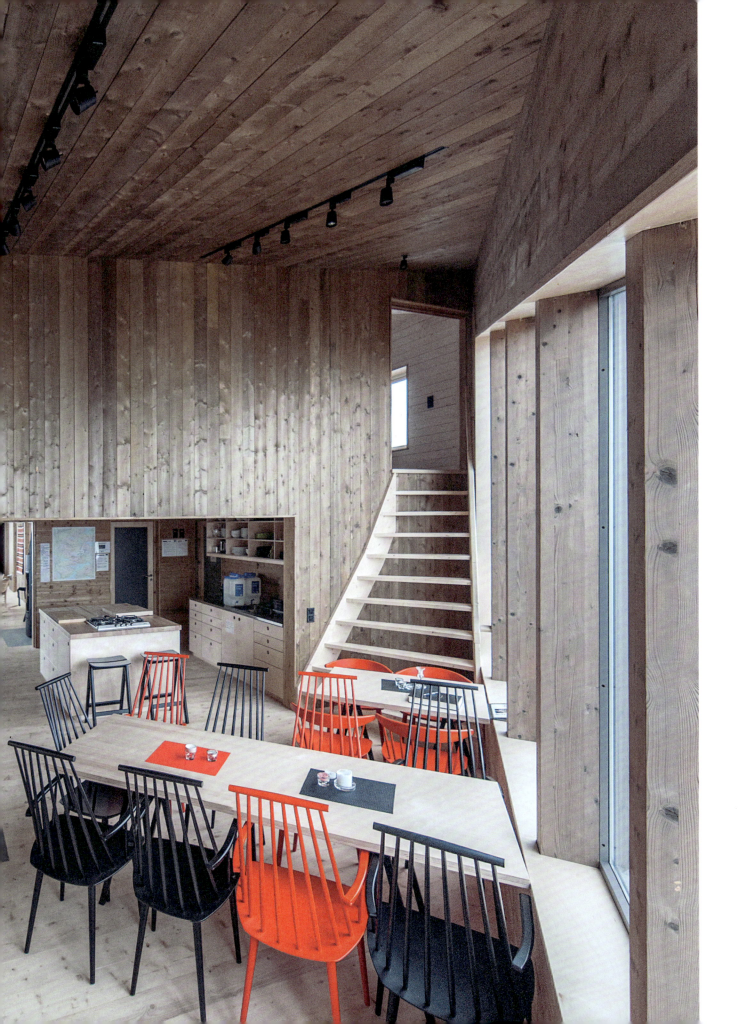

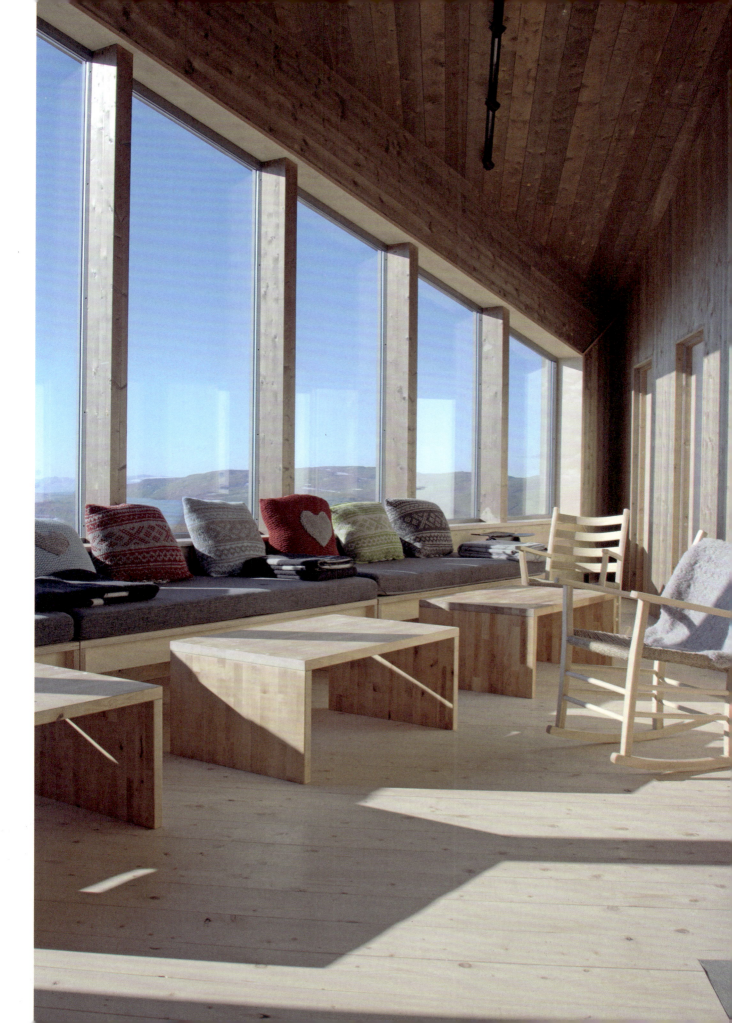

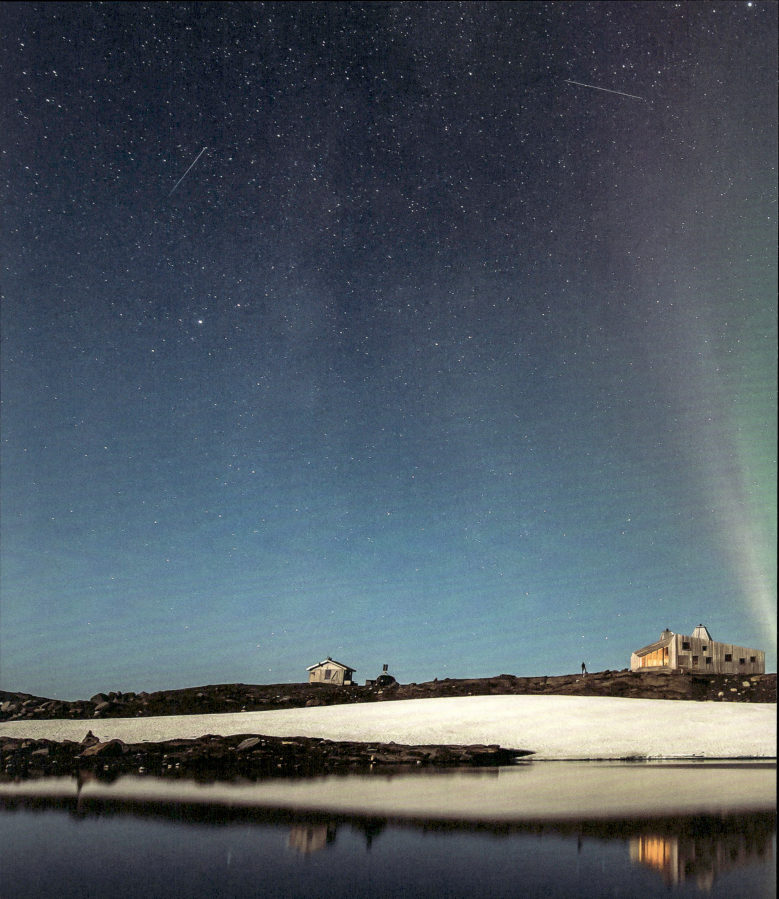

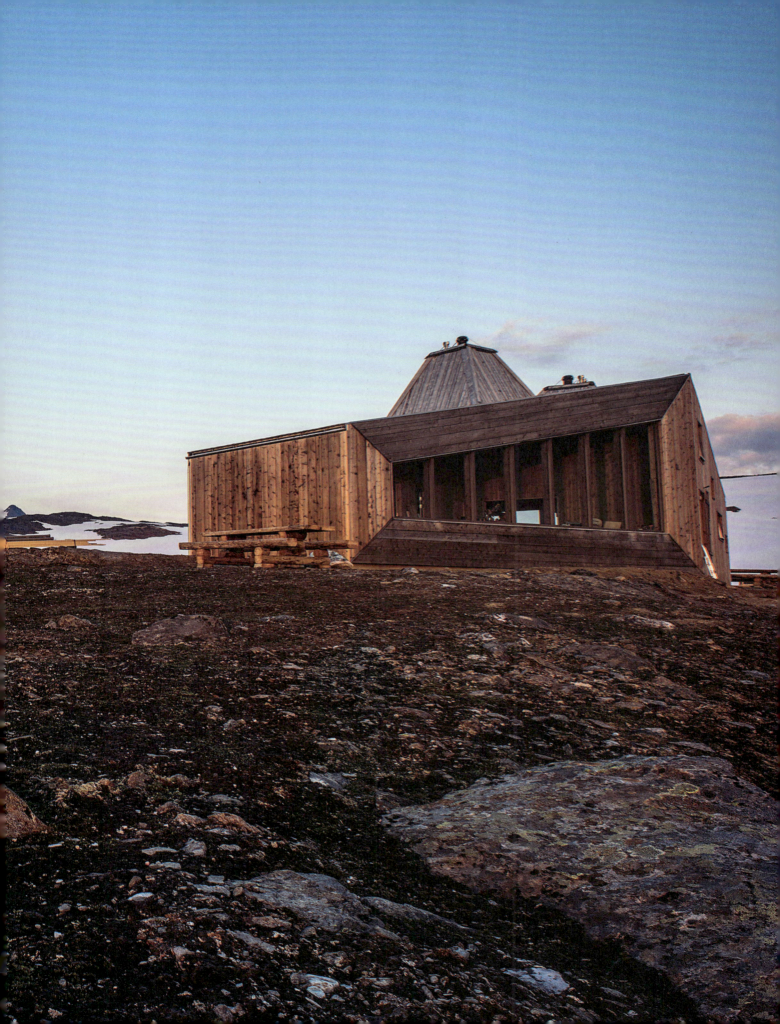

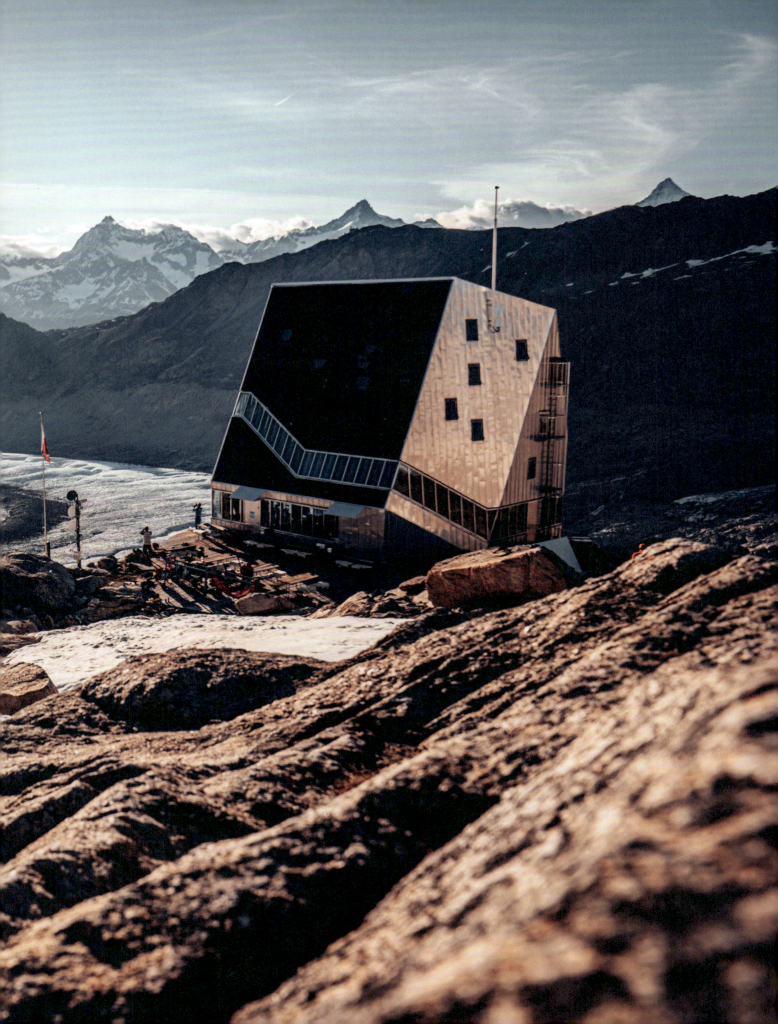

MONTE ROSA HÜTTE
ZERMATT, SWITZERLAND

Sitting in between three glaciers, Gorner, Grenz and Monte Rosa, the hut mimics their multifaceted shapes. The history of the place goes back to 1895 when the first wooden hut, Cabane Bétemps, was built for 25 guests. Renovated and extended over the decades, in 1940 it received the current name 'Monte Rosa Hütte'. Due to the damage sustained by the old structure, the Swiss Federal Institute of Technology (ETH) Zurich decided to build a new hut – the old one was demolished. The students of the Architecture Department, who worked on the project under the direction of Professor Andrea Deplazes, came up with the Crystal Design, which was inaugurated in July 2010. As much as this dynamic volume is reminiscent of the surrounding peaks, its distinctive shape is enhanced by the modern materials. The windows on various façades are intriguing as well, in particular those of the long, zigzagging opening across the lower part of the volume that refers to the topology of the terrain. The effect is even stronger at night, when lights animate the rock-like structure. The building, wrapped in a silver aluminium shell, has been equipped with high-tech solutions to make it self-sufficient. The designers from ETH Zurich developed special software to manage and monitor these solutions. A photovoltaic system as well as thermal solar collectors, which are integrated in the south façade of the hut, can produce up to 90% of the consumed energy. Water management includes a system for collecting melting snow in a rock cavern, while a microfilter plant using a certain type of bacteria cleans the wastewater and greywater to reuse it for flushing the toilets.

The altitude and the glacier do not make it easy to get to the hut, but there are several paths leading there. However, the paths need annual restoration and installation of stairs and a rope in several sections. While crampons are required on all routes, ladders and a steel bridge make it easier to cross over the edge of the glacier as well as the moraine. Hikers use the hut as the base for conquering 4000-metre peaks, including Dufourspitze, Nordend, and Lyskamm, or to cross over to Italy.

ACCESSIBILITY
There are various routes across the glacier that lead to the hut, all rather challenging, with required crampons, annually installed stairs, and a fixed rope on some sections of the path.

ARCHITECTURE
Swiss Federal Institute of Technology (ETH) Zurich, 2010

LOCATION
Zermatt, Switzerland

ALTITUDE
2883 m

NUMBER OF BEDS
120

INFO
www.monterosahuette.ch

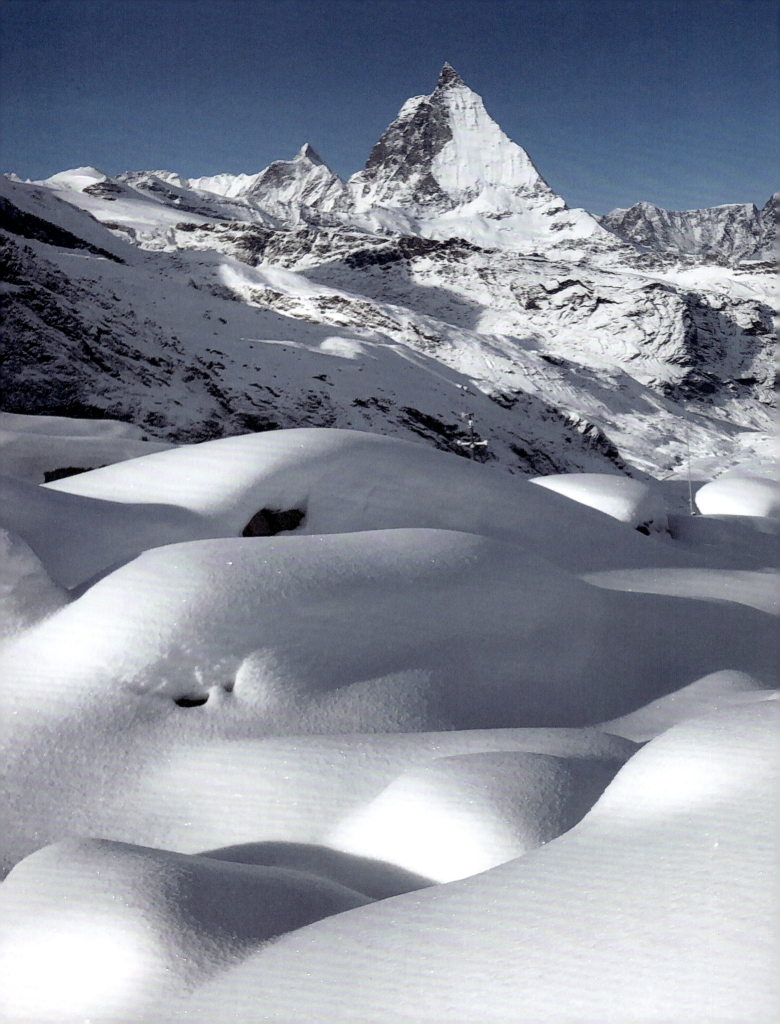

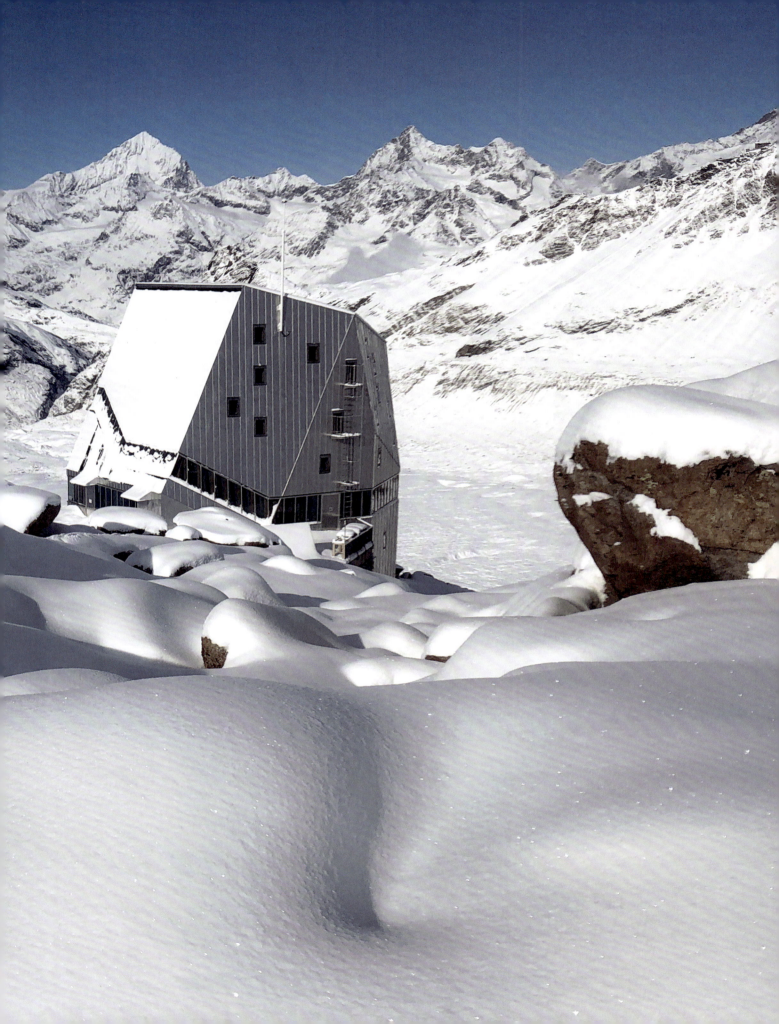

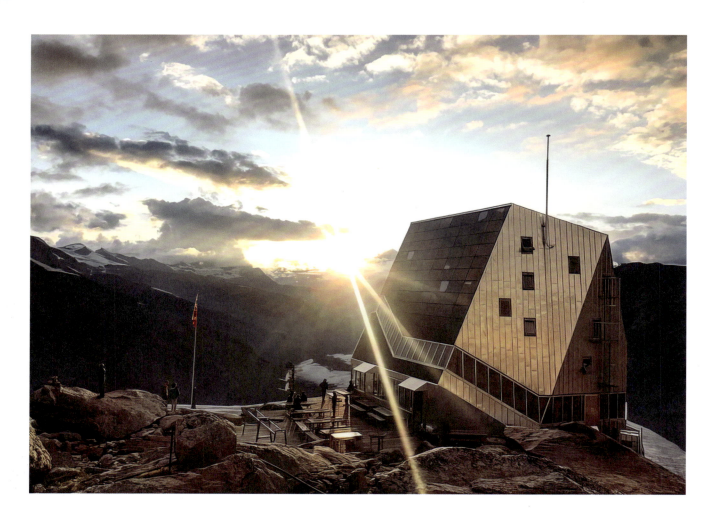

The windows on various façades are intriguing, in particular those of the long, zigzagging opening across the lower part of the volume that refers to the topology of the terrain.

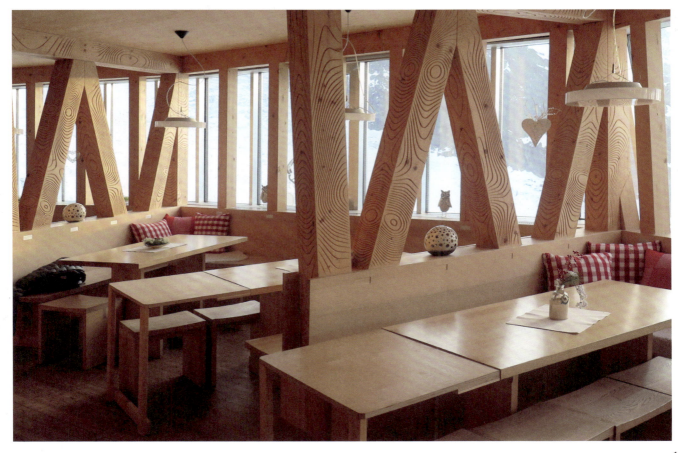

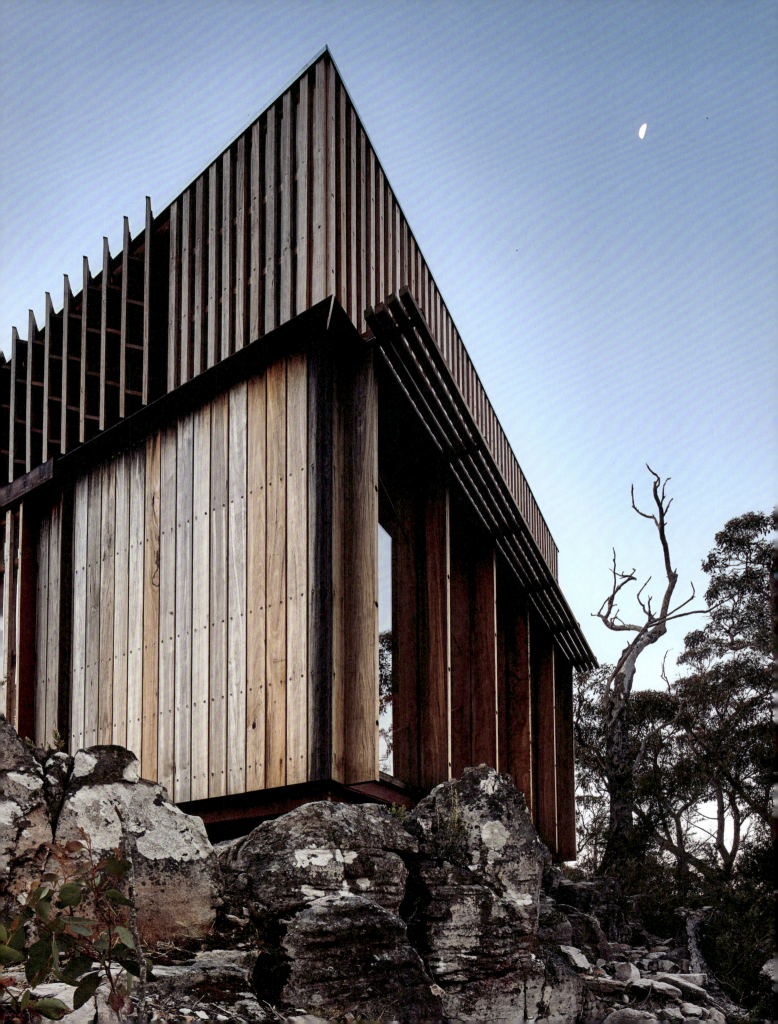

GRAMPIANS PEAKS TRAIL
VICTORIA, AUSTRALIA

McGregor Coxall and Noxon Giffen studios teamed up to envision a series of 11 unique hiker camp locations that would mark the 164-kilometre hiking tour along the Grampians Peaks Trail (GPT). The design team responded to the variety of the significantly stretched terrain with an impressive environmental consciousness. The trail is known for the beauty of its dense vegetation and natural wilderness. From the outset, the architecture was intended to be only an addition to the landscape and not the other way around. "GPT is bound by a series of breathtaking views and memorable experiences," comment McGregor Coxall. "The walk will conserve, protect and celebrate the unique beauty of Gariwerd (Grampians), achieving the highest possible grade of environmental sensitivity through the protection of site-specific conditions such as biotope preservation, overland flow management and microclimate," the studio adds. As Grampians National Park is part of the Gariwerd Aboriginal cultural landscape, the idea was also to bring the visitors closer to the land originally belonging to the Aboriginal cultures of the Jardwadjali and Djab Wurrung people.

These thoughtfully planned, off-grid camping sites required the architects to completely immerse themselves into the context and carefully analyse the sites. Preserving the biodiverse landscape and highlighting the striking vistas has been achieved each time as a direct response to each location, its context, and geological conditions. Other factors included synchronising the cabins with site lines and taking into account the sun exposure and wind. Each site consists of a platform, communal area, shelter, and a toilet – organised in a simple yet comfortable way. The colours and textures initiate a harmonic dialogue with the natural context. "Four core types of cladding underpin robust site materiality, drawing on a mix of oxidised mild steel and sandstone, bushfire-charred timber, silvered timber form, and branches of organic cladding that seamlessly embed structures within topography," notes the McGregor Coxall studio. To experience the complete Grampians Peaks Trail, hikers need two weeks. The route starts at Mount Zero in the north and heads south through diverse terrains, leading to the summit of Gar (Mount Difficult). It continues through Halls Gap, with hiking highlights like Redman Bluff, Mount William, Major Mitchell Plateau, Signal Peak, Mount Abrupt, and Mount Sturgeon, before finally reaching Dunkeld in the south. Another partner collaborating on this spectacular group of cabins, OPS Engineers, was responsible for the structural engineering.

ACCESSIBILITY
The complete trail is very difficult, with steep terrain, and is suitable for experienced long-distance hikers only, but the level of difficulty to each cabin varies and cabins can also be visited individually.

PROJECT TEAM
McGregor Coxall, Noxon Giffen and OPS Engineers
LOCATION
Victoria, Australia

ALTITUDE
from 320 m (Barney Creek) to 1017 m (Redman Bluff)
NUMBER OF BEDS
Variable

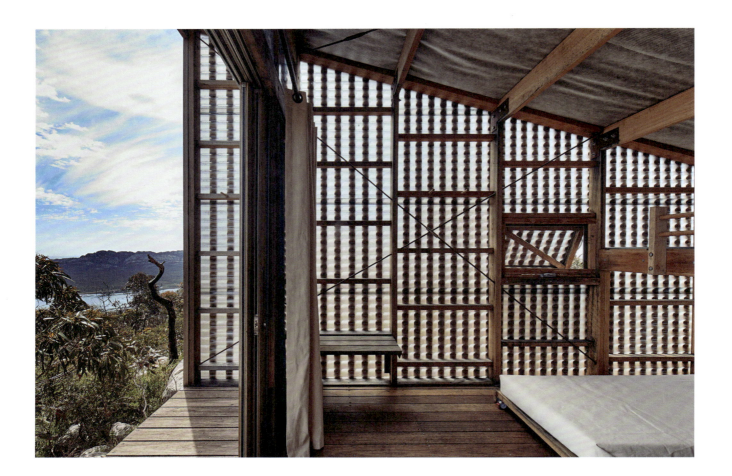

The platform, communal area, shelter, and a toilet are organised in a simple yet comfortable way. The colours and textures blend in with the natural context.

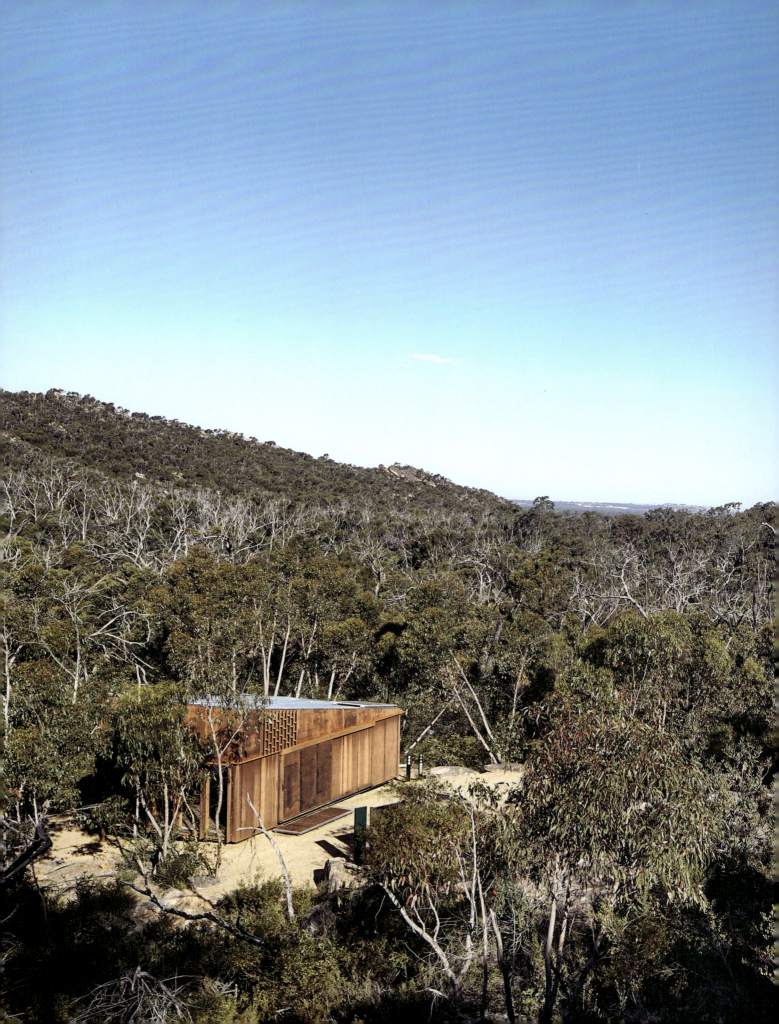

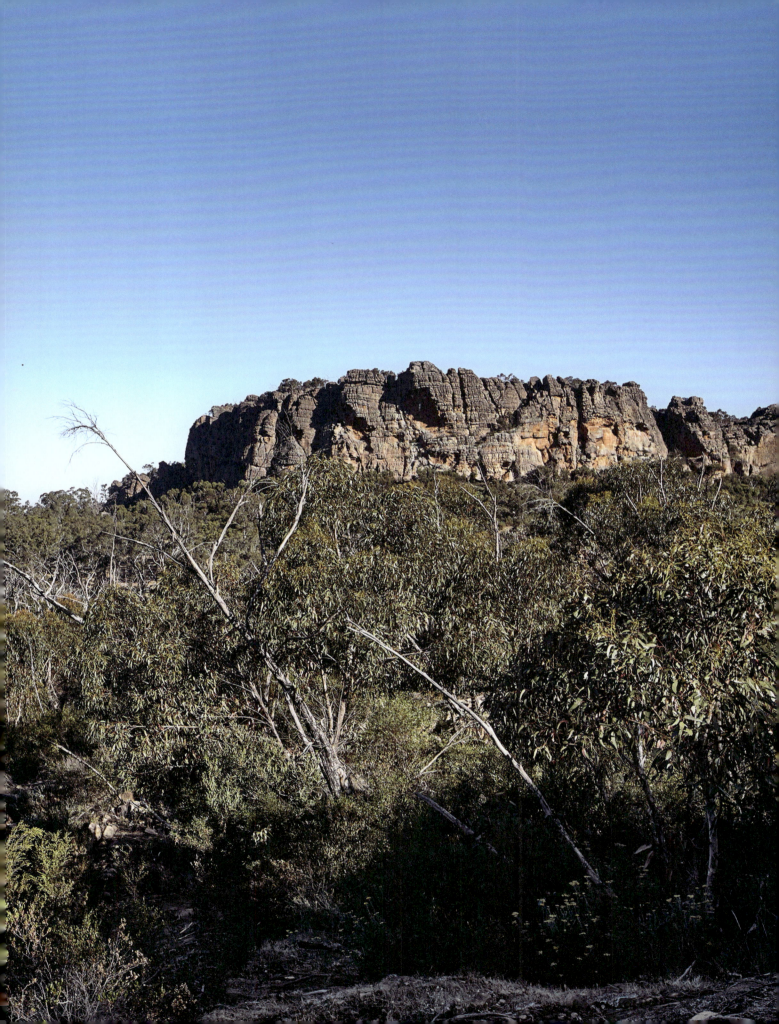

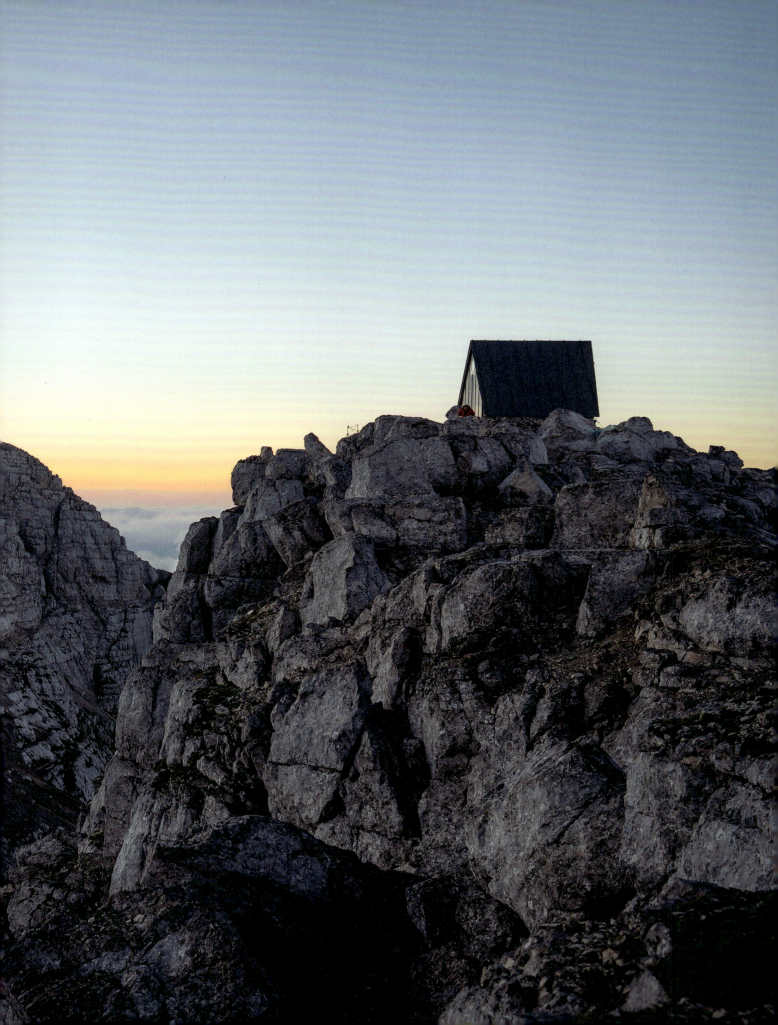

CAMPING LUCA VUERICH
JULIAN ALPS, ITALY

The stunning location on the very crest of a rocky summit (over 2500 metres above sea level!) makes this cabin one of the most extraordinary bivouacs in the world. It is certainly not easy to reach but offers a unique experience. While it is a perfectly safe structure, even in the middle of a heavy winter, it gives the genuine impression of becoming part of nature, surrounded by other summits and hidden in the clouds. The spectacular site selection of the Foronon del Buinz Mountain was not random. A 34-year-old talented and internationally renowned Italian mountaineer, Luca Vuerich, who took part in many successful Himalayan expeditions, lost his life in an avalanche while climbing an icefall nearby. The Camping structure was commissioned and built by his family to commemorate his life. The hut-like cabin, characterised by an extremely steep roof, which some compare with the shape of a chapel, has the practical functions of supporting heavy snow falls and resisting strong winds. The entrance door has been located on the south side to allow the sun to melt the masses of snow – the three other façades often remain entirely covered.

Made of a prefab modular wood structure built of XLam panels, the 16-square-metre volume does not stand directly on the rocks, to limit its impact on the environment, but the base in larch wood is elevated above the surface on six large concrete columns. The floor plate, panels and three trusses forming the construction were brought to the site by helicopter and assembled according to an easy numeric system. Given the exposure and quickly changing weather conditions, the building process had to be quick. The assembly team had to climb up first, and managed to erect it within just one single day. Inside, the bivouac is very cosy. Modest in size and finish, it wraps the visitors with its all-wood interior. The natural material and colour harmonise with the surrounding nature but also create a welcoming cocoon for the visitors. The total immersion into nature is enhanced by the presence of goats around the cabin, which this place is known for; they walk effortlessly on the rough slopes of the surrounding mountains and continue to surprise visitors with their lightness and presence at such a high altitude. Regardless of the time of the year, access to the bivouac is quite challenging, and in the winter, it should be considered only by very experienced hikers.

ACCESSIBILITY
The road can be very steep in some places and hikers are challenged by ten sections of ferrata cables, so climbing up in the winter requires skill. Sella Nevea Pass at the altitude of 1190 m is the starting point and a place with parking to leave one's car.

ARCHITECTURE
Giovanni Pesamosca Architetto, 2012
LOCATION
Foronon del Buinz Mountain, Julian Alps, Italy

ALTITUDE
2532 m
NUMBER OF BEDS
8

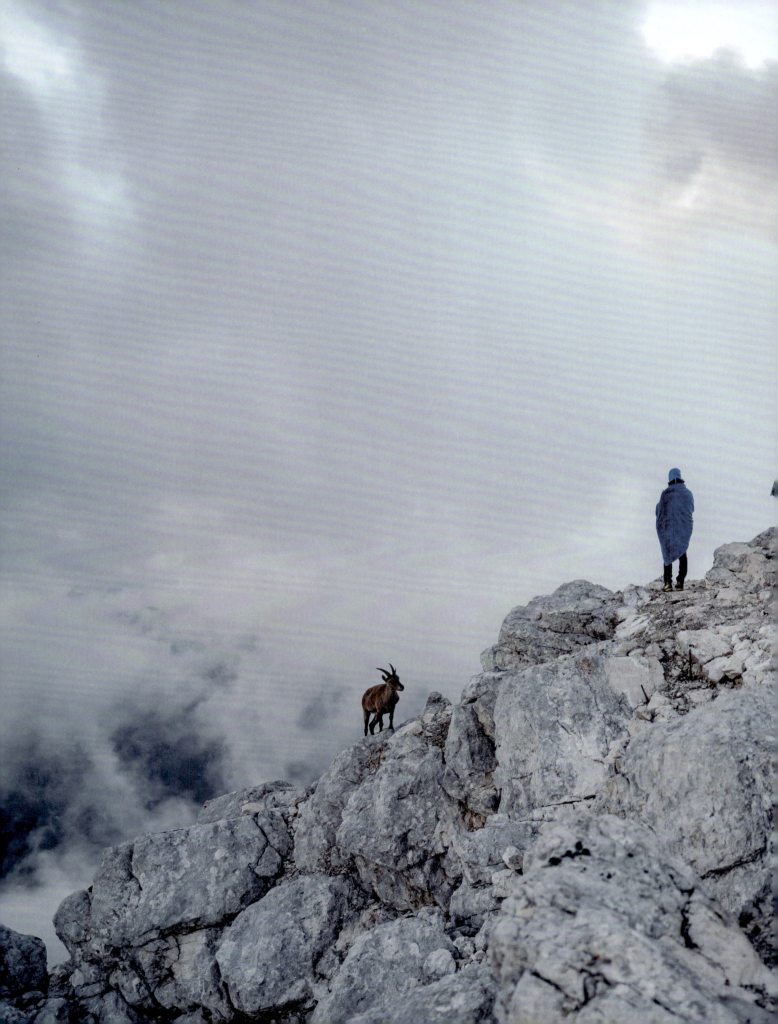

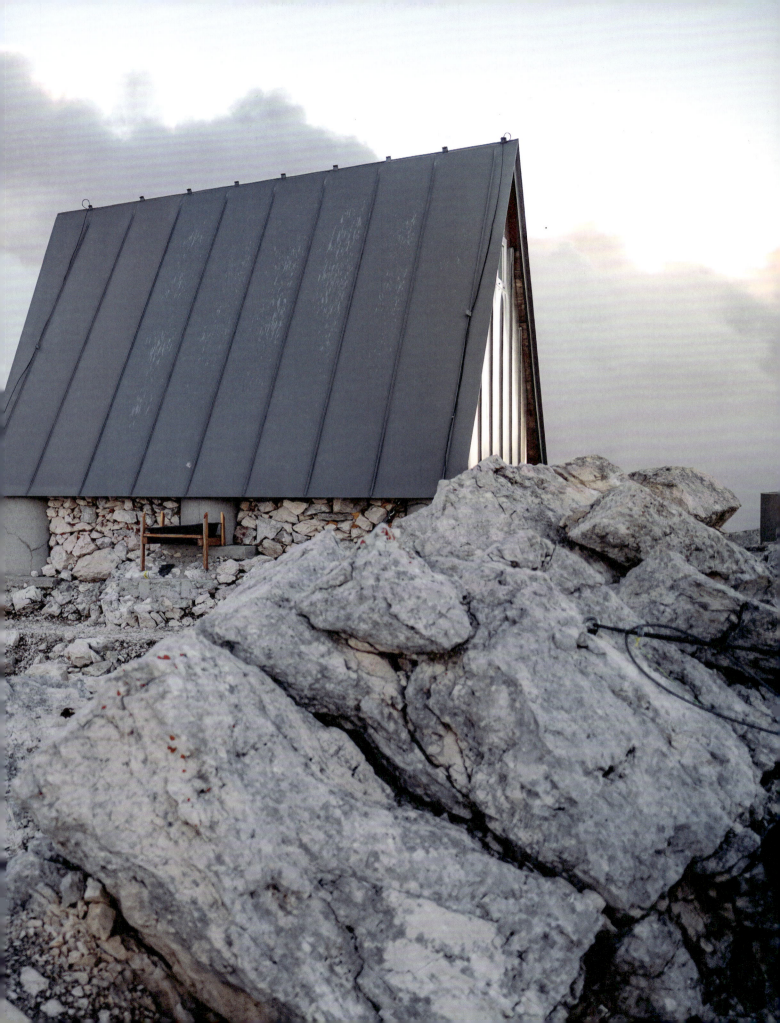

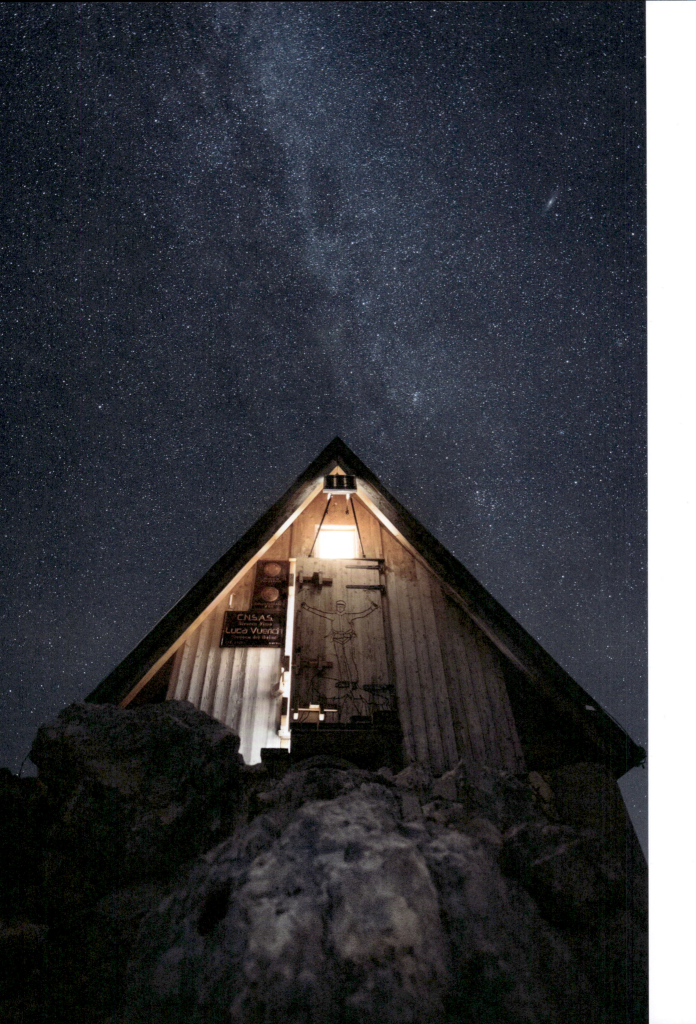

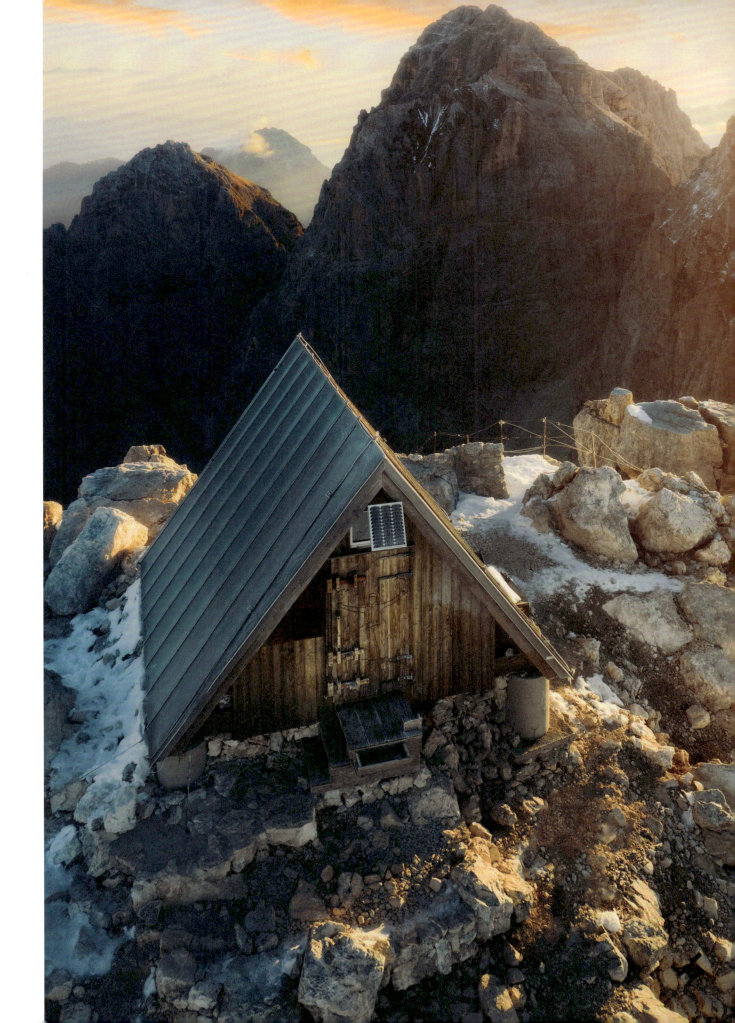

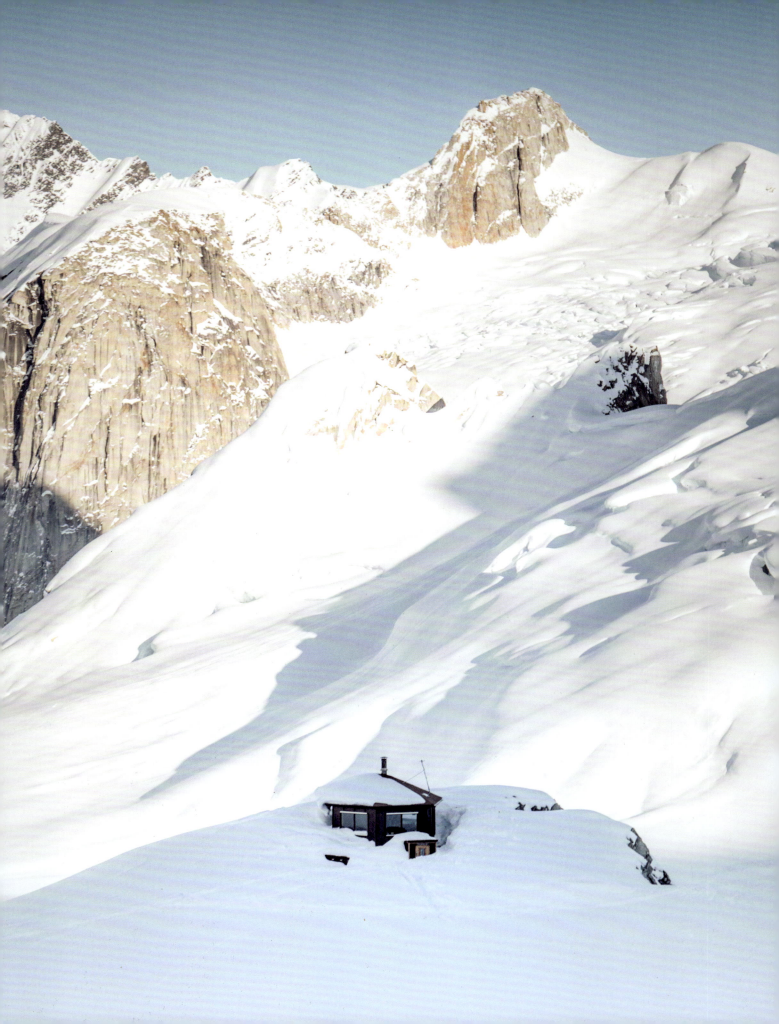

SHELDON MOUNTAIN HOUSE
DENALI NATIONAL PARK, ALASKA, US

Surrounded by striking summits, the Sheldon Mountain House is a private estate run by the Sheldon family and located in the heart of Denali National Park on Ruth Glacier in Alaska (only 10 miles from its summit). Disappearing into the surrounding mountainous landscape, the cabin looks out on breathtaking panoramas. The vast space and majestic peaks create an impressive atmosphere. The location is not accessible by any roads or trails, so getting here is possible only with a ski plane from Talkeetna, the closest town. From the landing spot, the Don Sheldon Amphitheater, visitors have to trek up one third of a mile. Ruth Glacier and Denali National Park form part of North America's tallest massif. In the past, to spend a night here meant being a skilled climber, sleeping in a tent, and eating camping food. Don Sheldon decided to turn it into a more comfortable experience, building the Sheldon Mountain House with dual-purpose bench-beds for sitting and sleeping, and a wood fired stove (for hot meals and warmth through cold nights). A true haven for adventurers, explorers and mountaineers alike. The Sheldon Mountain House served as a prototype for the later built Sheldon Chalet, also featured on the Sheldon's property.

The cosy interior of The Sheldon Mountain House is well equipped to support DIY adventures in the heart of Denali National Park. "Over the past 50 years, The Sheldon Mountain House has stood the test of time, continuing the vision of Don and Roberta Sheldon and their legacy in the heart of Denali National Park while quietly watching over the Don Sheldon Amphitheater," explains third generation owner Ryan Sheldon. The 19-square-metre mountain house sits modestly on a small isolated rock, called a nunatak, overlooking the glacial and mountainous setting. Lucky guests will be able to see the Northern Lights in full force like no other place on earth as the Sheldon Mountain House's unique elevation combined with a thin troposphere, give way to spectacular, vibrant colours in the northern sky. This single room mountain house can accommodate up to four people comfortably - or six people less comfortably. Exploration of the many glaciers and mountains surrounding the Sheldon Mountain House range from an intermediate understanding of glacial travel and mountaineering experience, to challenging and treacherous terrain that is to be carefully charted and respected. Here, the unique nature of Alaska's glaciers can truly be witnessed as the highly active Ruth Glacier moves, on average, one metre a day while featuring ice that is up to a kilometre thick around the nunatak. The Sheldon Mountain House is accessible from February to June of each year, showcasing the best time of year to see the Northern Lights/Aurora Borealis with the exception of the months of May and June.

ACCESSIBILITY
Air transportation is the only way to reach the Sheldon Mountain House, as there are no roads or trails to access the location. The closest town is Talkeetna.

LOCATION
Ruth Glacier, Denali National Park, Alaska, US

ALTITUDE
1700 m

NUMBER OF BEDS
6

INFO
www.sheldonchalet.com

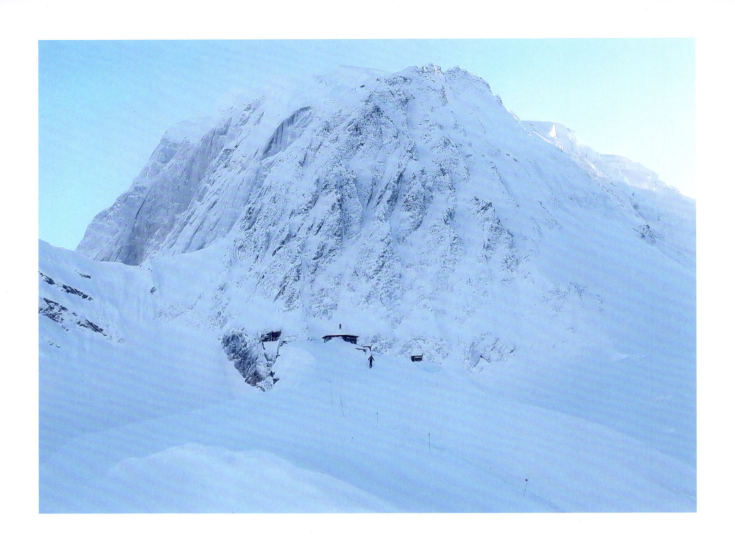

A visit between September and April is a great opportunity to see the Northern Lights/Aurora Borealis.

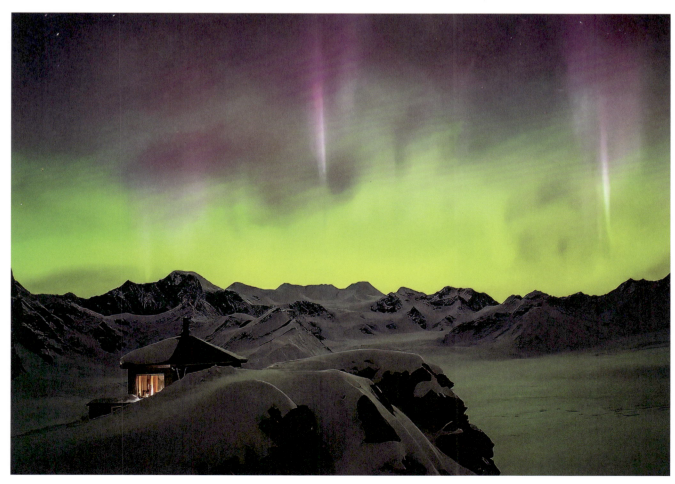

RIFUGIO VAL DI TOGNO
SPRIANA, ITALY

The very first Rifugio Val di Togno, built in the early 1900s between two streams and at the junction of three ancient tracks, served as a strategic base for Italian customs officers. Abandoned in the 1960s, the building was transformed into a Rifugio twenty years later. The current owners, Luna and Wout, bought the ruined building in 2020 after it had stood empty again for 10 years, to create a gem hidden from the hustle and bustle of contemporary life, in a hard-to-reach valley with breathtaking views of the Bergamasque Alps. Instead of a mere renovation, they decided to practically rebuild it. "After heavy demolition works, only three outside walls remained standing," they explain. "A new foundation was poured, the cement brought by helicopters that flew more than 200 times back and forth from the bottom of the valley." The walls, made of stone, have been covered with larch wood, with a thick layer of insulation in between for thermal efficiency. The Rifugio is a passive-energy building, which is energy self-sufficient and uses its own spring water. This was particularly crucial given the unspoilt natural surroundings forests, alpine meadows, waterfalls, and streams, as well as access to many hiking trails, make the place quite a hideout. The natural colour and character of the volume is an architectural highlight that fuses into the surroundings of the valley, which runs from the Valtellina Valley to the Swiss border. The all-wood interiors create a pleasantly cosy atmosphere, especially during the colder times of the year. Large windows open onto stunning panoramas and invite the landscape inside. The guests can truly enjoy the remoteness and quietness of the place, even from their bed. All rooms have been set up with modern and elegant equipment to make the stay truly comfortable. The South Room under the roof, although the smallest, offers the best view of the valley through its characteristic round window preserved from the original structure.

Asked about the best time to visit, the hosts suggested that each season offers something different. While challenging winter time, with its risk of avalanches, reduces opportunities for hiking, it can on the other hand offer a cocooning experience. The months between June and October are definitely ideal for hikers. The Rifugio's location features easy access to many trails of various difficulties and lengths. From seven-hour conquests of nearby summits with steep slopes and an altitude change of 2000 metres to much smoother and shorter walks with picturesque vistas, numerous detailed suggestions can be found on the Rifugio's website.

ACCESSIBILITY
It is not easy to reach the Rifugio even in the summer if you don't have a 4x4 – the ride counts 29 hairpin turns. Alternatively, it is possible to arrange pick up by the owners – first parking in Arquino if coming by car, or at Sondrio station if by train.

ARCHITECTURE
Zer0architettura, 2022
LOCATION
Spriana, Italy

ALTITUDE
1317 m
NUMBER OF BEDS
12
INFO
www.rifugiovalditogno.com

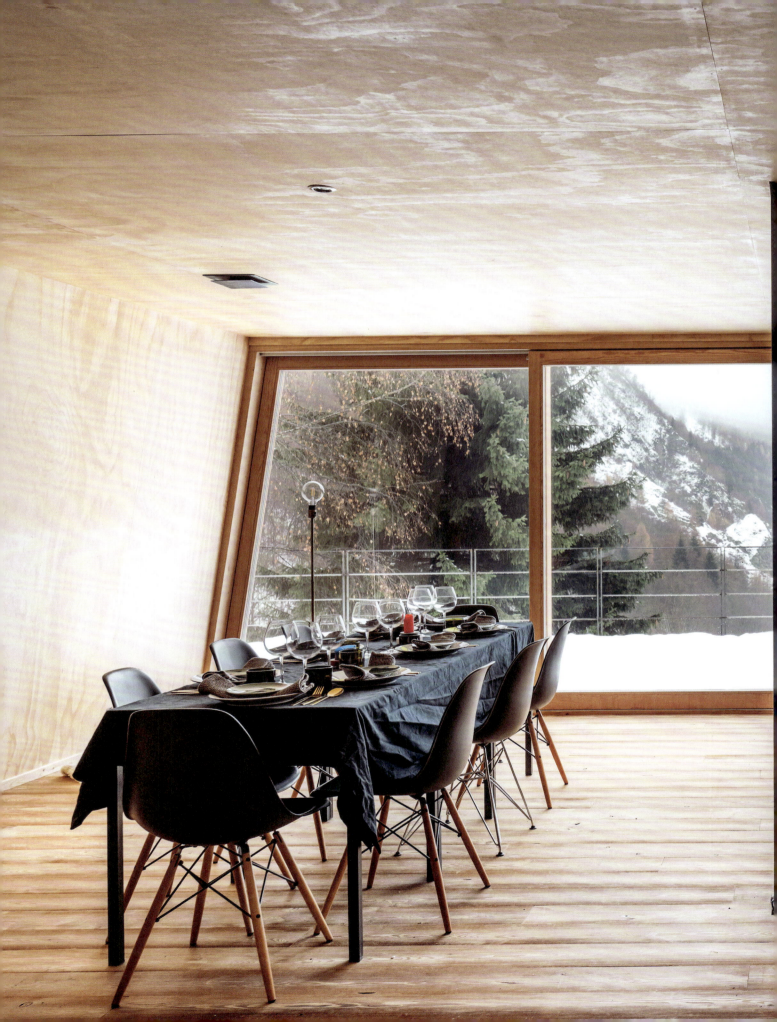

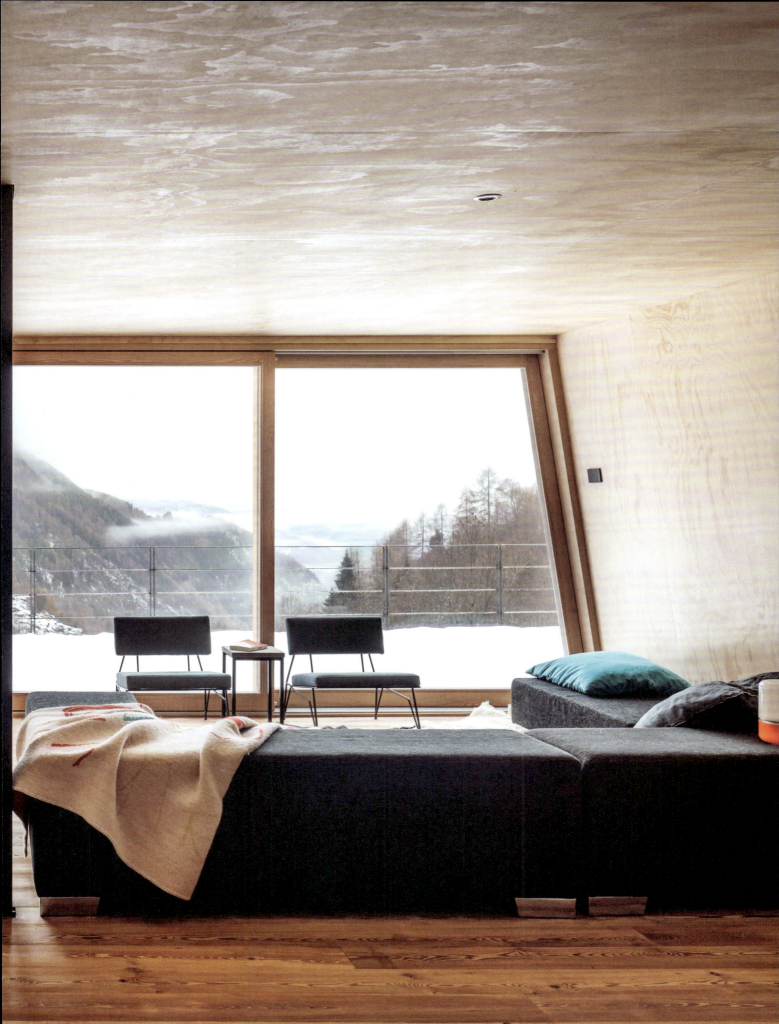

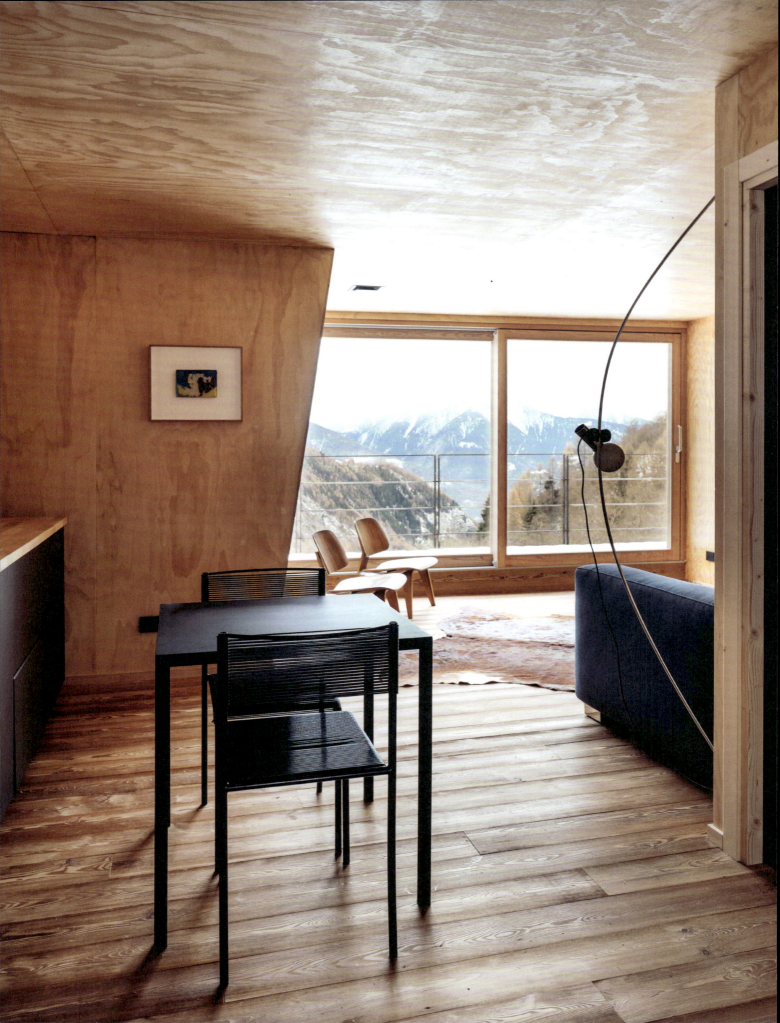

"We offer you nothing. So you can get away from everything."

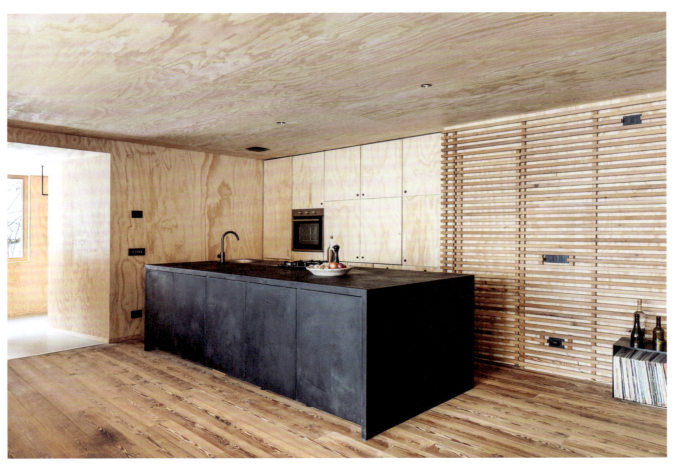

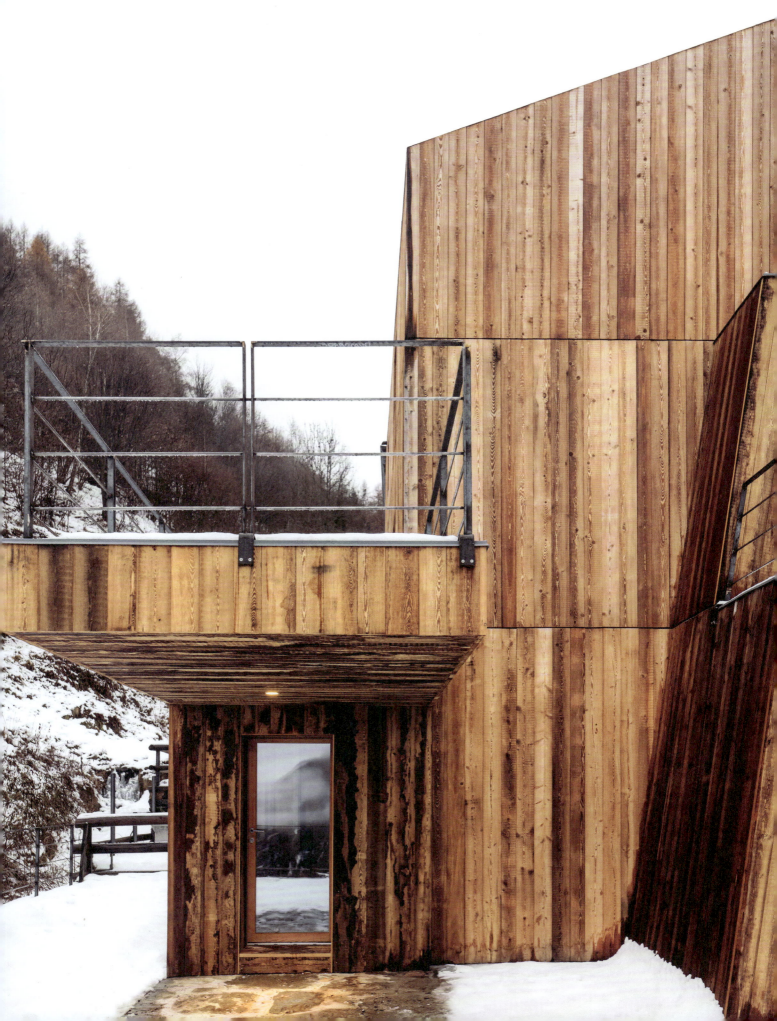

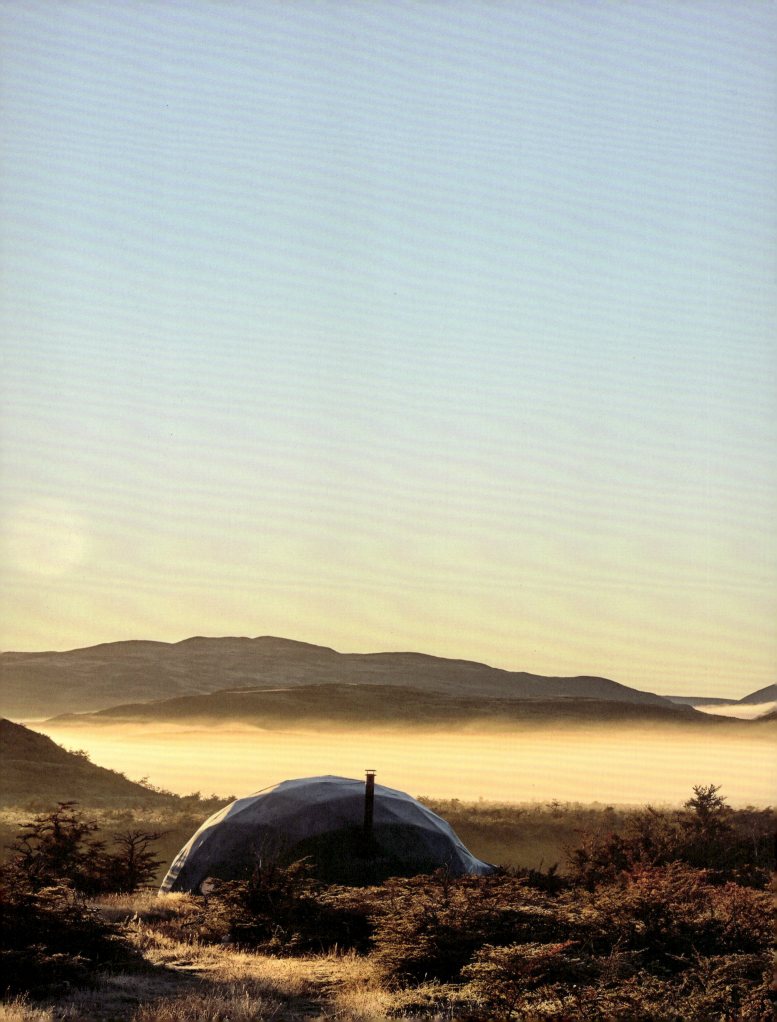

ECOCAMP PATAGONIA
TORRES DEL PAINE NATIONAL PARK, CHILE

In the midst of one of the most spectacular Chilean national parks, Torres del Paine, a curious group of dome-like structures of various sizes creates EcoCamp, which is said to be the world's very first geodesic dome hotel. Behind this exceptional venture are Yerko Ivelic, Javier Lopez and Nani Astorga, the founders of Cascada Expediciones, the tour operator company that owns and runs the EcoCamp. "We provide and encourage deep connections with nature through extraordinary travel experiences that emphasise an active lifestyle, promote sustainable development of the environment and create memorable spaces to connect with people," reads their mission. Eco-friendly activities include a wide range of hiking and trekking adventures, including the challenging 'W' route in between Torres del Paine National Park's monumental mountains, which is one of Patagonia's most popular trails, highlighting the French Valley and Grey Glacier, all with ravishing views. Other tour options include the Wildlife Safari, offering the chance to observe and explore the park's fauna, and a great selection of outdoor sports programmes, like rafting, kayaking and biking. These customised adventure packages are organised by the dedicated and professional EcoCamp team. Throughout the year guests need to be prepared for all kinds of weather conditions. Even in the summer between December and March, there might be cold and strong winds (up to 130 km/h) as well as intense rainfall, while the temperatures range between 2ºC and 24ºC with an average of 11ºC. "The vast unbroken stretch of ocean to the west and south of the South American continent leaves the Patagonian Andes very exposed to the saturated winds that circle the Antarctic landmass," explain the organisers, so "fine weather may deteriorate almost without warning, bringing rain and even snow".

This unique place can truly encourage reconnection with nature thanks to the remote location and its surrounding vast mountainous landscape. EcoCamp Patagonia has been built to keep the natural environment in its pristine state and to have a positive impact on it. The sustainable lodgings are dome-shaped structures with eco-friendly solutions, like heating with low-emission pellet and wood stoves, and solar panels for hot water in showers and composting toilets. The guests can select between various lodgings, from the smaller most affordable standard option to the large and extra comfortable Suite Domes. All the interiors, regardless of size, feature a pleasant combination of textiles and natural wood, with views of striking Chilean panoramas. EcoCamp's four interconnected communal domes are no less important during the stay – accommodating a large bar, two restaurants, and a great space to practice yoga.

ACCESSIBILITY
Arrival with regular daily (yet pre-ordered) shuttles from two possible airports – Punta Arenas Airport and Puerto Natales Airport.

ARCHITECTURE
2001
LOCATION
Torres del Paine National Park, Chile

ALTITUDE
175 m
NUMBER OF BEDS
72
INFO
www.ecocamp.travel/en/domes

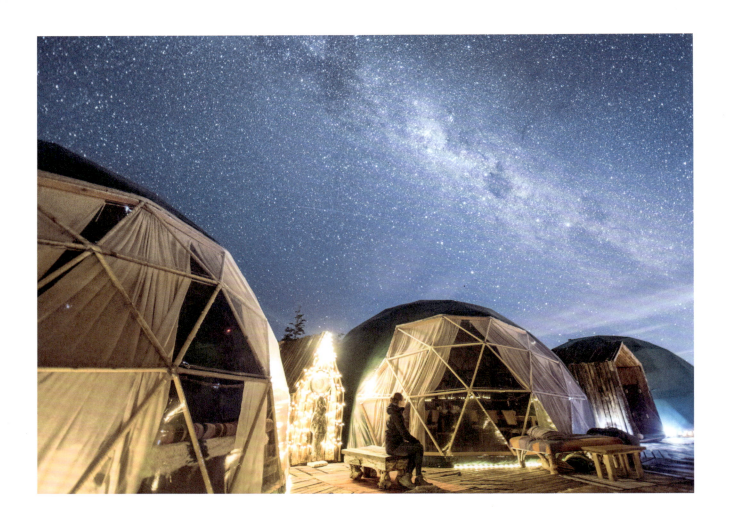

This unique place can truly encourage reconnection with nature thanks to the remote location and its surrounding vast mountainous landscape.

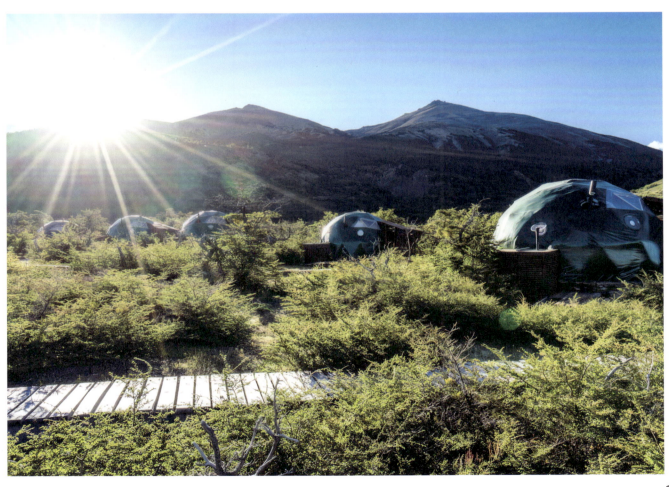

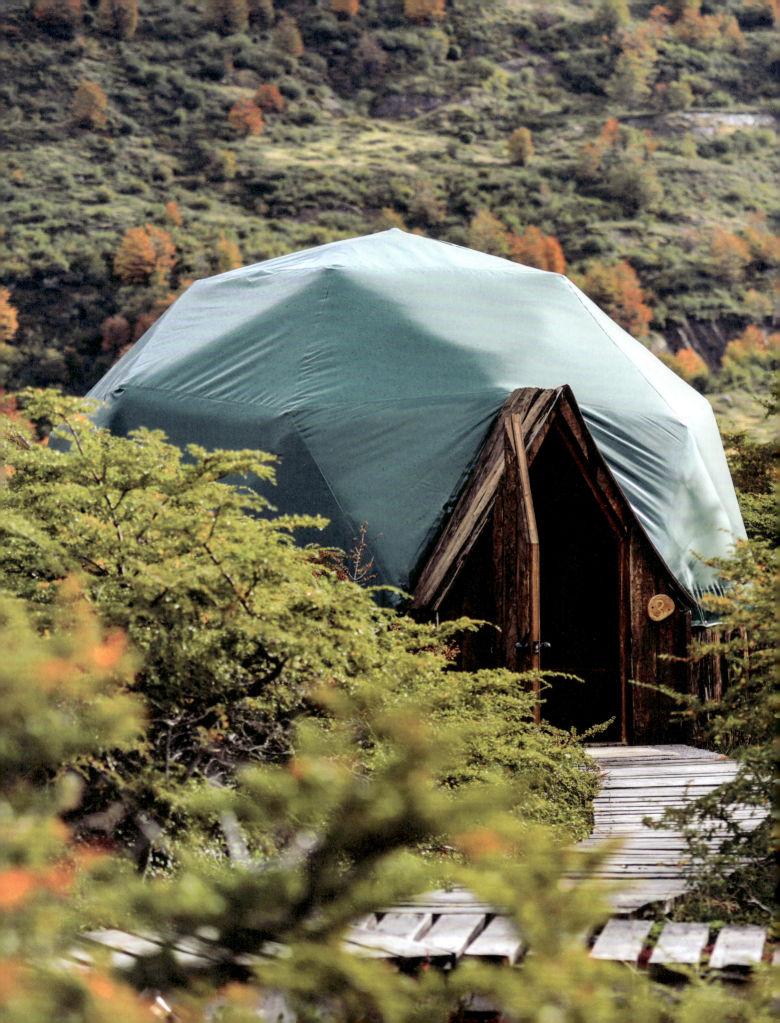

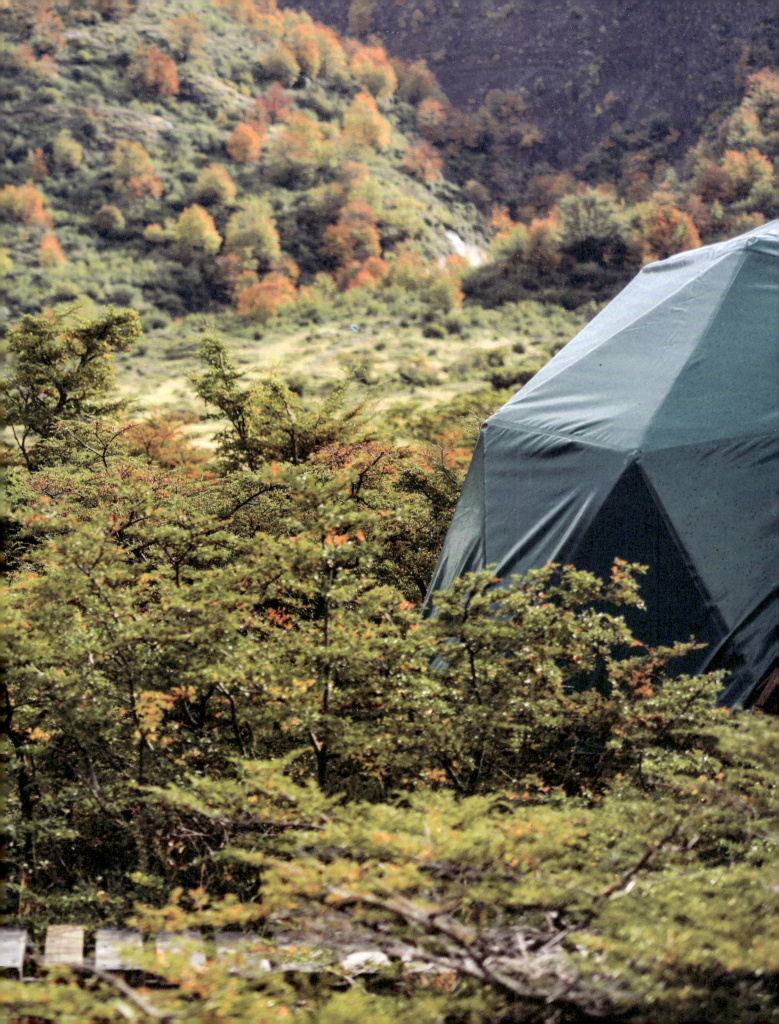

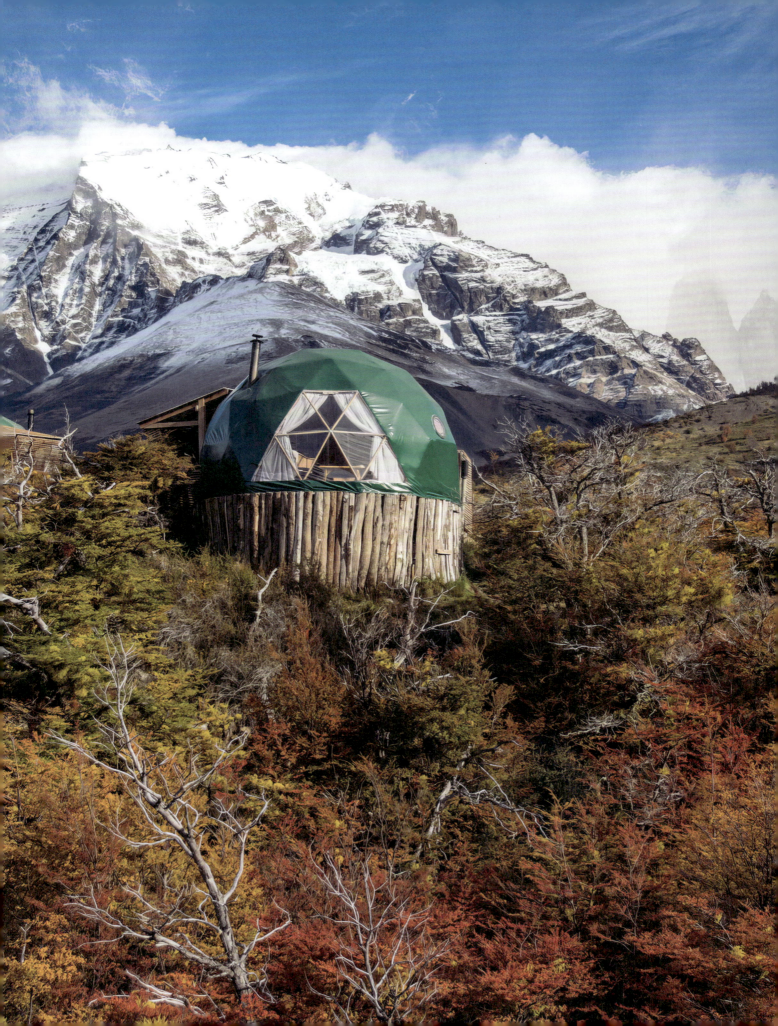

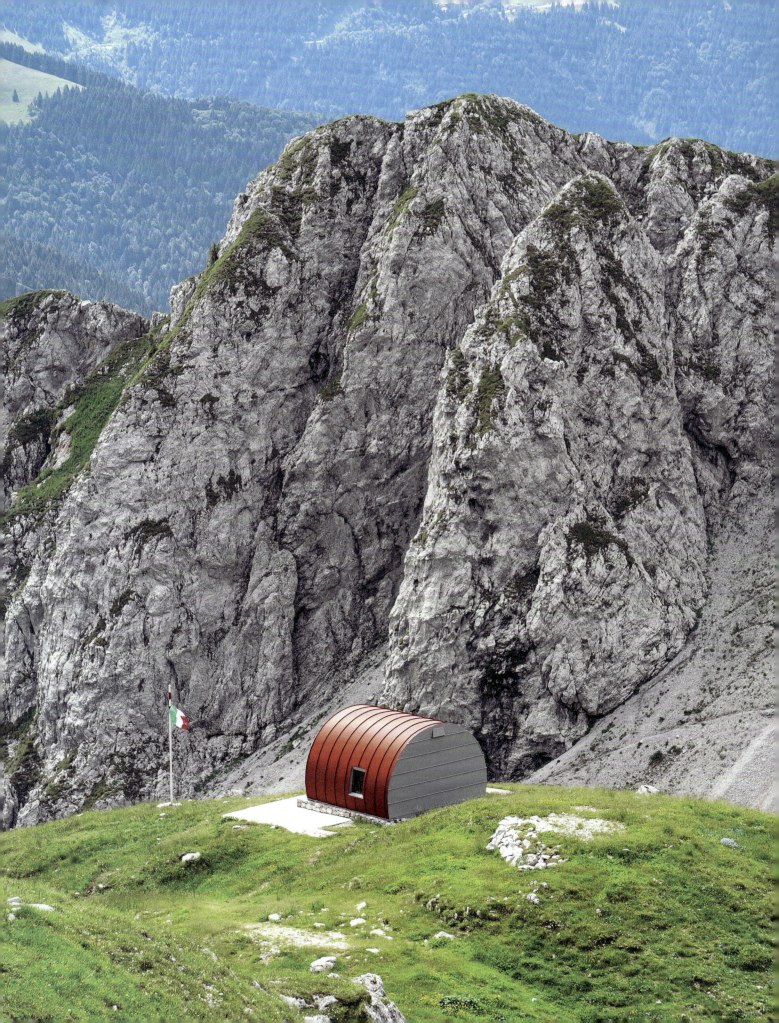

BIVACCO CITTÀ DI CLUSONE
PRESOLANA MASSIF, ITALY

Located in a meadow on the southern slope of the Pizzo della Presolana, the bivouac was rebuilt in 2015 to replace the previous all-metal structure from 1968 that commemorated the death of seven men in an avalanche in the same year. The new volume is built of wood and its outer shell is formed of metal sheets to protect the structure from extreme weather conditions. It is equipped with five bunk beds with mattresses, a table and two benches, all nestled in the fairly high U-shaped interior. The curved form and natural colour of the wood create the nice atmosphere of a guest house. The lighting system uses a solar-powered battery, but there is no water in the area so guests need to bring it with them. The bivouac, which is open all year, also serves as an operational base and depot for the mountain rescue team – visitors can communicate with them thanks to a radiotelephone inside.

The hike to the bivouac is of medium difficulty, while the views of Presolana are simply breathtaking. Many climbers also enjoy the proximity of the Savina Chapel above (at the altitude of 2085 m) as well as Grotta dei Pagani. To get there it is best to start the climb either from the village of Castione della Presolana (at the altitude of 1006 m) or to first go by car to the Presolana Pass (located a bit higher at 1297 m) and start the hike from there. Summer is certainly less challenging, but despite significant snowfall, hikers praise the winter views of the surroundings. While many paths run through the Presolana massif, the longest 'Sentiero delle Orobie' route is around 85 kilometres long and has been divided into seven sections with many rifugi (mountain huts serving hot meals and offering room and board) on the way and varying hiking difficulty levels.

ACCESSIBILITY
The best access is from the Presolana Pass with a large parking area. From there, the climb lasts about 2,3 hours and the route's difficulty is marked as medium.

ARCHITECTURE
2015

LOCATION
The southern slope of the Presolana massif, Castione della Presolana, Italy (the province of Bergamo)

ALTITUDE
2027 m

NUMBER OF BEDS
5

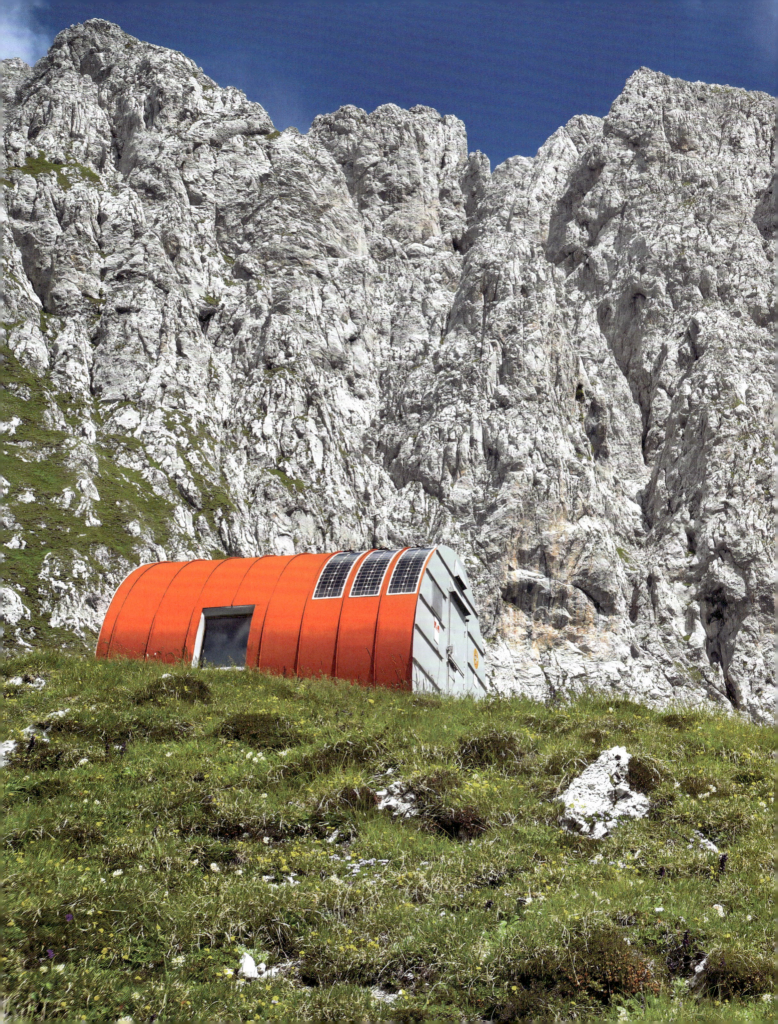

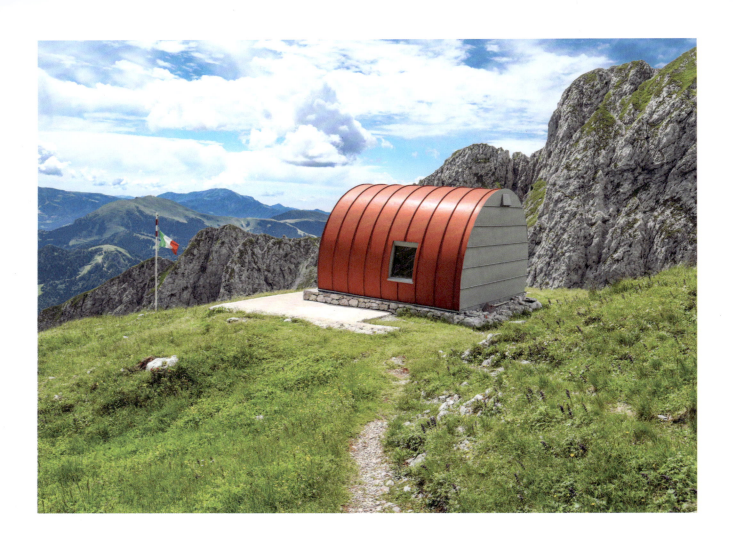

The curved form and natural colour of the wood create the nice atmosphere of a guest house.

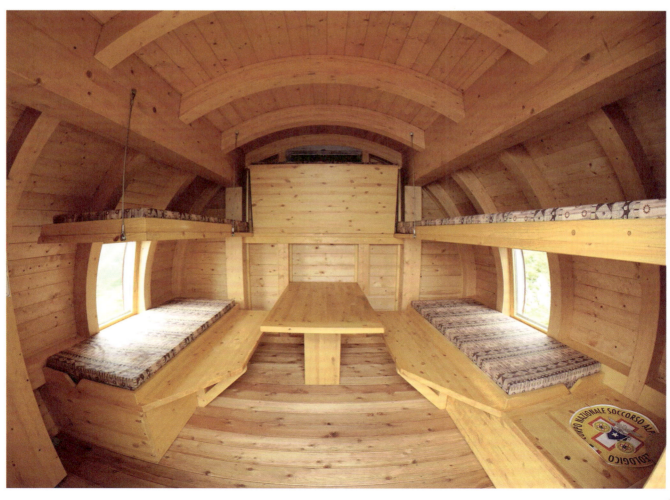

BIVACCO FELTRE & WALTER BODO
DOLOMITES, ITALY

Also called 'Red shacks', the Bivacco Feltre and Walter Bodo are located in the Val Canzoi, a valley known for its rocky foundation intertwined with spans of grassy wilderness, featuring beautiful landscapes. The two minimalist huts covered with pitched roofs are encircled by a picturesque amphitheatre of the peaks, offering breathtaking vistas. Climbers are advised to leave their cars in an extensive lot below Lago della Stua. The hike starts very gently, largely along a flat area around a scenic lake. Then the climb up the Val Canzoi starts (along CAI path 806), with some demanding parts requiring ropes and ladders. Even though the altitude difference is quite modest and the trail is technically not difficult, it requires climbers to be fit and should be not underestimated. On the way, climbers pass by many waterfalls, gullies and ravines. The last part of the route becomes steep, but once at the top, climbers can admire a 360-degree vista of the magnificent amphitheatre that creates a striking setting for the two small bivouacs. They are visible from afar thanks to their red hue, which stands out against the rocky landscape. Their location marks the junction where the most significant paths meet.

As much as the route is a fantastic opportunity to see the wild side of the Feltre Dolomites, hikers should also carefully consider the atmospheric conditions. Rain, damp leaves on the rocky ledges and slopes in the autumn, and ice in the winter all require special attention, not only while climbing up but particularly during the descent. Summer thus seems to be the best season to visit, especially for less experienced hikers. Even with excellent weather, to do a loop in a day, mostly due to the length of the trail, climbers must be well trained and equipped. The shacks are quite simple inside. Both are equipped with bunk beds; the smaller volume can host five and the larger up to twelve hikers. The second also has a larger space with tables and benches to prepare food and eat. There is a water spring at the bivouacs.

ACCESSIBILITY
The route is technically not difficult but climbers should not underestimate its substantial length or some of the more challenging sections, like ascents in the upper, rocky part of the trail. The climb starts at a large parking area below Lago della Stua.

LOCATION
Val Canzoi, Cesiomaggiore, Dolomites, Italy (the province of Belluno)

ALTITUDE
1930 m

NUMBER OF BEDS
5 and 12

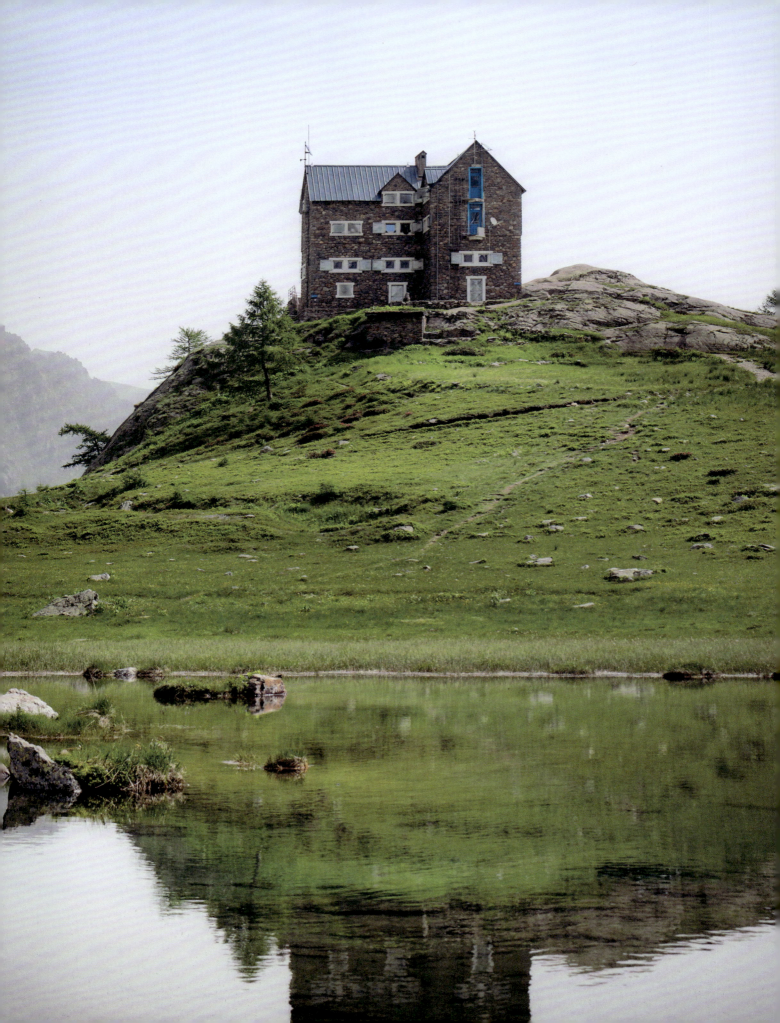

RIFUGIO GUGLIELMO MIGLIORERO
BAGNI DI VINADIO, ITALY

The mountain shelter Migliorero in the Stura of Demonte Valley, Piedmont, considered by many hikers to be the most elegant refuge of the Maritime Alps, is quite a gem. Its beautiful location between two amazing natural reserves – the Maritime Alps Park on the Italian side and Mercantour Park on the French one – is not all. The rifugio is surrounded by numerous peaks as well as the Ischiator Lake, with an extremely enjoyable hike leading to it from a parking lot near the Ponte del Medico at the altitude of 1564 m, advised as the ultimate starting point. The level of difficulty is estimated as moderate with an average time of under four hours to reach the goal. To get to this scenic refuge with a lake and a peat bog, the trail starts in a forest, which thins out after a while, opening to a vast, mountainous landscape. The trail becomes harder with a strong altitude gain but there are many lovely spots for short breaks, like to enjoy waterfalls or birding. There are two ascents – either through the Wymper trail, which was used for many years to bring food to the shelter on horseback, or an easier route leading through an extensive valley inhabited by shepherds and their herds. Sitting elegantly on the rocky spur, the four-storey building in stone has an amazing view of the surroundings. With a retro style, it was initially built in 1934 as a hotel at a high altitude. In 1962, after the damages caused by wars and neglect, the building was restored. Today it uses solar panels to produce electric energy and offers an internet connection to guests. There are 88 beds, in both small and big rooms, distributed across two floors as well as a big, fully equipped kitchen where hikers can cook and eat their own meals, an ample salon with tables for 70 people, a library, and warm showers.

Rifugio Guglielmo Migliorero is open between March 1 and November 15. The only time when it is entirely closed is from November 16 to February 28, when the separate, winter premises with good insulation offer six sleeping places with mattresses and blankets, a table and an efficient stove – hikers just need to bring wood to cut. Next to the refuge there is a source of drinking water. "From the Migliorero shelter one can reach different mountain tops and take different paths, among the most beautiful and interesting ones of the whole province of Cuneo," explains the rifugio's team, which gladly advises visitors on any itineraries. "Some of these can be done in the summer as well in the winter," they add.

ACCESSIBILITY
The trail, starting from a parking lot near the Ponte del Medico, is considered moderately challenging and is said to be doable in both summer and winter months from March 1 to November 15 – with adequate equipment in the latter case.

LOCATION
Inferior lakes of the Ischiator, Bagni di Vinadio, Piedmont, Italy (the province of Cuneo)

ALTITUDE
2100 m

NUMBER OF BEDS
88 (season)/6 (off-season)

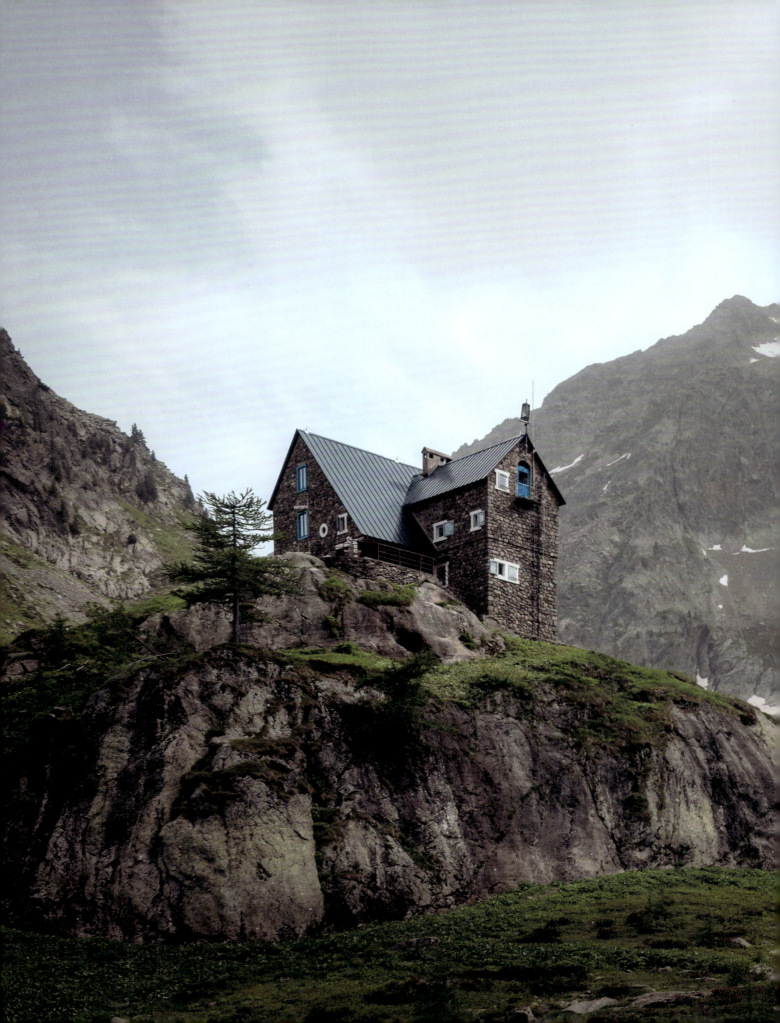

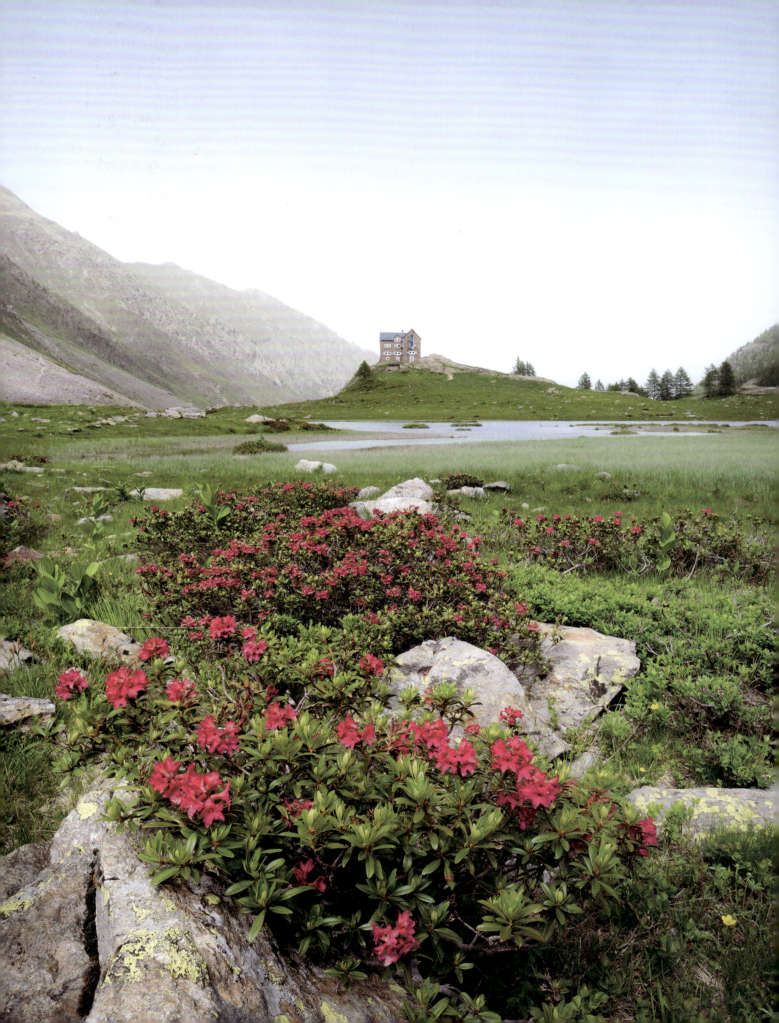

Sitting elegantly on the rocky spur, the four-storey building in stone has an amazing view of the surroundings.

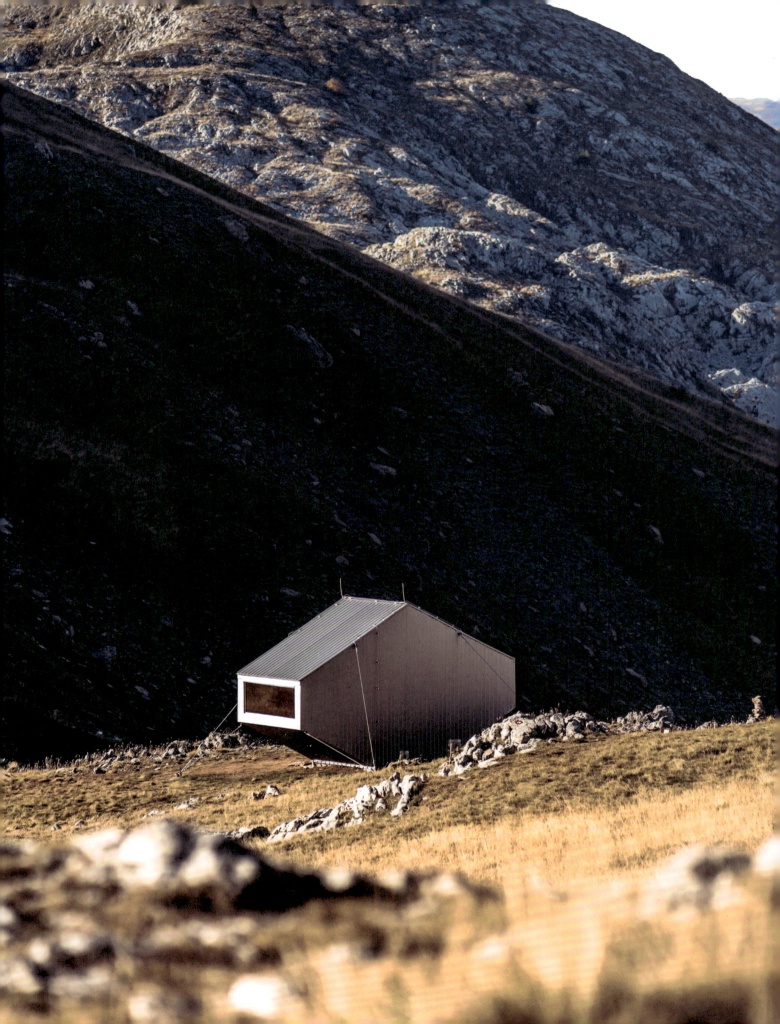

BIVOUAC ZORAN ŠIMIĆ CABIN
PRIDVORCI, BOSNIA & HERZEGOVINA

Filter Architecture designed a playful cabin that is only 14 square metres. The functional interior is divided into three platforms that flexibly become floor areas, beds or sitting spaces. Thanks to this arrangement the cabin can accommodate between 9 and 12 guests. As much as the interplay of the platforms stands behind the curious shape of the cabin, it has also been planned to limit its impact on the terrain to a minimum. The sturdy structure is based on a steel tube frame, first welded in a workshop and then transported by air to the site, which in the high-altitude conditions was quite a challenge, as was the assembly. The outer shell is made of metal roofing sheets, while the interiors are enveloped in wood floor planks (with efficient insulation in between the layers). This natural envelope stands in perfect harmony with the landscape outside and, particularly in the winter, creates a cocooning effect. A steel basket filled with locally sourced stones makes up its non-invasive foundation, and special ropes anchor the multi-sided volume to the ground.

The remote location at the edge of Rakitnica Canyon that runs between two mountains, Visočica and Bjelašnica, is not random. It is here where trekking paths cross the canyon and connect the two mountains. As an important part of an ambitious plan to develop the network of trails in the area, the cabin is a curious feature of the landscape. Its two huge panoramic windows open onto the surroundings and act as a link between the inside and outside. The goals of embracing the views and giving visitors a perfect observation spot were at the heart of this project. The architecture of the cabin and its precise placement are intended to enhance the experience of being high in the mountains. One of the lead architects happens to be an experienced mountaineer, which definitely influenced the vision as well as the final result. The playful shape is distinctive so it can be seen from afar, yet on the other hand the grey multifaceted volume somehow resembles a rocklike formation, thanks to which the bivouac fuses into the landscape. Since it is so original and enjoys such a great location, the cabin has become a very popular spot for hikers. And as the trail leading to it is not of high difficulty, it is quite often visited.

ACCESSIBILITY
It is said that the cabin is accessible even for inexperienced hikers and the trail is categorised by hikers as easy. Arrival at the starting location is recommended from the Konjic direction, via Bjelimići, or from Sarajevo via Bjelašnica, Šabić and Sinanović road.

ARCHITECTURE
Filter Architecture, 2019
LOCATION
Pridvorci, Bosnia and Herzegovina

ALTITUDE
1804 m
NUMBER OF BEDS
9–12

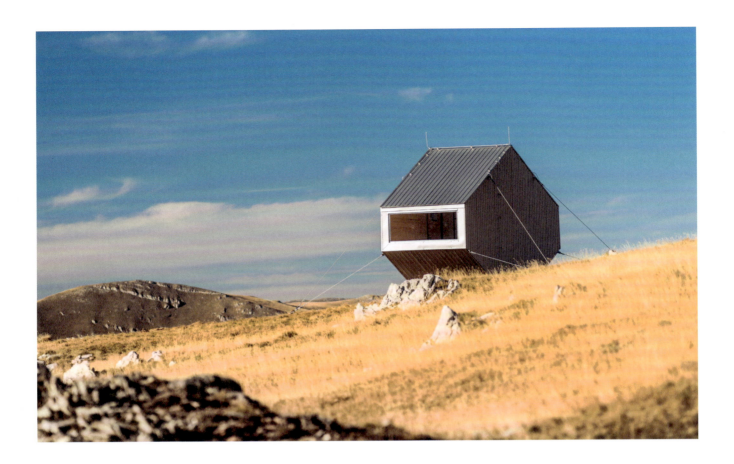

The playful shape is distinctive so it can be seen from afar, yet on the other hand the grey multifaceted volume somehow resembles a rocklike formation.

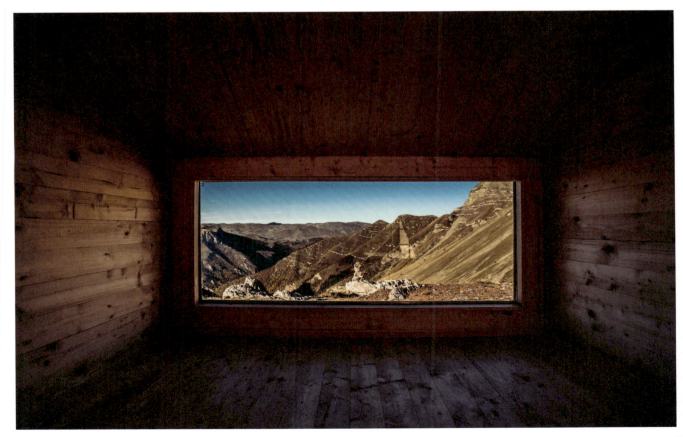

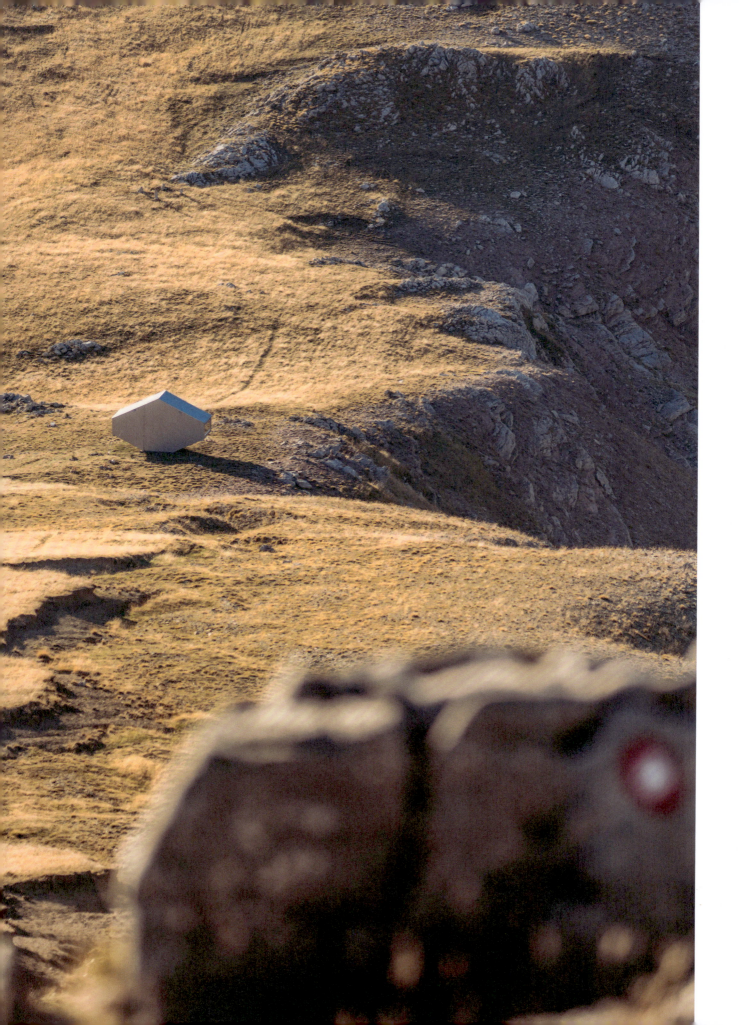

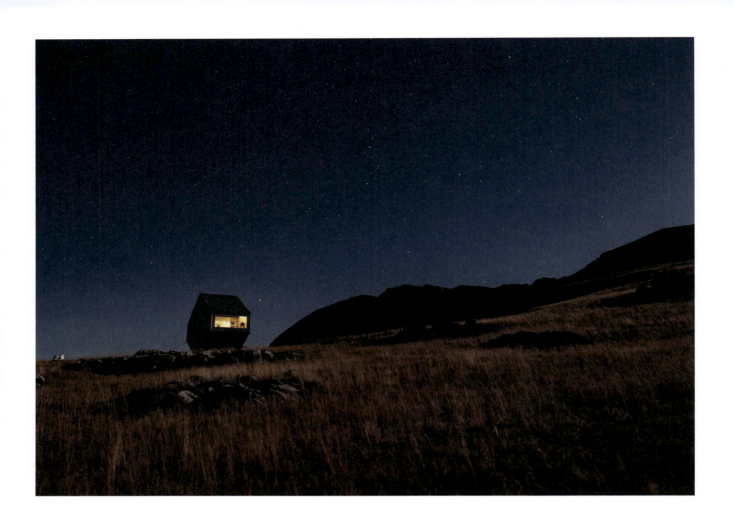

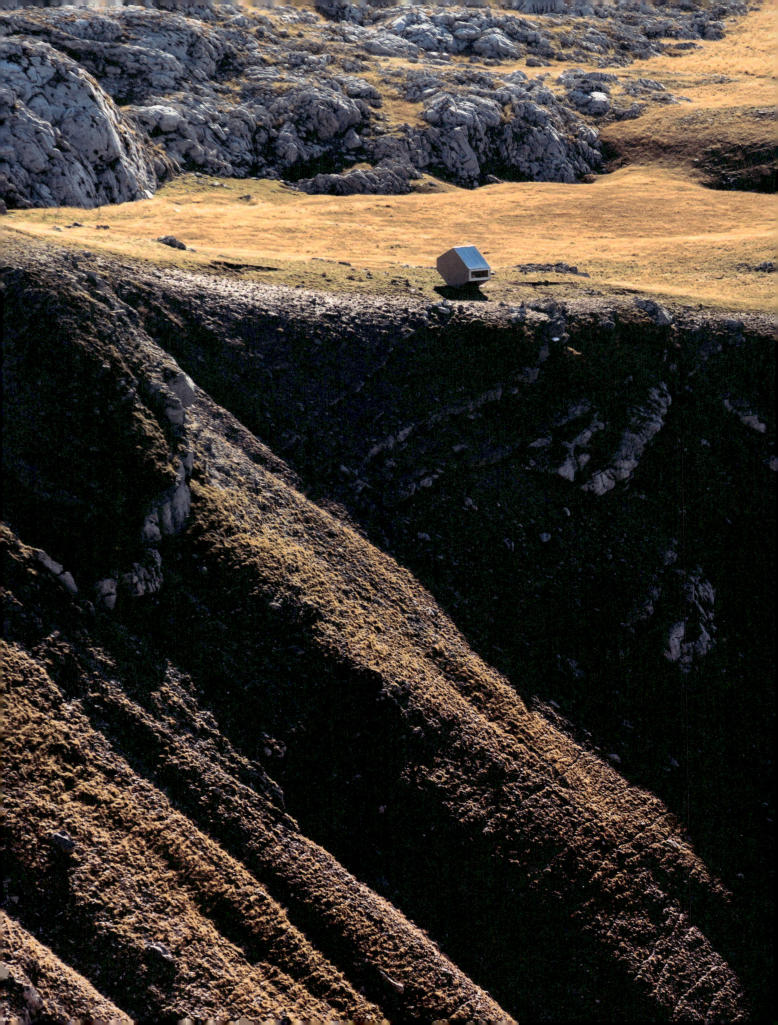

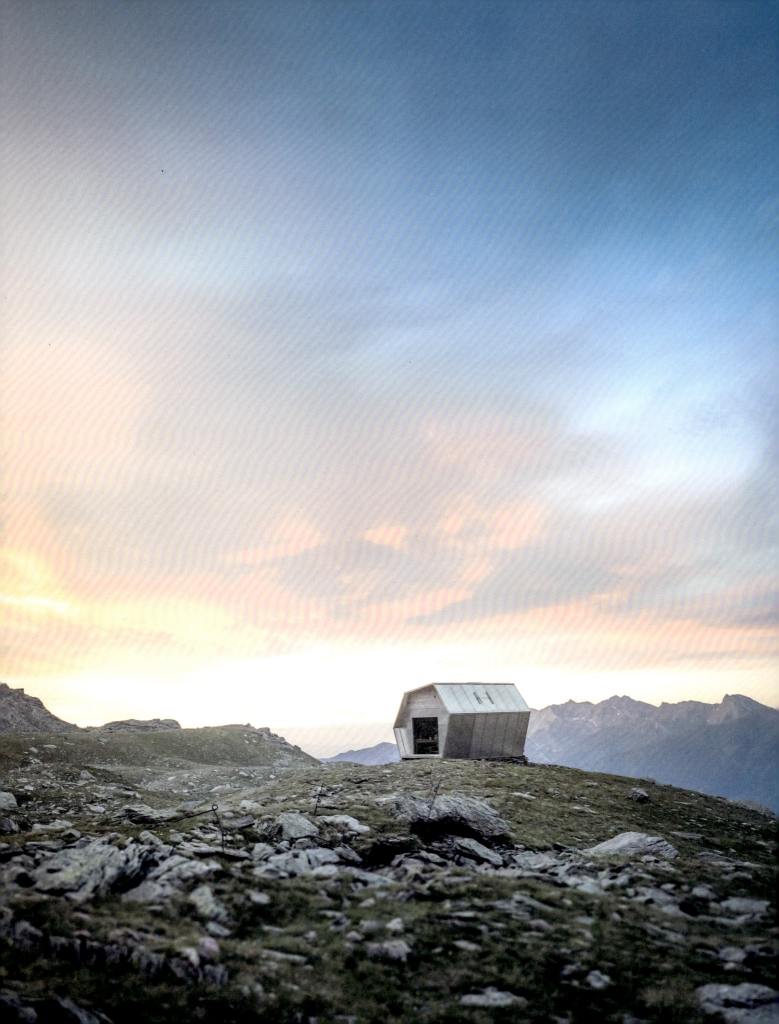

BIVOUAC HANNIBAL
COL DE CLAPIER, ALPS, ITALY

Since 2014, Bivouac Hannibal (also referred to as Bivacco Col Clapier) is a great attraction of the alpine mountain pass Col de Clapier on the border between France and Italy. It was built in the frames of the European project 'In the footsteps of Hannibal', aimed at reviving the link between the two countries. According to the studies of English researcher Marc-Antoine de Lavis-Trafford from the 20th century, this was the place where Hannibal crossed the Alps with his army and elephants to invade Italy.

Although the bivouac's contemporary shape is distinctive against the mountainous landscape, it is not easily visible from the paths leading up to it. After dark there is outdoor lighting to help with locating the cabin. The electricity is provided by solar panels and there are even two USB charger connections. A thermostat for temperature setting can be used to heat the space. The all-wood interior is divided into the main level, which has two big tables with benches and two fold-down bunks, and the upper level.

A small ladder leads to the upper level under a glass roof – perfect for star gazing – with six comfortable sleeping places (with mattresses and blankets). The highlight of the volume is the large panoramic opening overlooking the Vallon de Savin, which offers striking vistas during the day when the sky is clear.

The bivouac is open both during the summer and winter. It is well equipped, and climbers have praised not only the location but also the quality of the cabin, which is often used on the way to more remote peaks, like Dents d'Ambin or Mont Giusalet (both over 3000 m). The only problem is that stoves must be used to cook food outside only, due to the closed-circuit ventilation system, which is quite difficult when the weather conditions are not good. The trail is said to be possible to complete on foot, by mountain bike, or by ski touring and snowshoeing during the winter time.

ACCESSIBILITY
The hike starts from the village of Bramans, through Le Planay (still reachable by car) and then the trail proceeds up to the Savine Valley and the Col de Clapier. In the winter, access to Le Planay by road is allowed only for a free shuttle bus.

LOCATION
Col de Clapier, Alps – on the border between France and Italy

ALTITUDE
2477 m

NUMBER OF BEDS
6–8

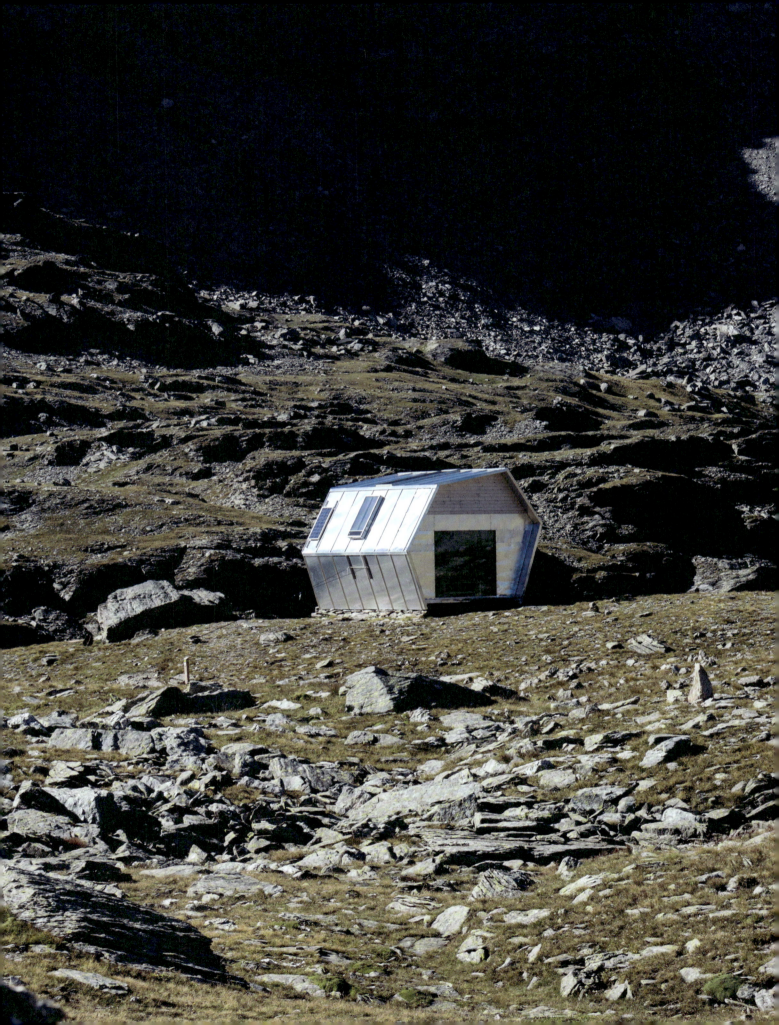

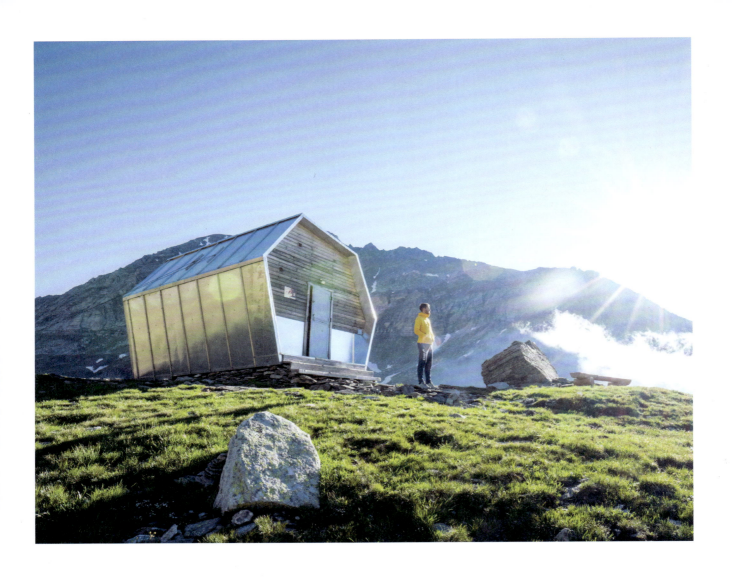

The highlight of the bivouac is the large panoramic opening overlooking the Vallon de Savin, which offers striking vistas during the day when the sky is clear.

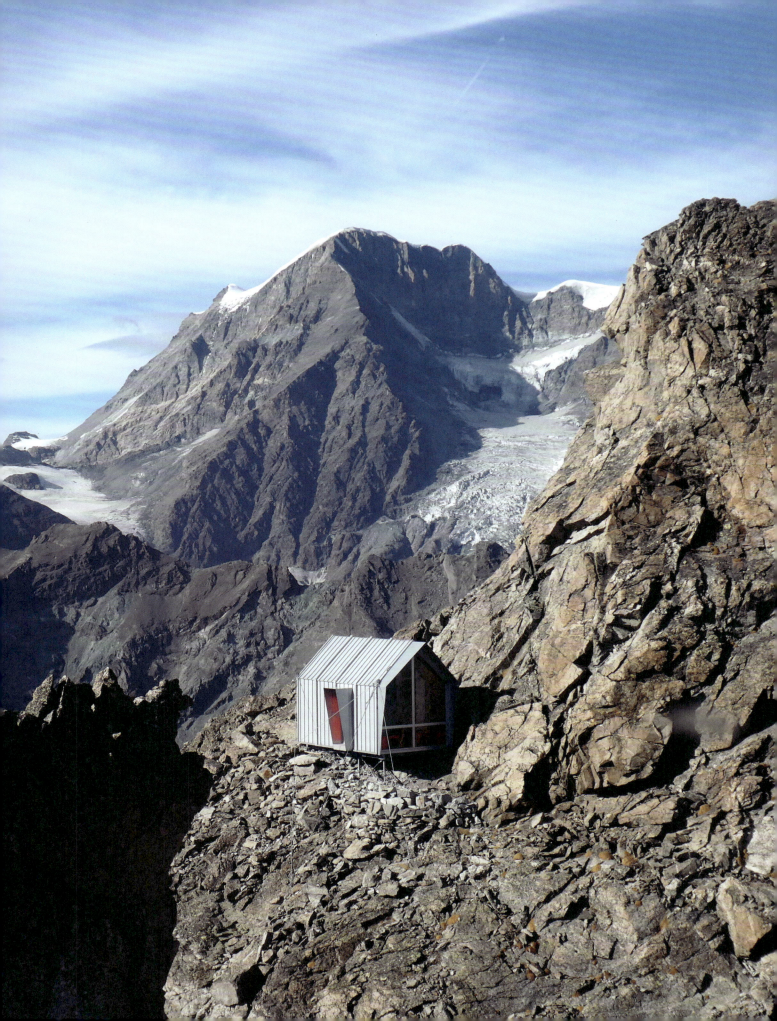

BIVOUAC LUCA PASQUALETTI
MORION RIDGE, AOSTA VALLEY, ITALY

Designed by architects and researchers at the Istituto di Architettura Montana of the Politecnico di Torino, Roberto Dini and Stefano Girodo, in cooperation with LEAPfactory, the bivouac is an answer to the rising number of alpinists wishing to climb to high altitudes and discover the remote and wild area. It was also inspired by the local alpine guides association Espri Sarvadzo, which translates into 'Wild Spirit' in the local dialect. The volume, made of prefab wood and steel composite panels, was inaugurated in 2018 in its most remarkable context, neighbouring the distinctive rocky hole of Becca Crevaye, over 3000 metres above sea level, and surrounded by numerous rocky peaks.

The architects envisioned a simple yet efficient 13-square-metre volume covered with a pitched roof, as in a typical shelter. Extreme weather conditions on the site, including very low temperatures and super strong winds, as well as heavy precipitation and snowfall, required a structure that would resist, protect and also embrace in this remote and nearly inaccessible spot. The centrally located entrance marks the border between the living area, with a table and seats, many storage compartments and space to prepare food, and the sleeping area in the rear, made of two wooden platforms with mattresses. Courageous climbers can immerse themselves in breathtaking views of Becca di Luseney, the group of Monte Rosa and the Matterhorn, through a panoramic window placed in the main façade that also lets in an ample amount of natural light and warms up the interior. Additional lighting is possible thanks to a small solar panel.

Not only do the sharp lines and grey tones allow the cabin to mingle into its surroundings, adjusting to their severe geomorphology. The bivouac is also entirely reversible to reduce its environmental impact – it is anchored to the rocks without any foundation and its eco-certified components can be easily dismantled and recycled. The respectful protection of the high-altitude environment was at the core of this unique project. The Pasqualetti couple wished to dedicate this bivouac to the memory of their son Luca, a mountaineer who lost his life in the Apuan Alps four years earlier. Mountaineers can reach the bivouac through various trails, each of which is very demanding and requires considerable skill. The extraordinary experience of staying in this special cabin is a great reward, as are the most striking views all around it.

ACCESSIBILITY
The bivouac is categorised as hardly accessible and only for very experienced mountaineers and in good weather conditions. There are several itineraries, all highly difficult, including parts of a glacier and a variable rocky context.

ARCHITECTURE
Roberto Dini + Stefano Girodo, 2018

LOCATION
Morion ridge, Valpelline, Aosta Valley, Italy

ALTITUDE
3290 m

NUMBER OF BEDS
8

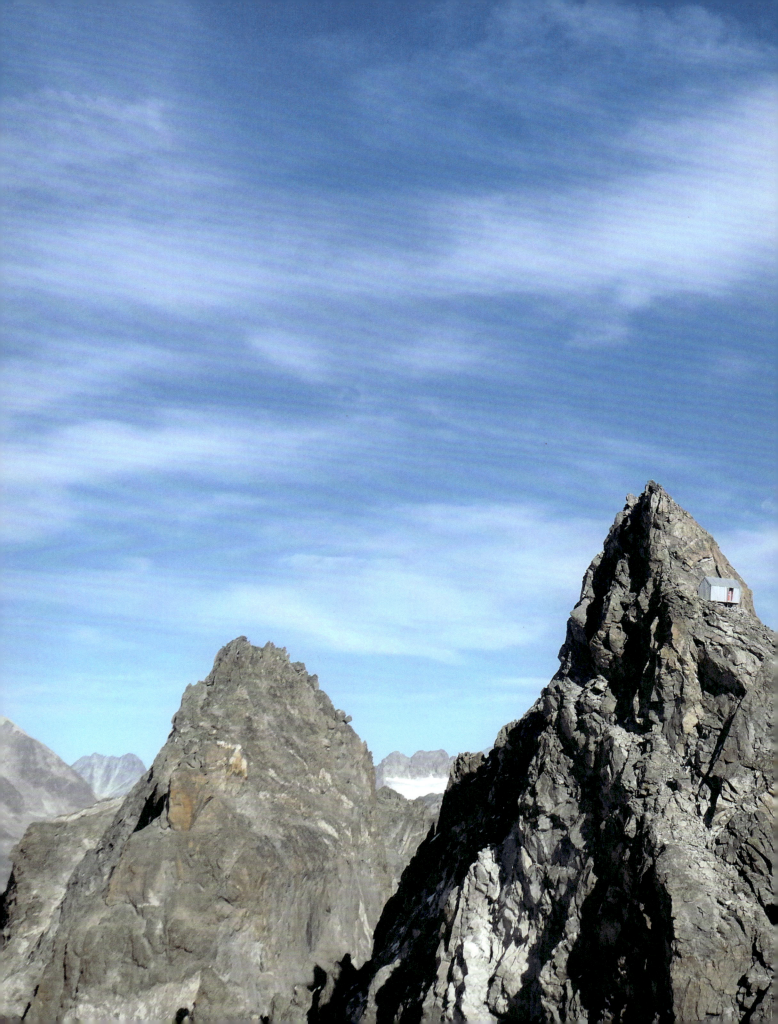

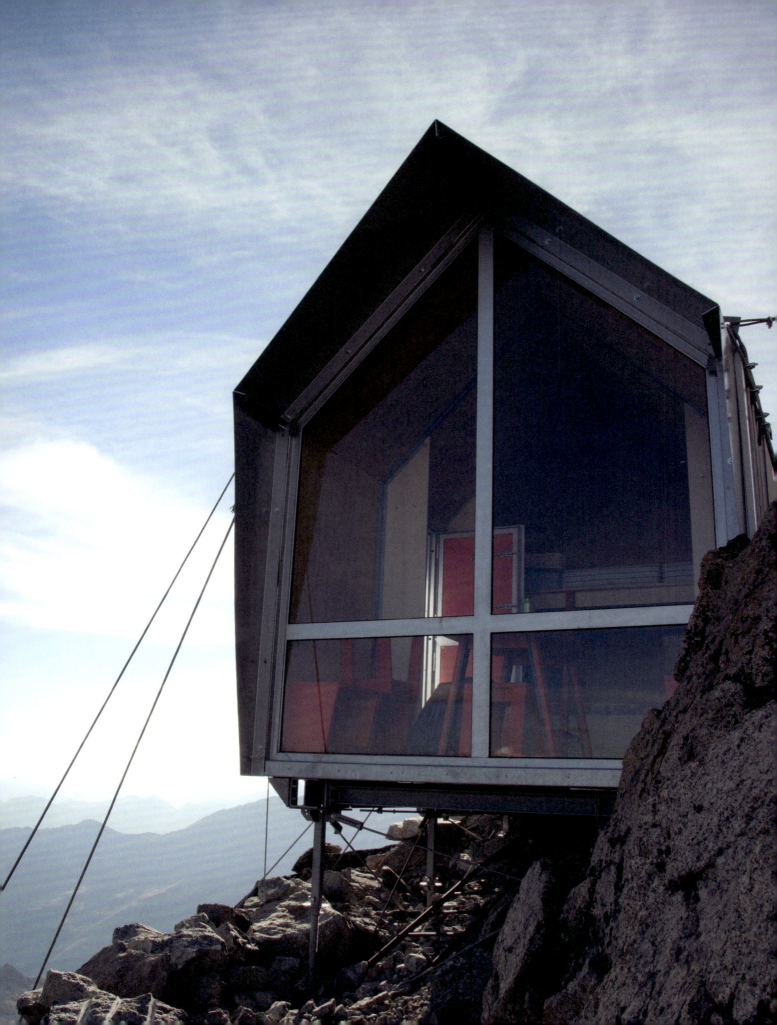

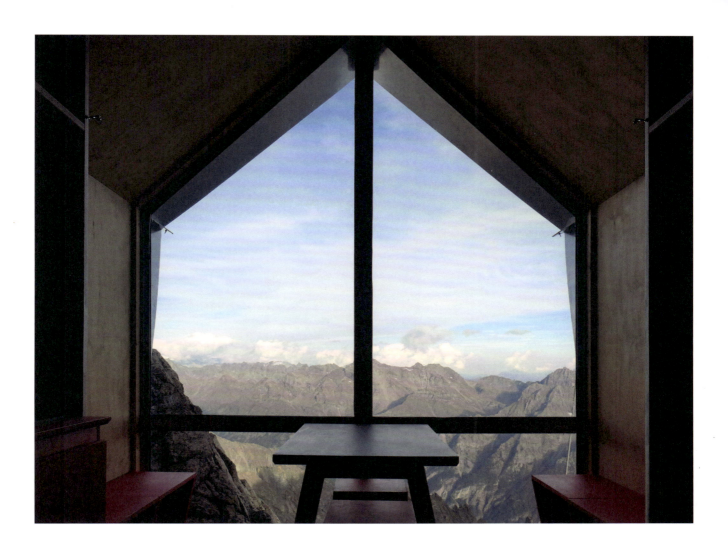

Courageous climbers can immerse themselves in breathtaking views through a panoramic window that also lets in an ample amount of natural light and warms up the interior.

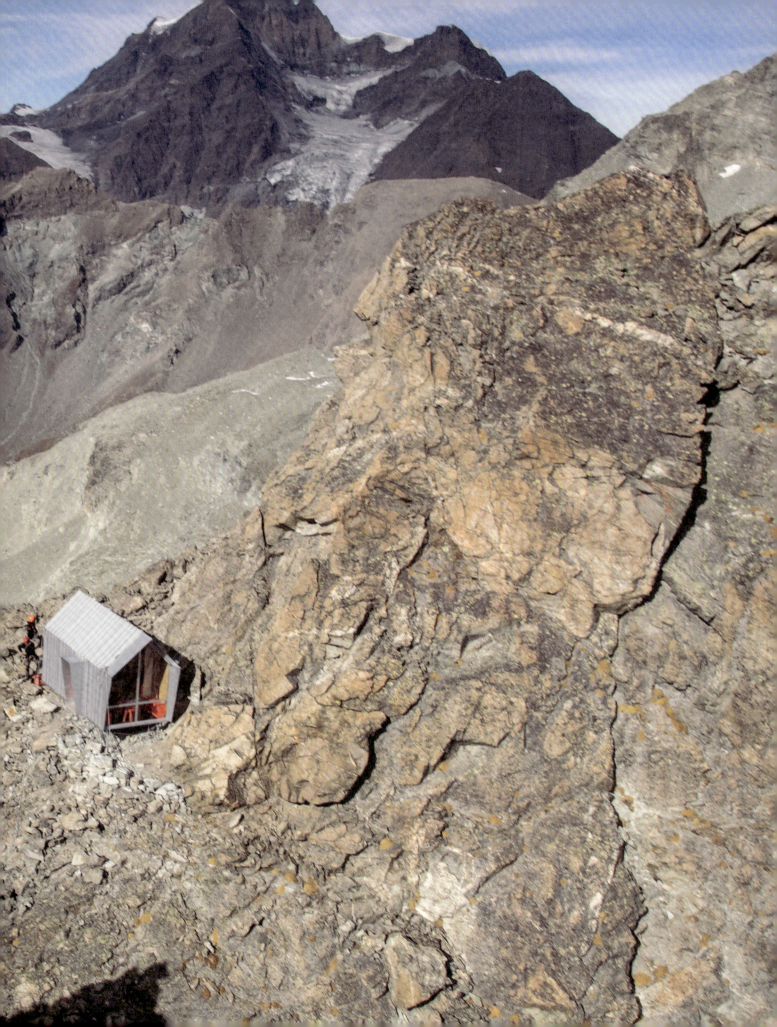

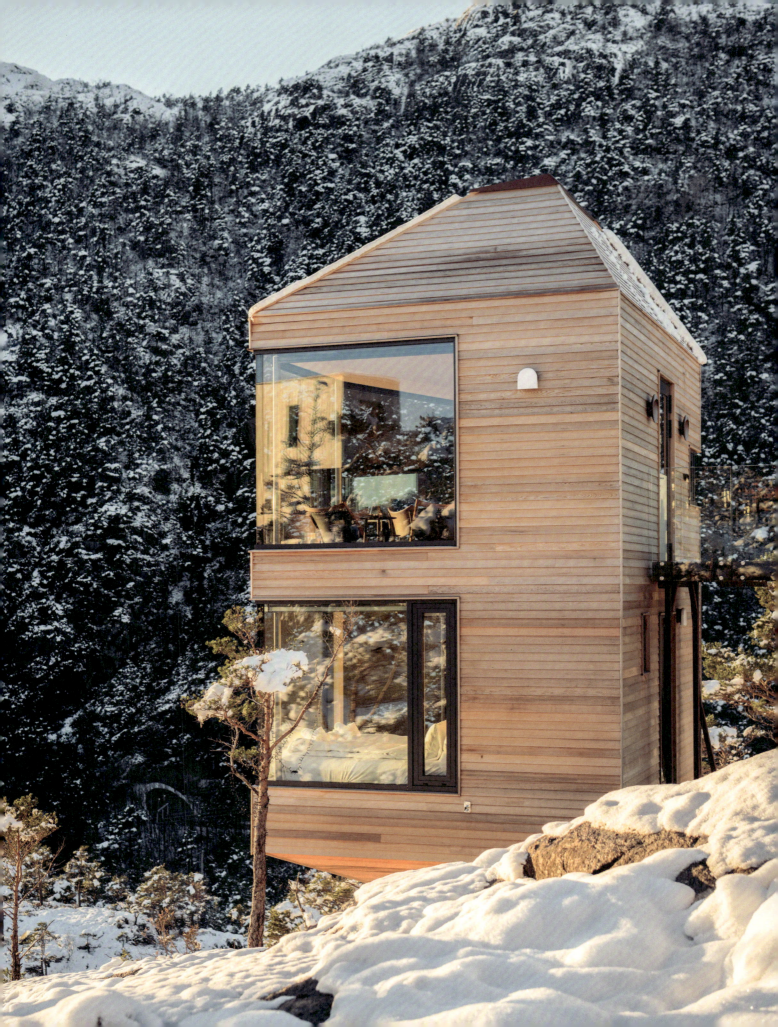

THE BOLDER
LYSEFJORD, NORWAY

The Lysefjord is one of the most scenic fjords in Norway, so it creates a perfect setting for The Bolder Lodges, which literally hover over the fjord to minimise the impact on the untouched ground. This raised position also enhances the experience of being immersed into nature. Additionally, as the architects of the Snøhetta studio explain, "The Bolder Lodges have a mirrored design, which means that the roof and underside have the same design for the visual effect of weightlessness." Protruding from the pine trees, they offer stunning views of the mountains and the fjord. The lodges are located close to the Pulpit Rock (Preikestolen), a spectacular viewpoint at the height of 604 metres above sea level, which is only one of many natural attractions for hikers in the region. Many of the hikes are of moderate difficulty and suitable for walkers in good physical condition. There are also more challenging routes, like the hike to Kjeragbolten, a rock wedged in a deep gorge several hundred metres above the fjord. Most of the trails are open all year round but in the winter months guests are advised to hire a local guide.

Raised from the terrain, The Bolder cabins vary in size and shape. The Star Lodges have tall ceilings and large panoramic windows that are particularly striking in the bedroom. The bigger Grand Lodge, a new addition to the project, houses two double bedrooms and offers a lounge and dining area that can comfortable accommodate up to 12 guests. And last but not least, the most impressive two-floor Sky Lodges, designed by John Birger Grytdal, welcome guests with a 180-degree view and skylight window in the main bedroom. "With fully adjustable beds you are as close to sleeping in the clouds as you will ever get," emphasise the owners. Both the outer shells of the multifaceted volumes as well as their well-lit interiors are made of natural materials, with brightly hued wood as the dominant material to fuse the architecture with the surrounding landscape. The elegant and comfortable interiors in a pared-down colour palette have been furnished in collaboration with leading Scandinavian companies Vipp, Eikund and Expo Nova. The Scandinavian charm and timeless elegance of the furnishings work perfectly with the surrounding scenery, which becomes part of the cabins' interiors thanks to the large and generously planned openings. The lodges can be easily reached by car. There is a road leading all the way up to the lodges for unloading luggage, with a parking area located 100 metres down the road.

ACCESSIBILITY
Easily accessible by car with the town of Jørpeland nearby and a 50-minute drive from Stavanger.

ARCHITECTURE
Snøhetta, 2020-2023
LOCATION
Lysefjord, Norway

ALTITUDE
750 m
NUMBER OF BEDS
3 Star Lodges: 2 each
1 Grand Lodge: 4
2 Sky Lodges: 4 each
INFO
www.thebolder.no

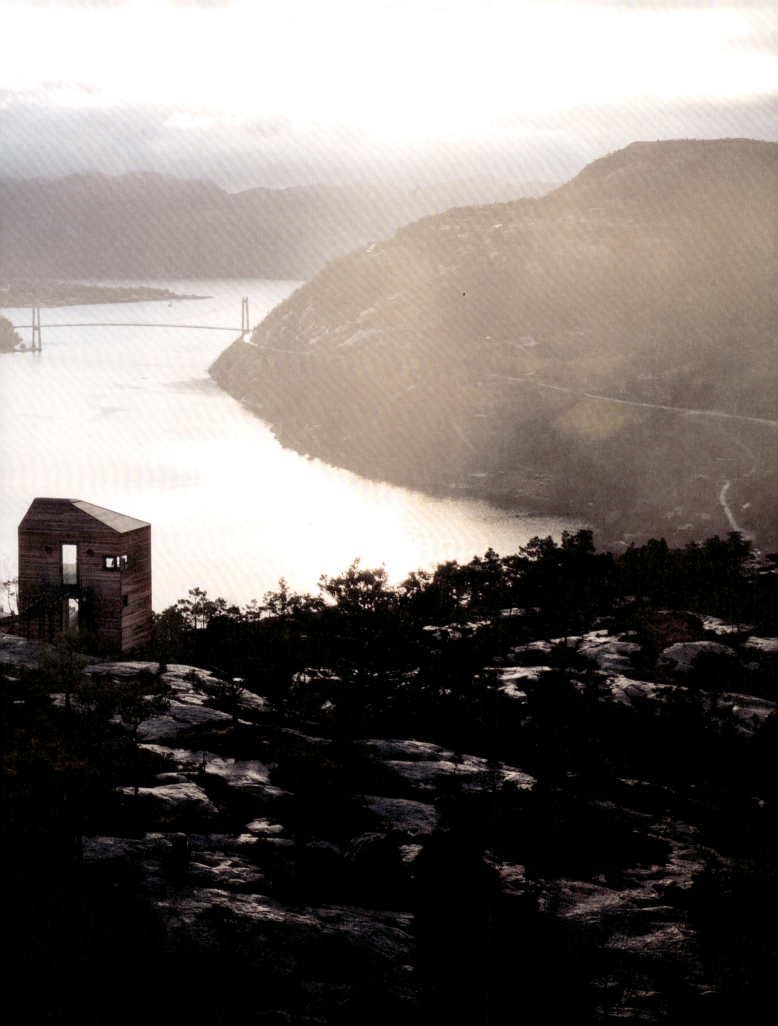

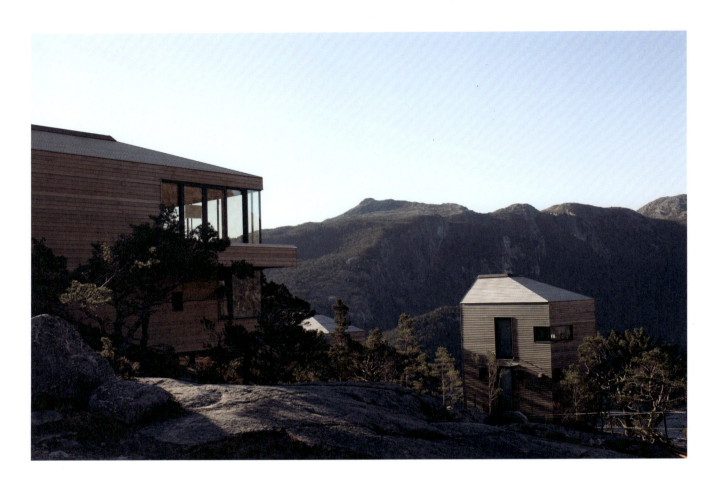

Both the outer shells of the multifaceted volumes as well as their interiors are made of natural materials, with brightly hued wood to fuse the architecture with the surrounding landscape.

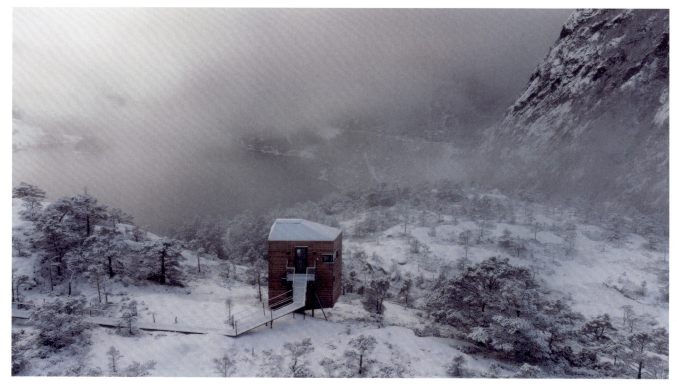

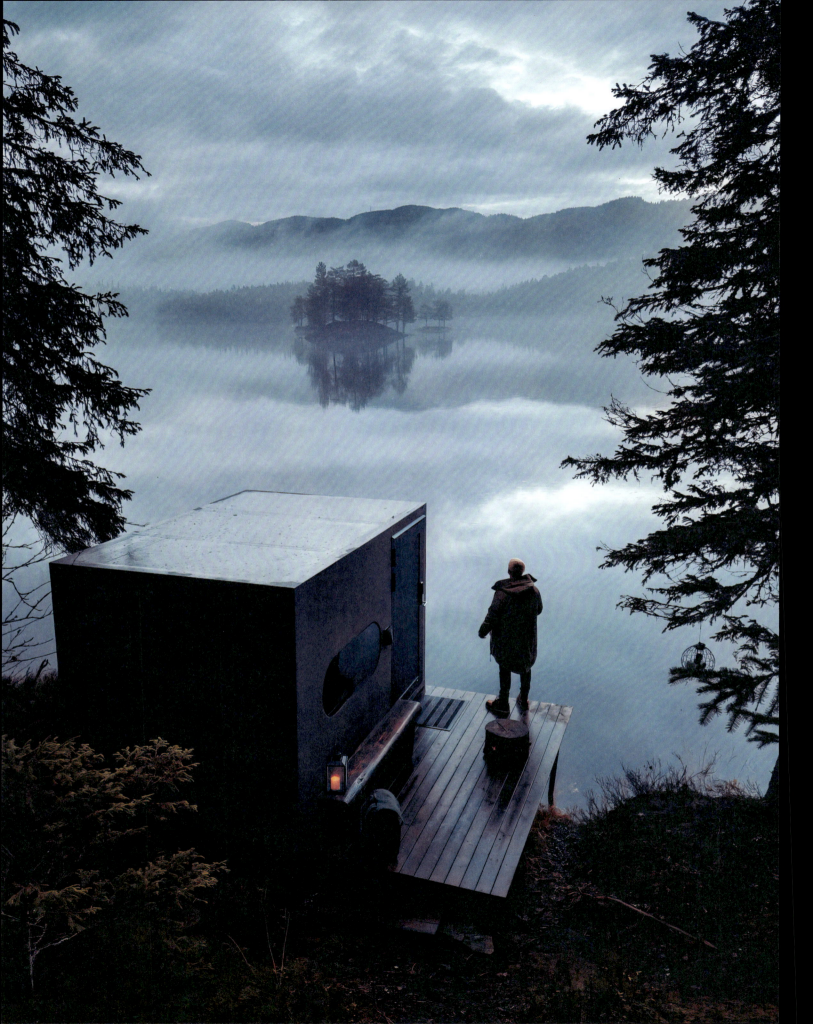

BIRDBOX
VARIOUS LOCATIONS IN NORWAY & SWITZERLAND

"Birdbox is a glamping product designed for the growing adventure tourism," explains Livit, the producer of the very smart cabin called Birdbox, available in two sizes. This hotel room in a remote location is a prefab construction, delivered to the plot fully furnished with fixtures, bed linens, electrical setup, and adapted columns for installation. Thanks to the fact that the cabins are made of carbon fibre (just like Formula 1 racing cars), with an aluminum door and tempered glass openings, they can be placed in some of the most challenging locations – they have been envisioned to create minimal interference with nature. Not only are they small and therefore light for transportation, but they can also withstand extreme weather and do not need much maintenance. As they are installed on special columns, the cabins have a minimal impact on the ground and can be easily removed or relocated.

The futuristically shaped windows open onto nature, while the intentionally dark interiors focus the guests' attention on the landscapes. The dimensions are modest – Birdbox Medi is 5,3 x 2,25 x 2,25 metres and offers a comfortable stay with all the essential elements. Inside, there is a continental bed with storage, a kitchen counter with a sink, as well as two lounge chairs and a key side table surrounded by panoramic windows.

The Mini version is 3,5 x 2,25 x 2,25 metres and comes without a kitchen or lounge area. The Birdbox bathroom is a minimalist toilet in a separate volume with black tinted glass in front to complement the cabin. All is planned to make the off-grid stay as sustainable and self-sufficient as possible. Found in numerous locations across Norway and one in Switzerland, they allow hikers to spend the night immersed in nature. The routes to reach each of the locations are different but generally present a moderate difficulty, so that Birdboxes are available in all seasons – the cabins are open throughout the year – for the average hiker. They are all located in the mountains, fjords, and often close to lakes, so visitors can enjoy not only hiking sessions but also taking a dip into the water in the summer or birdwatching. Some are enveloped by greenery, while others sit high, often on rocky mountaintops with epic views, like Birdbox Storehesten at the base of the Majestic Mount Storehesten. Winter, although more challenging yet equally picturesque, can also offer an experience that is both adventurous and cosy.

ACCESSIBILITY
Varies for each cabin, but of moderate difficulty.

LOCATION
Fauske, Langeland, Tokke, Storehesten, Sotra, Arbakka, Fjellvaak, Eikefjord, Lote, Reksta, Amli (Norway), and Curzútt (Switzerland)

ALTITUDE
Varies for each cabin, between 200 and 600 m.
NUMBER OF BEDS
2 each Birdbox
INFO
www.birdbox.no

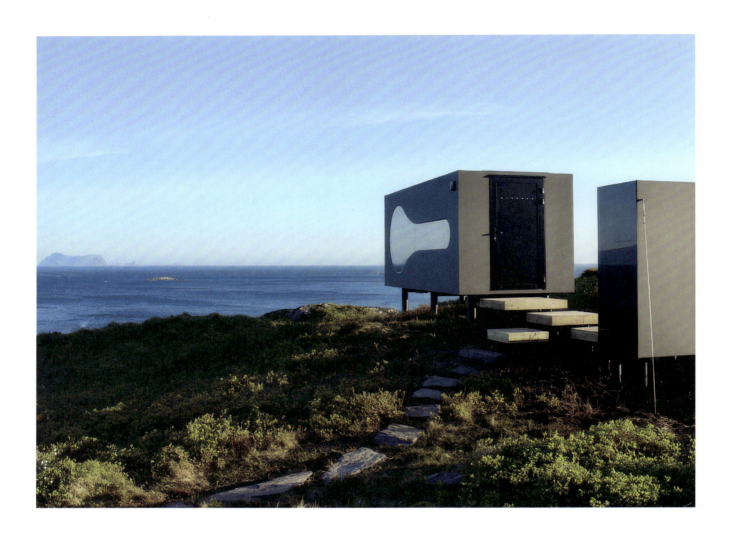

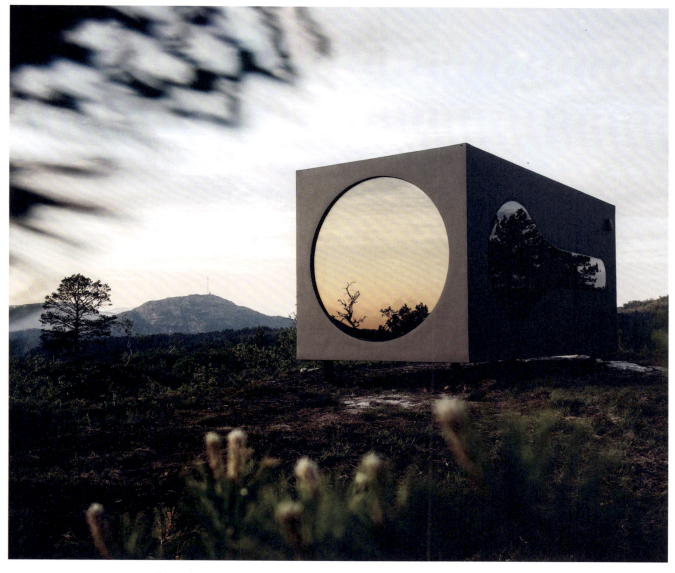

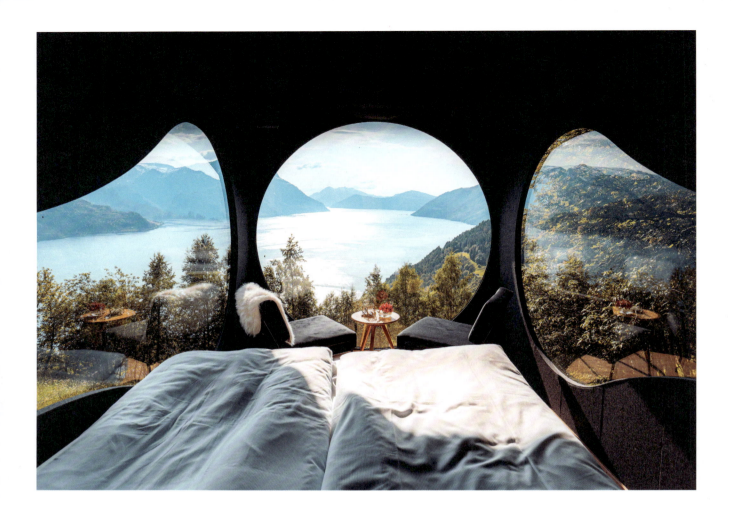

The futuristically shaped windows open onto nature, while the dark interiors focus the guests' attention on the landscapes.

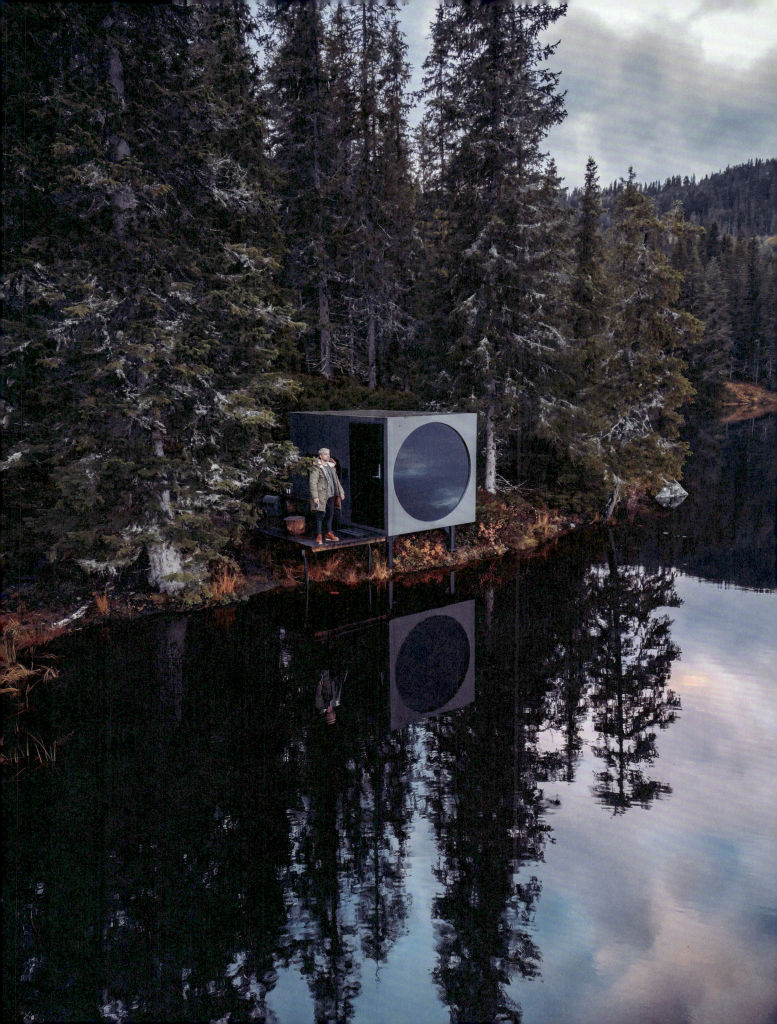

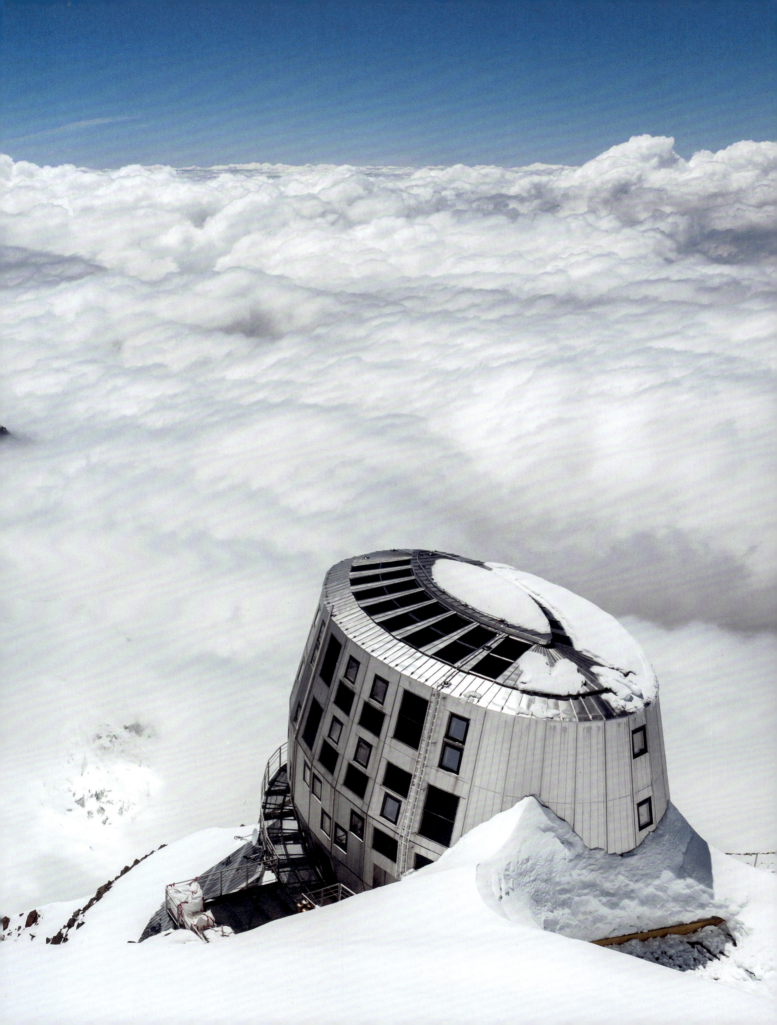

REFUGE DU GOÛTER
AIGUILLE DU GOÛTER, FRANCE

This is the highest guarded mountain refuge in France and a popular starting point for hikers planning to climb Mont Blanc – there is nearly no alternative for the last stage before the summit. The massive grey building covered with metal has an original shape that is pierced with numerous openings, allowing guests to admire the panoramic vistas. Perched above the Grand Couloir, and built with an exceptional budget of six million euro, this mountain hut was inaugurated in 2014. The very first refuge at the location, a simple hut, dates back to 1854 based on the initiative of Doctor Charles Loiseau "to allow mountaineers to sleep one night at the top of the mountain, Aiguille du Goûter, before leaving the next morning at dawn to complete the ascent of the roof of Europe." Over the decades, mountaineers saw the development of the shelter for the constantly growing number of climbers. The fancy architectural form of the current building is not the only innovative element. The refuge was envisioned in a very sustainable way, with solar- and wind-powered electricity, triple glazing for the best insulation, and recycled water (there is no running water, however, even in the lavatories). The accommodation options in the refuge include half-board, bed and breakfast, or bed-only. For those with their own food, there is a so-called 'picnic room' but guests cannot cook. Dorms are equipped with duvets and pillows, but hikers must bring a personal sleeping sheet with them (or buy one in the hut).

Hikers need to plan their trip in advance and pre-book their stay online, as those who have not done so will not be let inside. The hut's website explains that there are special trains dedicated to mountaineers planning to climb Mont Blanc via the 'normal' Goûter Route, also called the Cristalliers Route or even the Royal Route – from Le Fayet on the ascent, and Le Nid d'Aigle on the way down. The train tickets should be booked online and travelers need to double-check the complicated boarding validation procedure. Depending on the weather conditions, Refuge du Goûter is open between mid-May or the end of May and the end of September. Interestingly, the average usage during the staffed period is 9000 overnight stays. Many hikers are accompanied by high mountain guides. In the winter, as it is unstaffed, only a small part is available, with beds, blankets, and dishes, that can accommodate up to 20 hikers. This winter shelter is located in the annex.

ACCESSIBILITY
The challenging route leading to the hut as well as its high altitude make it a spot for advanced hikers only, particularly in the winter.

LOCATION
Aiguille du Goûter, Alps, France

ALTITUDE
3817 m

NUMBER OF BEDS
120 (season)/20 (off-season)

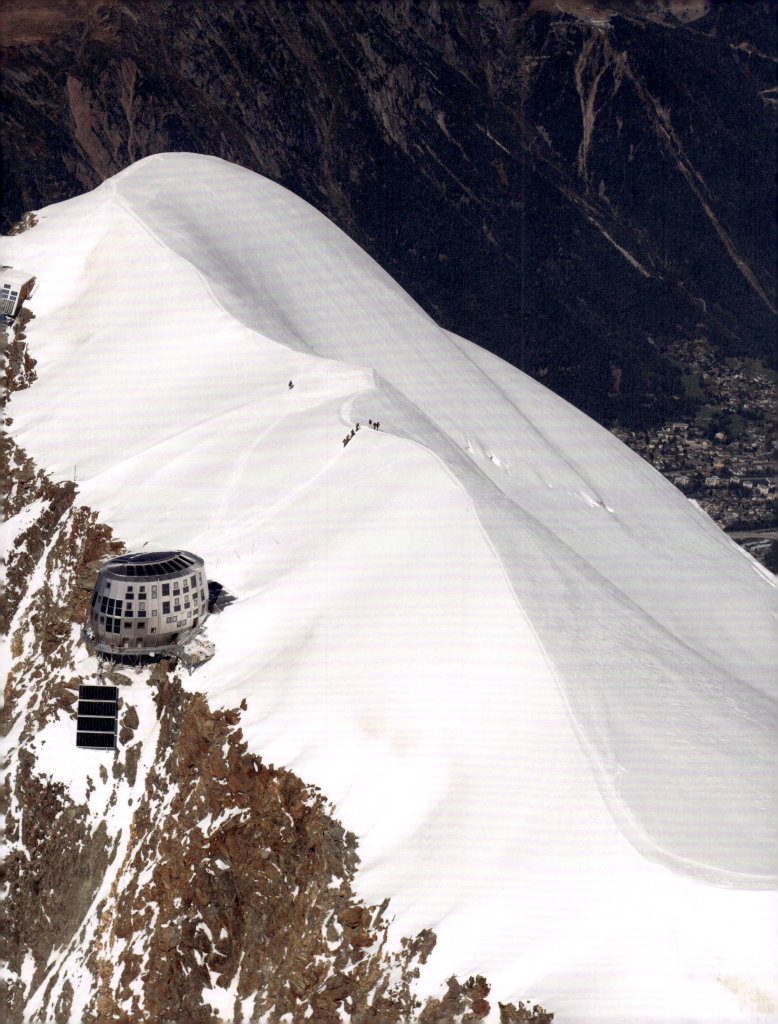

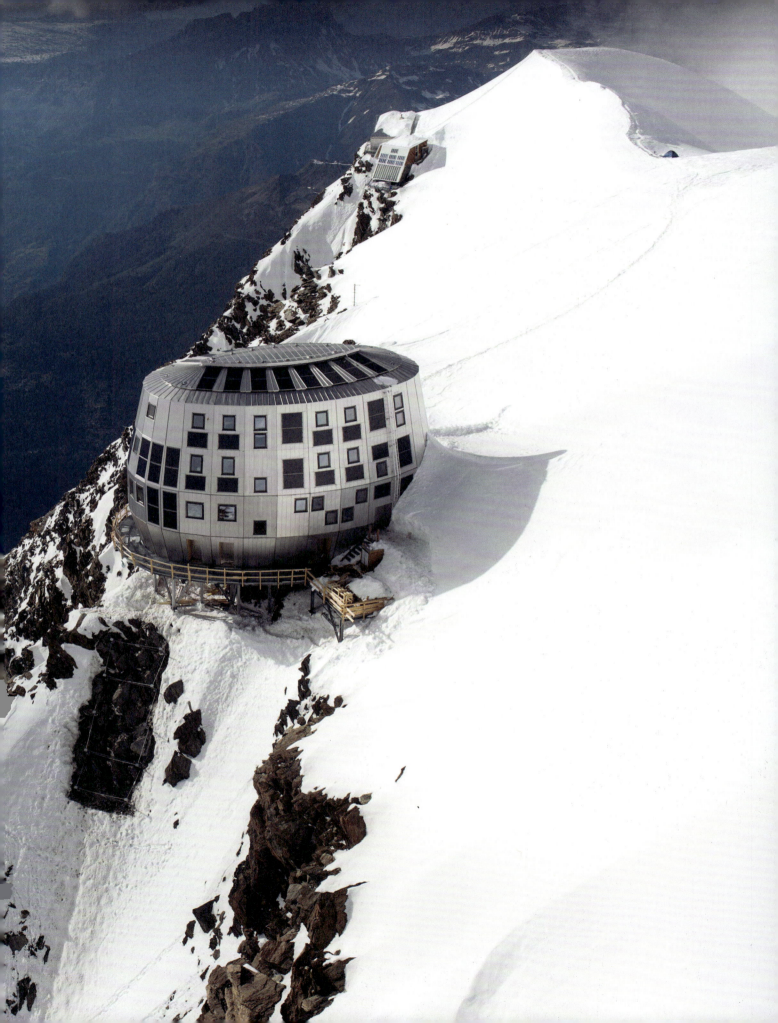

MOUNTAIN & CLOUD CABINS
YICHANG, HUBEI PROVINCE, CHINA

An interesting collection of 18 cabins with a cafe house and a swimming pool sit on wooded slopes, with a touristy mountain village of Hubei province at the foot. Placed cosily among the lavish greenery, the cabins are certainly not closed off from the views. Most striking are their shapes, often embraced by clouds, and the mirroring effect of the façades. Stacked on the hill, the huts range from 35 to 65 square metres and are available in several different types. The Bridge type takes the form of a 14-metre-long bridge that is suspended above a tea field and features a courtyard terrace. The vertical (14-metre-high) Loft type has two floors and is reminiscent of a multifaceted gem. Cabins of types T and Y have a so-called viewfinder layout, with their bathroom, bedroom and living area facing the panoramic mountain view of Deng Village, including spectacular sunsets.

Made of timber, the cabins are prefabricated using the mature HBE glue-laminated timber panels system, and their main structures can be assembled in one day. Not only does this provide structural strength but it also ensures a low deformation rate of the wood. The cabins use "a floor heating system and a fresh air system with an air exchange rate of 100 cubic metres per hour," explain the architects. "Energy consumption and somatosensory design make the cabin a container for breathing in nature," they add. The interior design, in the spirit of Nordic minimalism, features natural wood textures and was planned by Shanghai EERI studio and Ximan Design. Mu Wei, the leading architect in the project, used his experience of living in Norway in the design process. As the mountainous setting reminded him of the Norwegian aurora, he decided to make the architecture disappear into the natural surroundings. The volumes indeed seem to fuse smoothly with the landscape thanks to the mirrored metal plates as well as wooden grilles on the outer shells. The visual effects change depending on the time of the day and the sun's path. "They are the viewfinders of nature and breathe freely in the forest," reads the architects' statement. One of the goals of the architects was to create structures that would seem to be floating in clouds to enhance the feeling of being immersed into nature. One of the solutions to achieve this was placing the cabins on point foundations (with a system of columns in an inverted umbrella shape), which also demonstrates the architects' respect for the natural environment. A fantastic base for hikes in the surrounding tea fields and mountains, the cabins can be reached by a minibus from the village below.

ACCESSIBILITY
Easy, best reached by an urban minibus from the Yichang city centre, which is around one hour away.

ARCHITECTURE
Wiki World + Advanced Architecture Lab(AaL), 2019-2020

LOCATION
Yichang; Hubei province, China

ALTITUDE
1000 m

NUMBER OF BEDS
36

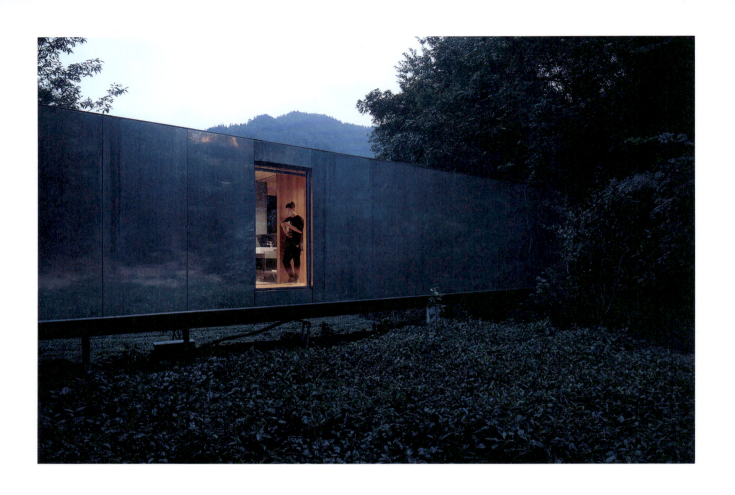

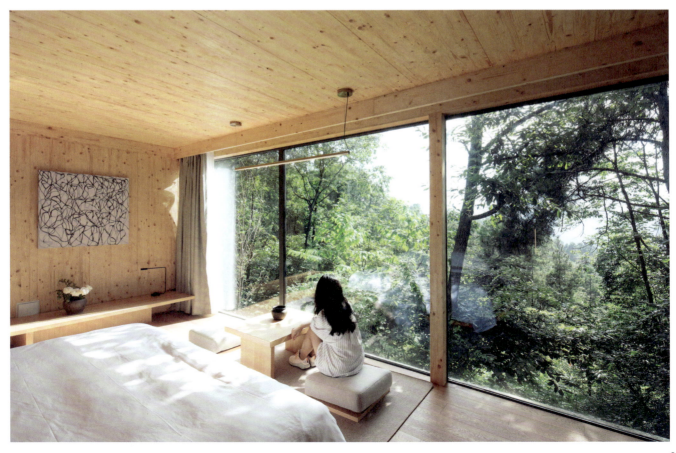

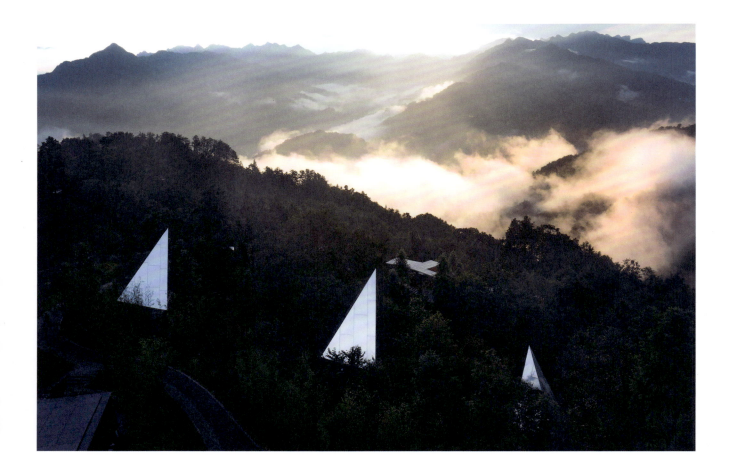

Most striking are their shapes, often embraced by clouds, and the mirroring effect of the façades.

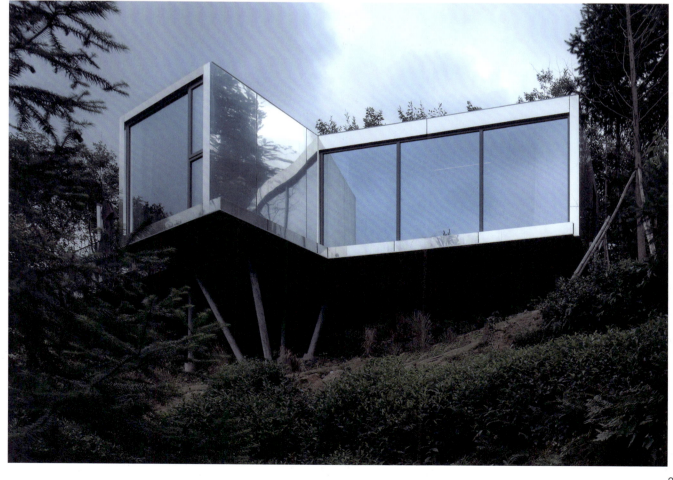

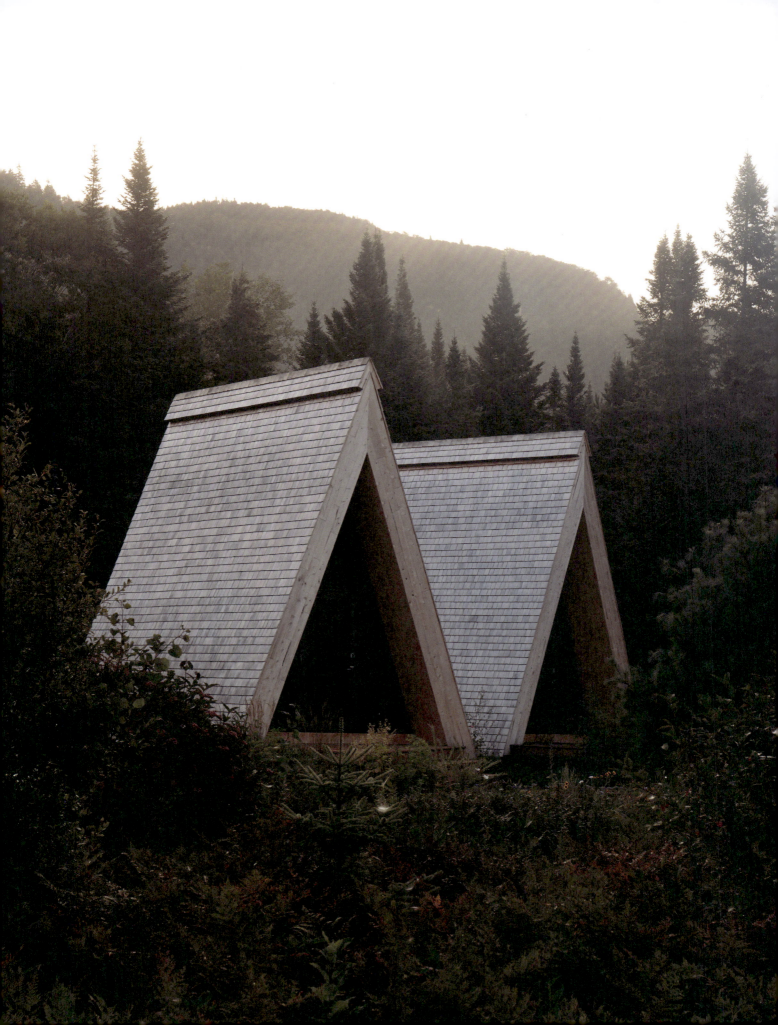

FAROUCHE TREMBLANT
LAC-SUPÉRIEUR, CANADA

Montreal-based studio Atelier l'Abri, which specialises in ecological, healthy and sustainable buildings, designed a group of cabins in the heart of Mont-Tremblant National Park. The project also consists of a Nordic farm with a barn and tunnel greenhouses, a cafe-bar, and an outdoor basecamp. The untouched wilderness of the dense wood presents itself as the perfect setting for the pitched-roof wooden cabins, which are connected to each other across the site by a winding path. The cabins designed by the architects to recede into the landscape offer an immersive experience to the hikers. Both tall and compact, the cabins are cosy nests dominated by natural wood and a sober colour palette. The furnishings provide all that is needed for a comfortable stay – a king bed, sofa and gas stove, particularly attractive in the winter months. The dynamic shape of the roof creates a strong feeling of being sheltered and, as the only openings are located in the A-framed façades (the entrance is fully glazed), the whole focus is on the pristine nature outside. In the summer, after a hike or a paddleboat session, guests can spend time on the extensive terraces. The cabins are not equipped with bathrooms, which are located at a 30-to-60-second walk from the refuge.

During their stay, guests can buy natural products from the farm or enjoy the cafe, a spacious meeting point at the very centre of the site. "The cafe lounge opens towards the river: its large west-facing windows offer unique views of Mont-Tremblant and sunsets behind the Laurentian mountaintops," remark the architects. Located in the Devil's River Valley, the Farouche Tremblant is a perfect base for exploring the surrounding mountains. Many hiking trails begin just behind the agricultural building, and guests can simultaneously enjoy Lac-Supérieur. Respect for nature was a key element for the founders, who clearly note: "By visiting us, you are helping us to care for the natural world around Farouche. We ask each and every one of our customers to apply the ethical principle of NO TRACE." The cabins are easily reachable by car. The parking area is designated at the rear of the huts within a one-minute walk, and the guests are offered a large-wheeled cart to move their belongings in and out of the cabins.

ACCESSIBILITY
Easily accessible by car.

ARCHITECTURE
Atelier l'Abri, 2022
LOCATION
Lac-Supérieur, Canada

ALTITUDE
180 m
NUMBER OF BEDS
7 x 2
INFO
www.farouche.ca

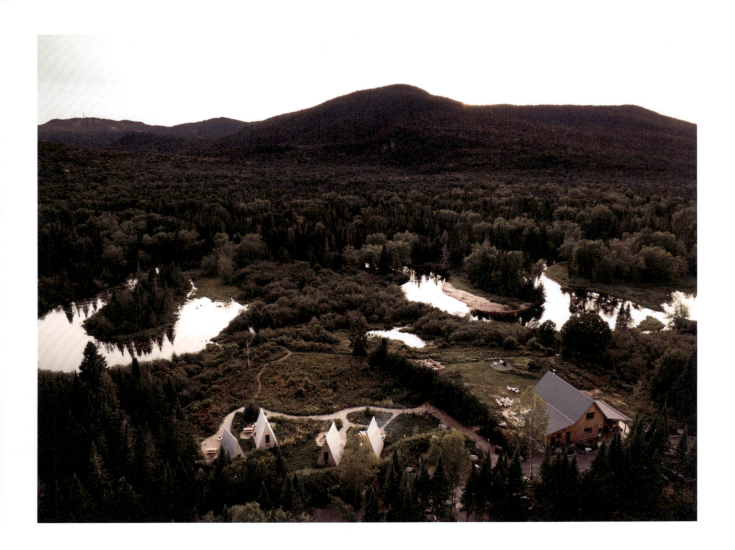

The untouched wilderness of the dense wood presents itself as the perfect setting for the pitched-roof wooden cabins, which are connected by a winding path.

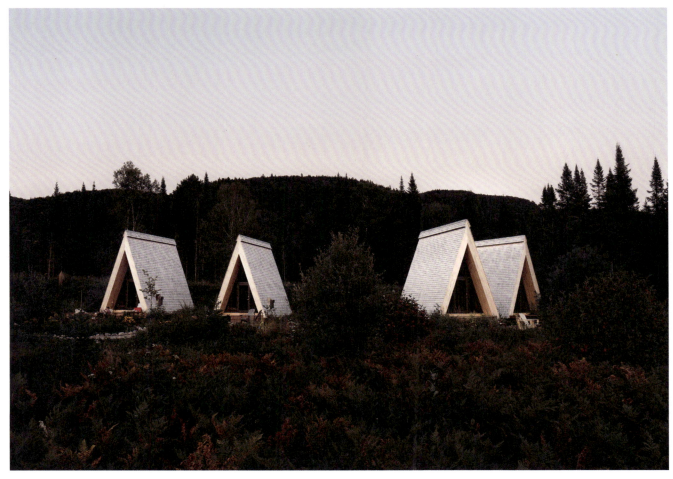

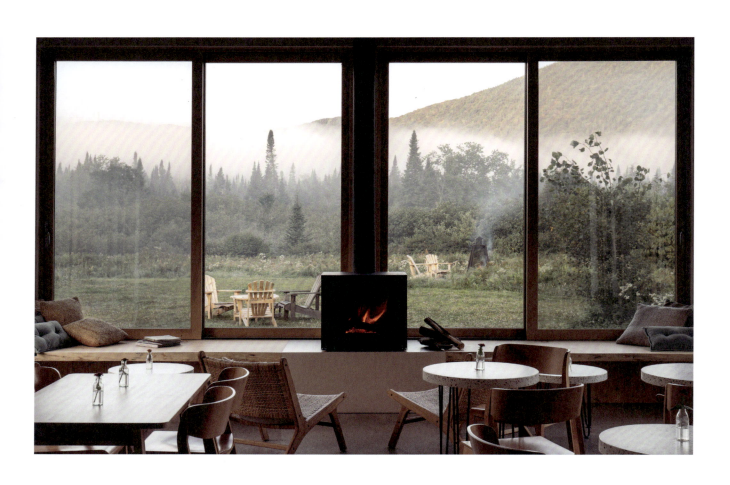

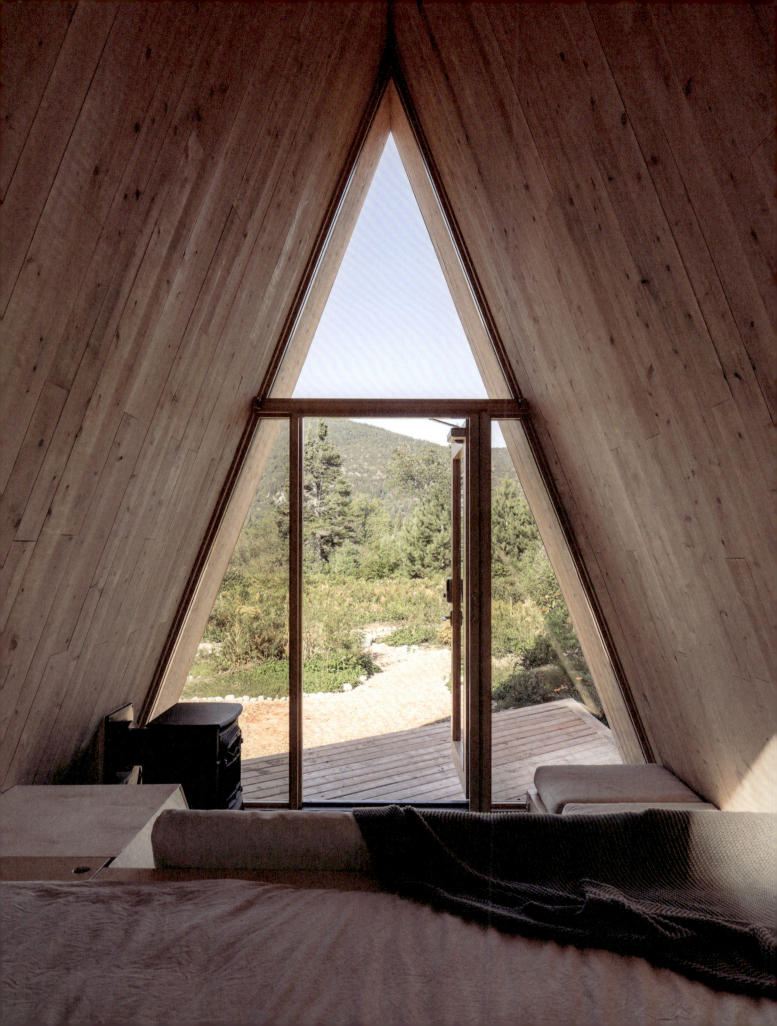

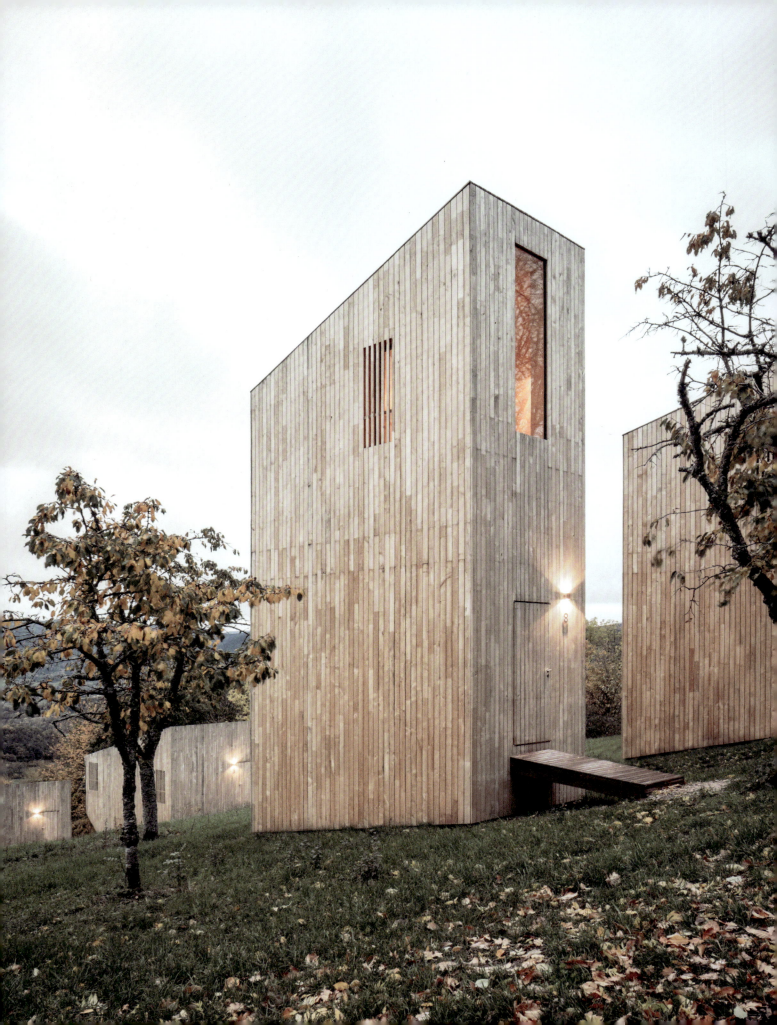

48° NORD LANDSCAPE HOTEL
BREITENBACH, FRANCE

Sitting in the picturesque landscape of the Vosges Mountains, the Landscape Hotel overlooks the Alsatian village of Breitenbach. The group of 14 cabins, perched on hills and designed by Norwegian architect Reiulf Ramstad, is a reinterpretation of a traditional Scandinavian hytte. Envisioned as a place to reconnect with nature, the architecture is highly sustainable and planned with respect for the natural environment on the protected site – including solutions like rain water collection, which is later treated through a reed bed filtration system. The complex of distinctive volumes also includes the main building, with reception, a restaurant, wellness facilities and the director's house. The main goal of the architects, Reiulf Ramstad Arkitekter in collaboration with ASP Architecture, was to make the design blend seamlessly into the landscape without getting lost in it. "The Landscape Hotel was specifically designed to fit into a preserved setting without disturbing it," emphasises the hotel's founder. The use of untreated certified wood (sourced locally) as well as the dynamic shapes that echo the silhouettes of hills (with green roofs) make this vision coherent. Each hytte is installed on piling and can be disassembled if needed. Following an environmentally friendly approach, the hotel runs an entirely organic and homemade restaurant, using produce from local suppliers as well as its own vegetable garden.

The cabins vary in size and range from 20 to 60 square metres. What makes the facilities more flexible for the guests and also visually more interesting for the mountainous landscape is the diversity among the types of cabins. The multifaceted Gress hyttes blend into the surface of the slope, with the main feature of a panoramic window opening onto a balcony to plunge visitors into the surrounding nature. The Eføy hyttes, explains the hotel owner, are "like ivy that twists, snaking in and out of the hedges" and "blend into the branches in the grove." The large windows also play a main role in blending the inside–outside division. Most curious are the Tre hyttes, which are very narrow volumes intertwined between the trees. With a gigantic opening in the façade, they resemble periscopes overlooking the valley. Last are the Fjell hyttes, located at the very top of the hill but hidden from sight and surrounded by woods. Featuring two terraces and a sauna with a view or a Nordic bath, these are the biggest cabins in the hotel. The minimalist interior design shared by all the hyttes excludes superfluous elements without compromising on comfort. The use of natural materials, soft fabrics, a bright colour palette, and functional yet elegant furniture guarantees a pleasant stay and works perfectly with the natural setting.

ACCESSIBILITY
As the cabins are located not far from the village, they are easily accessible by car or bike, or on foot. Hikers can begin many excursions from the hotel to explore the Vosges Mountains (or enjoy skiing in the winter). Trails are mainly recreational and of moderate or easy difficulty.

ARCHITECTURE
Reiulf Ramstad Arkitekter, 2020
LOCATION
Breitenbach, France

ALTITUDE
510 m
NUMBER OF BEDS
30
INFO
www.hotel48nord.com

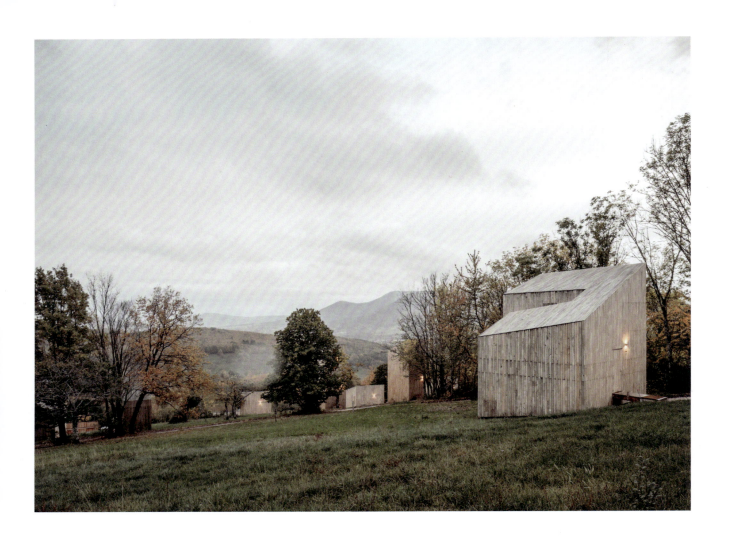

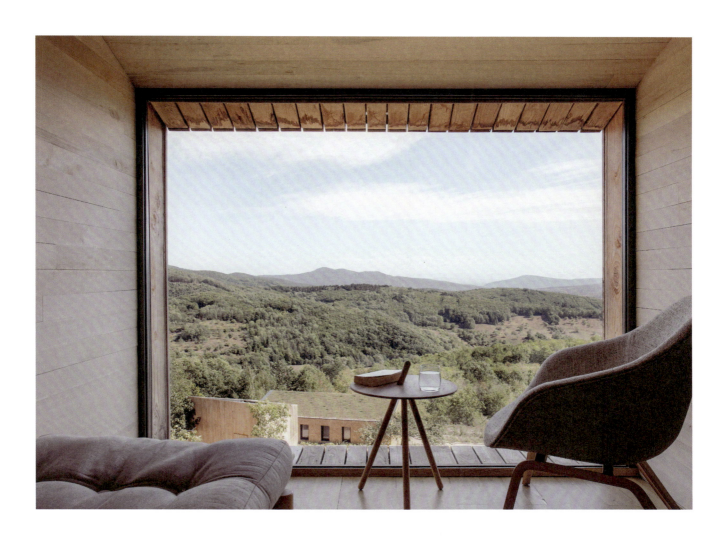

The large windows play the main role in blending the inside–outside division.

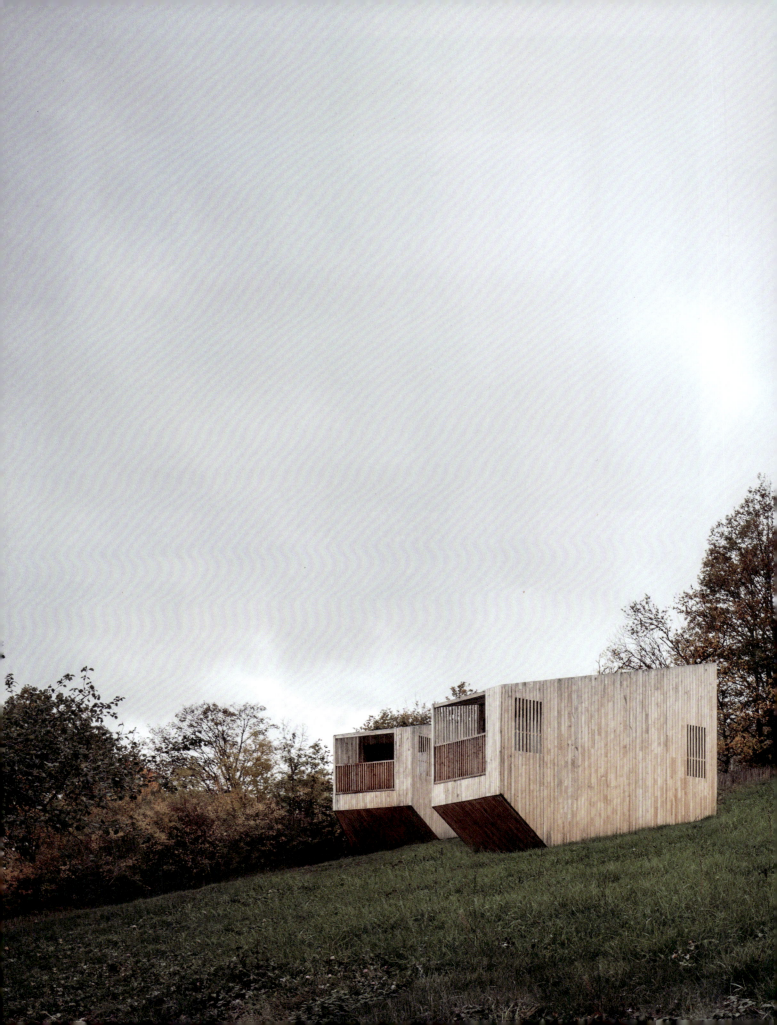

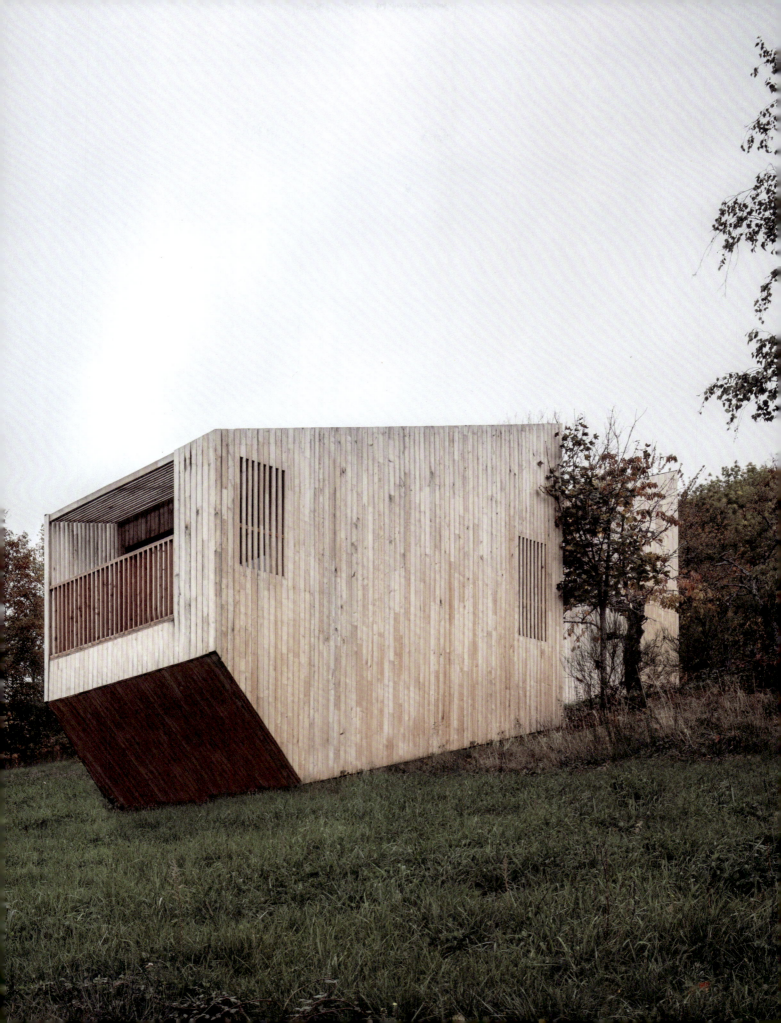

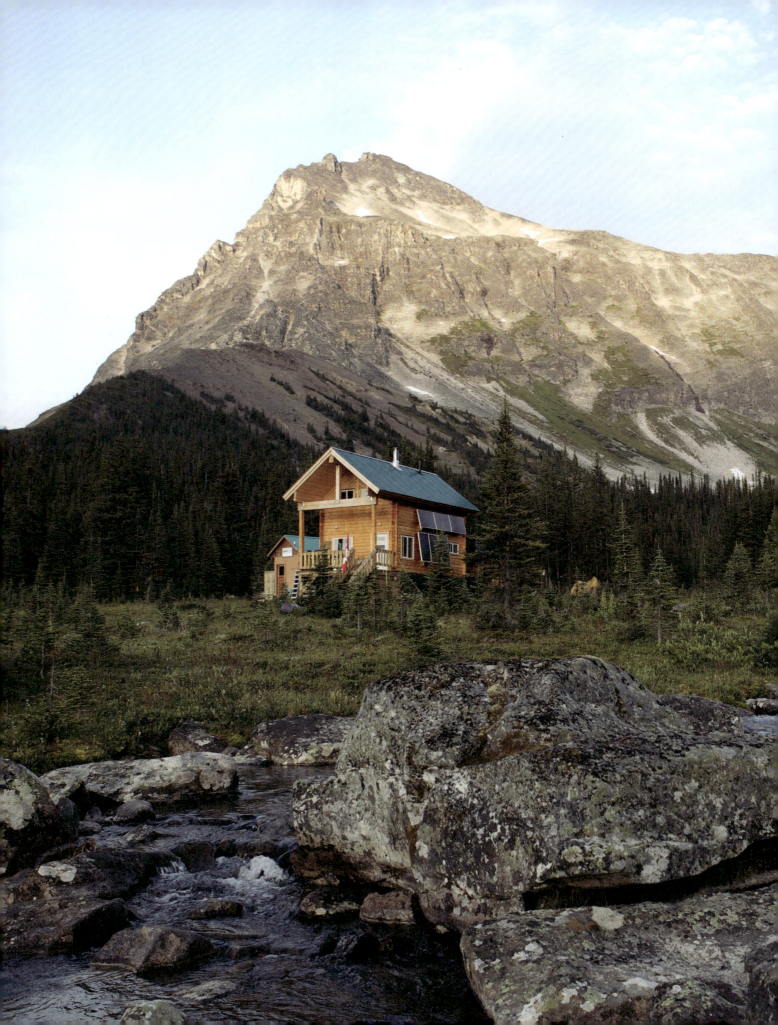

MALLARD MOUNTAIN LODGE
ROCKY MOUNTAINS, CANADA

The scenic lanscapes and equally impressive remoteness are definitely assets of this wooden lodge in the heart of British Columbia in Canada. Many guests find the vast terrain, untamed wilderness and striking quietness to be surreal. "On arrival at the Lodge, our guests find themselves enthralled by the remoteness and awed by the spectacular scenery," remark the hosts, the McManus family, whose members have years of experience operating adventure tours in western Canada, and have a great passion for the nature of British Columbia. To get to the lodge one has to take a 30-minute helicopter ride from Valemount – even this first part of the trip shows how exceptional the spot is. There are literally no roads in or out to this lodge, sitting deep in the western ranges of the Canadian Rockies and surrounded by lush woods and genuine wilderness. Upon arrival, guests are led through a short orientation before heading out for an afternoon hike or tour, and then coming back for dinner and settling for the night. Delicious meals are provided, and guests can enjoy mountainous adventures throughout the day before meeting at the table in the evening.

Open all year round, the lodge offers comfortable accommodation as well as a wide range of outdoor activities. Trekking and exploring various trails, especially for the first time, in such a remote place with only a few companions – not counting grizzly bears – is quite an experience. Numerous creeks, lakes, waterfalls, and extensive meadows and glaciers provide spots for hiking. In the winter this pristine place turns into heaven for skiing aficionados. The west slope of the Canadian Rocky Mountains is known for huge snowfalls of dry snow that is perfect for skiing and snowboarding. The solid lodge structure is made of wood and has a traditional shape with a pitched roof that creates a cosy and homey atmosphere, an effect also created by the wood stove in the living room. Mountain lovers are catered to and can be also guided by their hosts, so full relaxation is guaranteed. Various trails differ in difficulty level but can be adjusted to hikers' experience, although all guests need to keep the high altitude in mind. In the winter months, exploring the mountains is much more challenging and requires good physical condition.

ACCESSIBILITY
Accessible only by a 30-minute helicopter flight from Valemount, with no access road.

LOCATION
Rocky Mountains, Canada

ALTITUDE
1900 m

NUMBER OF BEDS
7

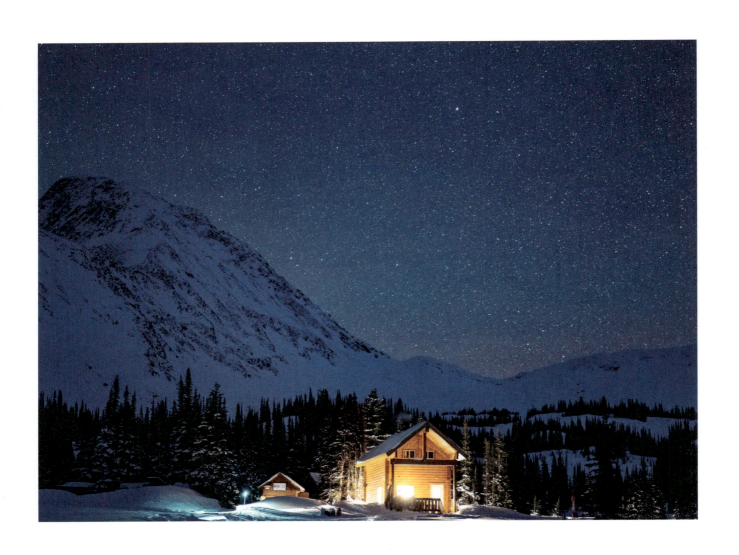

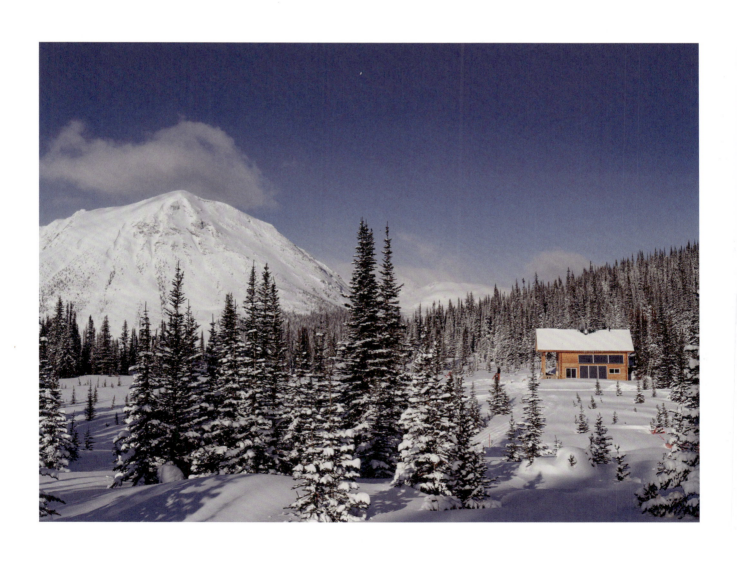

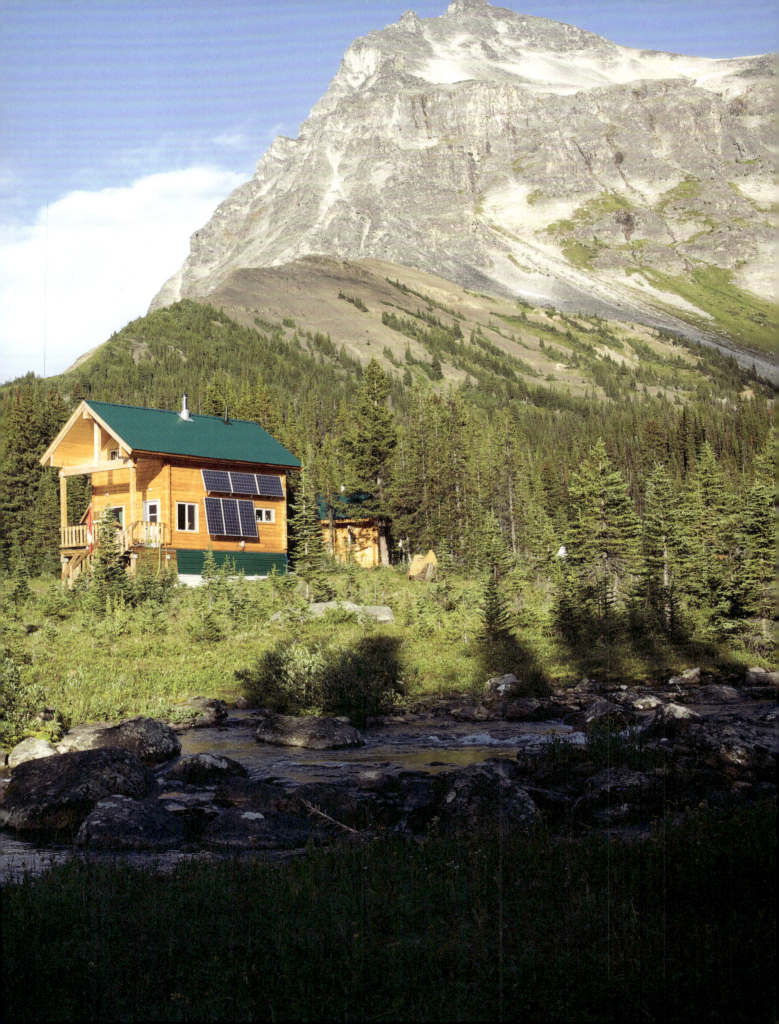

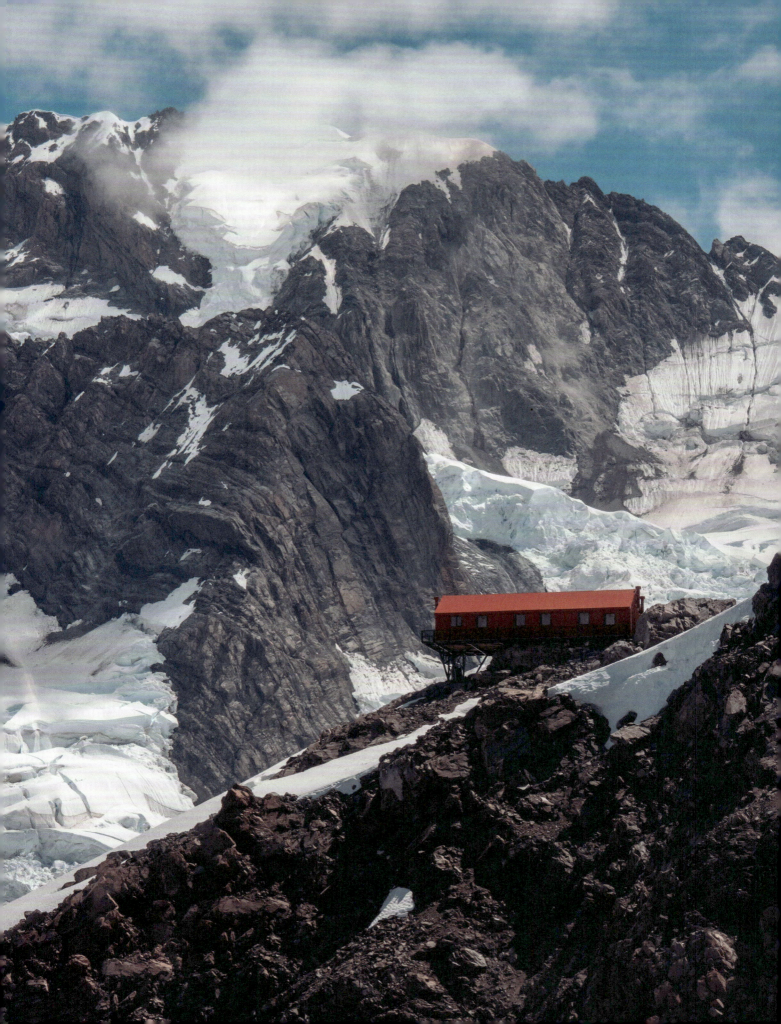

PLATEAU HUT
AORAKI/MOUNT COOK NATIONAL PARK, NEW ZEALAND

The Plateau Hut, one of the New Zealand's most-known alpine huts, sits on the flanks of Mount Cook. Ready to welcome 33 climbers and mountaineers, the hut is much more than a shelter – it offers an extraordinary experience. Suspended over a rocky slope, it is immersed into breathtaking scenery. Its red volume, drawing from traditional vernacular architecture, stands out against the snow-clad mountainous background. Within a 15-minute helicopter flight from the airport in Mount Cook village (located a 2,5-hour drive from Wanaka), one can explore the nearby Glacier Dome peak at the height of 2452 metre with panoramic views of the Tasman Glacier as well as the crevasses of the Grand Plateau – these trails require experience and alpine knowledge. It is important to know that there is always a risk of rock avalanches. Those that have recently occurred near the hut have been too small to reach it, but very rare large avalanches, such as might occur during an earthquake, could possibly hit the hut.

Plateau hut runs on first come first serve. While the hut is equipped with non-flush toilets and cooking facilities, the tap water is not treated, so it should be boiled before drinking. Plateau Hut is open for guests all year. The peak season for climbing Mount Cook is between November and early January, when the cabin tends to be very busy with mountaineers leaving very early to reach various nearby peaks. Professional organisers of trips to Plateau Hut emphasise the possibility of stargazing. The galactic core of the Milky Way is visible in the southern hemisphere from February to October with the brightest period during the winter months of June and July.

ACCESSIBILITY
Accessible only by helicopter from Mount Cook village, Plateau is an alpine hut mostly visited by experienced mountaineers and guided parties.

LOCATION
Aoraki/Mount Cook National Park, New Zealand

ALTITUDE
2210 m

NUMBER OF BEDS
33

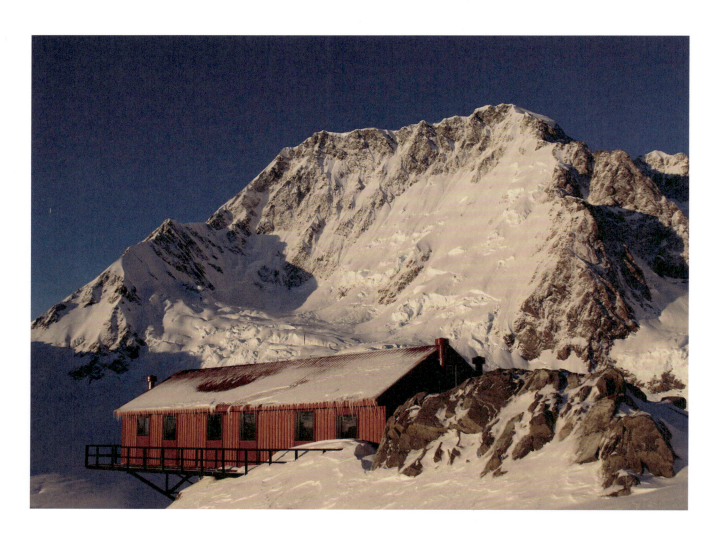

Suspended over a rocky slope, it is immersed into breathtaking scenery.

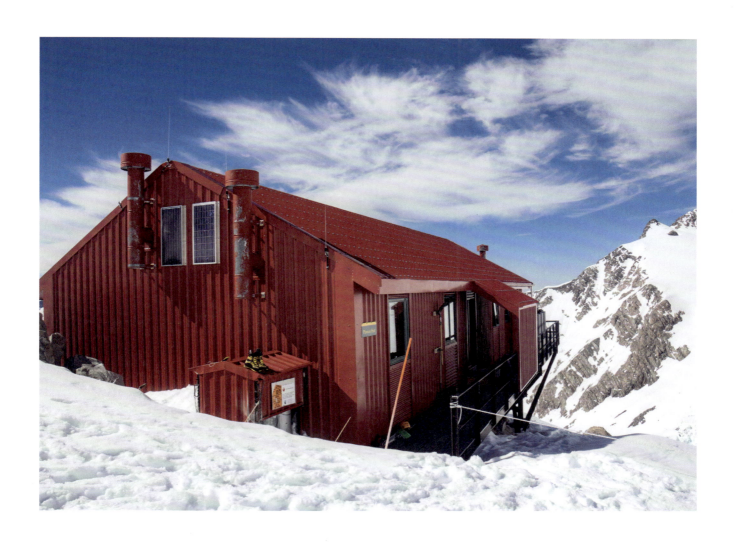

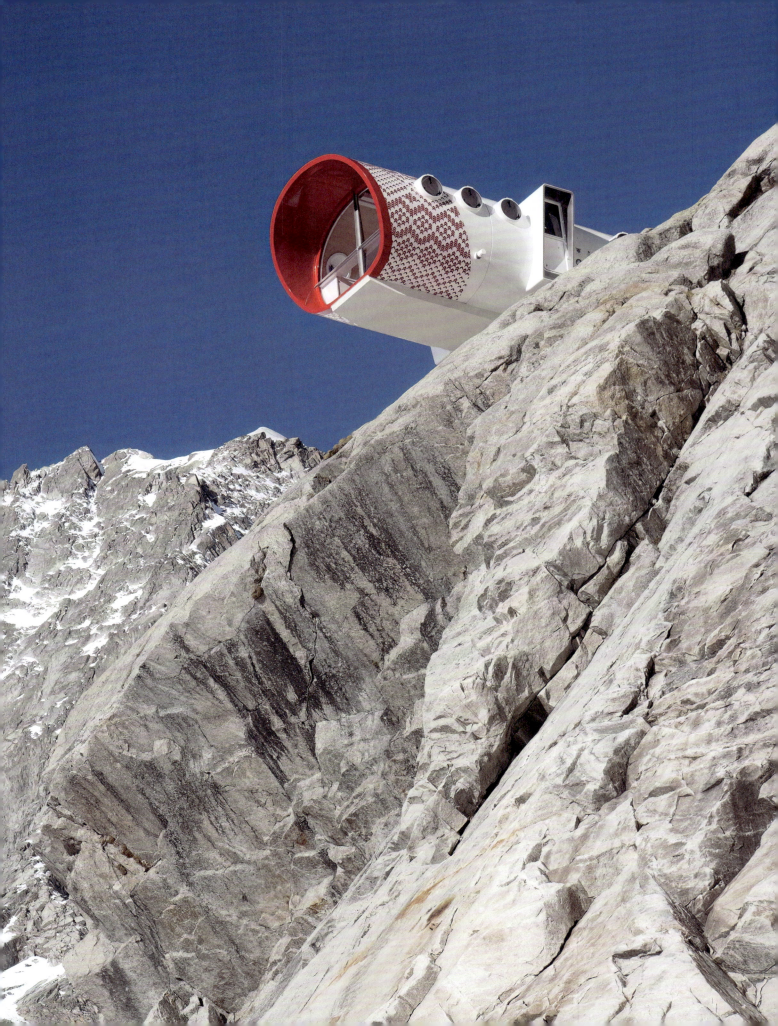

NEW GERVASUTTI BIVOUAC
FRÉBOUDZE GLACIER, AOSTA VALLEY, ITALY

Open permanently, this futuristic cabin is available for those experienced alpinists who can climb the 2800-metre-high rocks in truly challenging conditions. The approach is known for being long, tricky, and thus tiring, not to mention that there is no clear path, so it is easy to lose one's way. Boldly leaning out over the abyss, this bivouac is often chosen by advanced hikers as a basecamp for trails towards the Grandes Jorasses, Petites Jorasses, Aiguille de Leschaux, or Mont Greuvetta. The spacious and comfortably arranged interior includes bunk beds in two dormitories, a storage rack, and a kitchen and dining area with a spectacular view through a fully glazed round façade. Visitors may often have the impression of floating in the clouds and can admire the magnificent power of the mountain ranges they face. As it is nearly all white, the shape can disappear into the covering of snow, enhancing this extreme experience.

The very first, wooden, bivouac dedicated to Giusto Gervasutti, a mountaineer from Friuli-Venezia-Giulia, was set on the location back in 1948 and entirely rebuilt in 1961. The current ultra-modern structure was inaugurated in 2012 and envisioned by the Italian architects Luca Gentilcore and Stefano Testa, founders of LEAP, which stands for 'Living, Ecological, Alpine Pod'. The architects, who specialise in self-sufficient dwellings in the mountains, designed it in four modules made of a sophisticated composite structural shell, similar to the one of an America's Cup boat – it actually resembles part of a plane balancing on the very edge of the cliff. These modules relate to the specific function of each part – entrance, dining space and two dormitories. Thanks to the photovoltaic panels installed on the roof, the volume has light inside, a cooking plate and a PC with rescue service after connection. The structure was designed to be easily transported by a small helicopter and required only a limited number of operations on site. The innovative philosophy of LEAPfactory's architects resulted in a cabin that is equipped with technological systems to produce energy and which is resistant to harsh climatic conditions. The innovative New Gervasutti Bivouac can become a successful prototype for other alpine locations, as the concept substantially lowers the environmental impact of the building.

ACCESSIBILITY
Suitable for experienced hikers, climbers, and mountaineers only.

ARCHITECTURE
LEAPfactory, 2012
LOCATION
Fréboudze Glacier, Val Ferret, Aosta Valley, Italy

ALTITUDE
2870 m
NUMBER OF BEDS
12

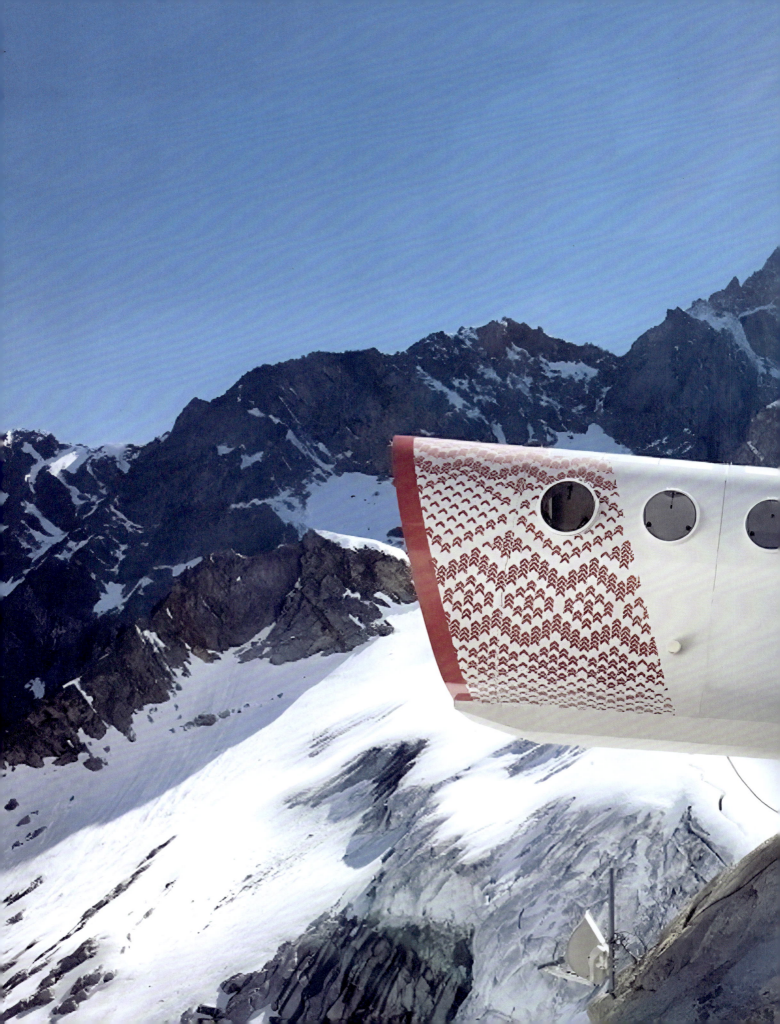

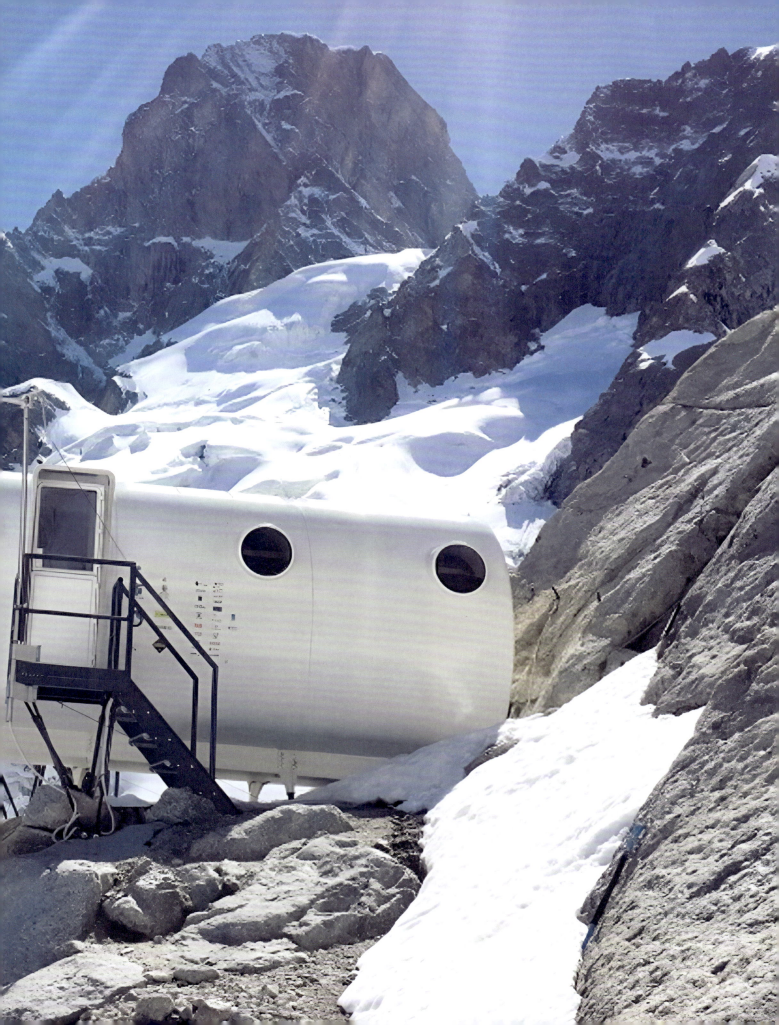

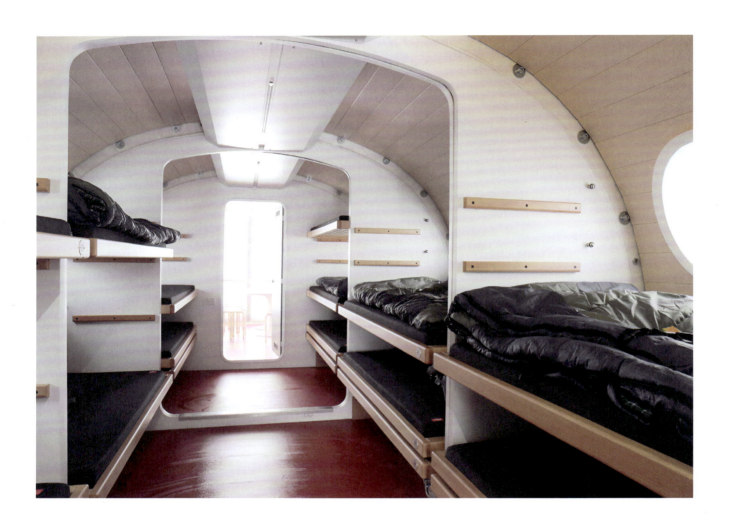

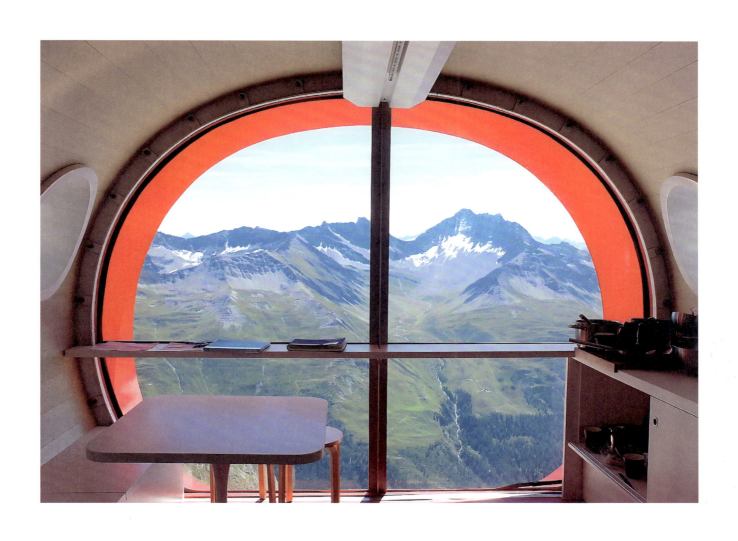

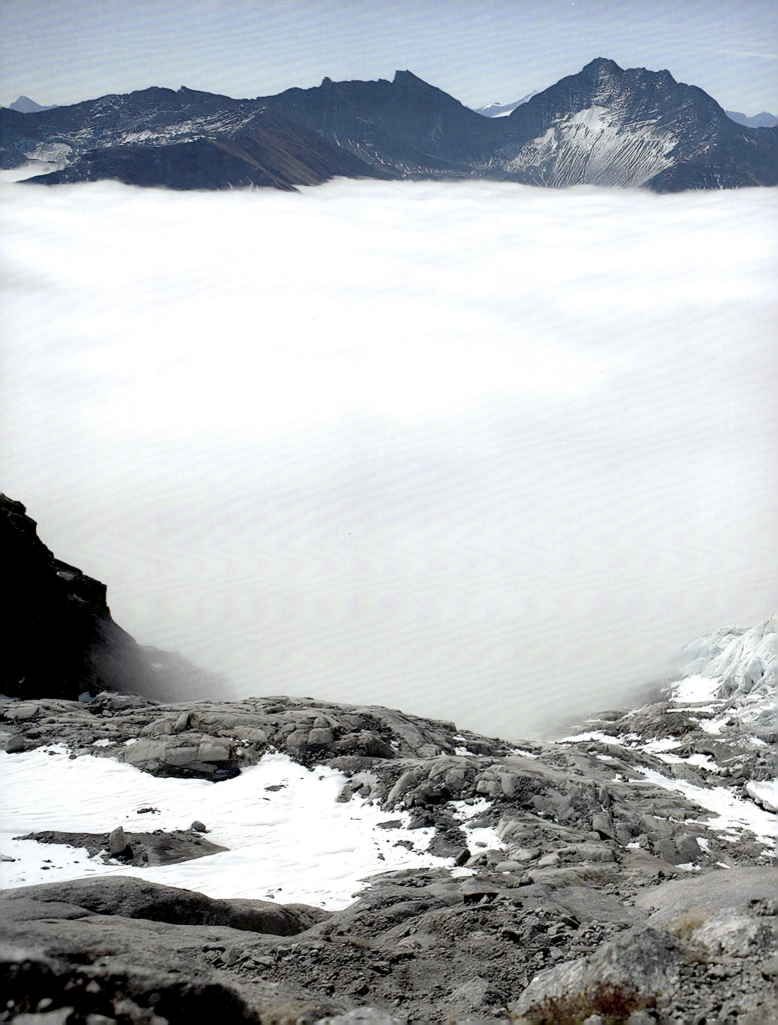

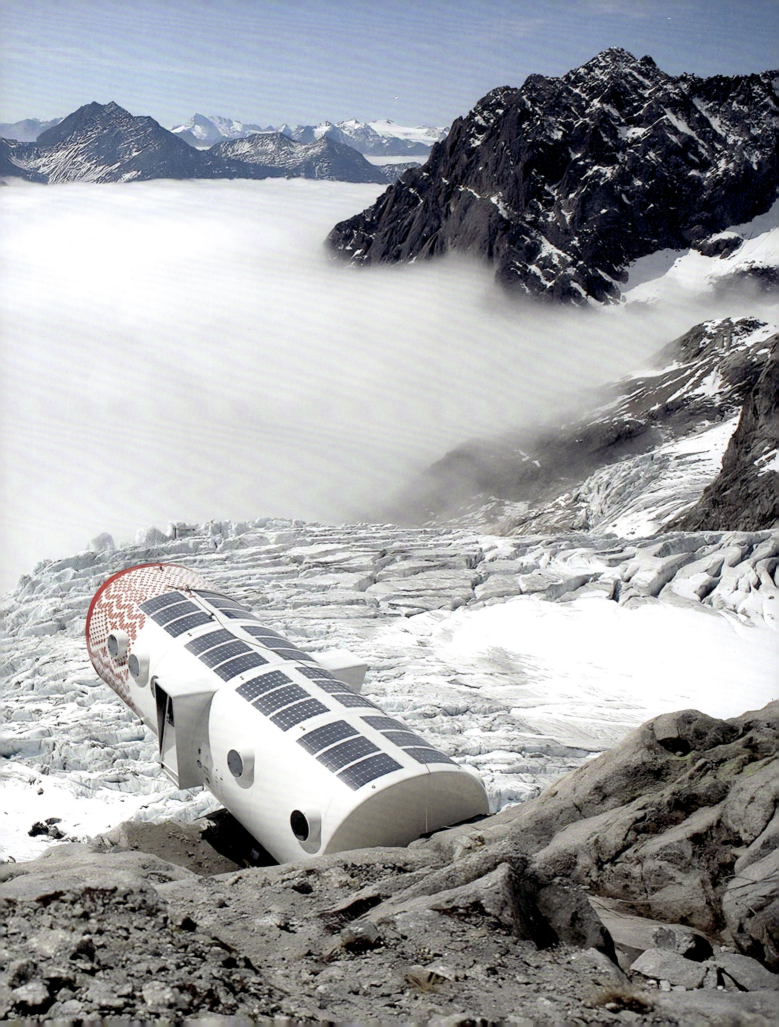

PHOTOGRAPHY INDEX

Cover photo © Jadran Čilić

pp. 2 © Grzegorz Grodzicki; 4, 116-117, 114, 120-121 © Pavel Kašák / Adobe Stock; 6, 8, 9, 10-11, 12, 13 © Iwan Baan; 14, 16, 18-19, 20, 21 © Anže Čokl; 17 © Janez Martincic; 22, 24, 25, 26-27 © Thomas Jantscher; 28, 30-31, 34, 35 © Jan M. Lillebø / Snøhetta; 32-33 © Ketil Jacobsen / Snøhetta; 36, 38-39, 40, 41 © BCW Collective; 42, 45, 46, 47 © Tor Even Mathisen; 44 © SPINN; 48, 50, 51, 52, 53, 54-55 © Giacomo Longo / Mimeus Architettura; 56, 58, 59, 60-61, 62, 63 © Matevž Paternoster; 64, 66-67, 68, 69, 70, 71 © Thomas Jantscher; 72, 74, 75, 76, 78-79 © Ivar Kvaal / Snøhetta; 77 © Ole Peter Stehen; 80, 82-83, 84-85, 86, 87 © Anže Čokl; 88, 90-91, 92-93 © Anže Čokl; 94 © Einar Aslaksen; 96, 100-101 © Jan Inge Larsen; 97 © Svein Arne Brygfjeld; 98-99 © Tommy Eliassen; 102, 104-105, 106, 107 © Monte Rosa Hütte; 108, 110, 111, 112-113 © Shannon McGrath; 118 © Michele / Adobe Stock; 119 © valdisskudre / Adobe Stock; 122, 124, 125 © Sheldon Family; 126, 128-129, 130, 131, 132, 133 © Marthe Hoet; 134, 136, 137, 138-139, 140-141 © Photo courtesy of EcoCamp Patagonia or Cascada Expediciones; 142, 144-145, 146 © Riccardo Meloni / Adobe Stock; 147 © C.A.I. Clusone Sez. Rino Olmo / Wikimedia Commons, CC BY-SA 4.0; 148, 150-151 © Nicola78 / Wirestock Creators / Adobe Stock; 152, 154-155, 156 © Alessandro Cristiano / Adobe Stock; 158, 160, 161, 162, 163, 165, 166-167 © Jadran Čilić; 164 © Zlatan Kurto; 168, 172, 173 © J.Cathala; 170-171 © Edoardo / Adobe Stock; 174, 176-177 © Adele Muscolino; 178, 180-181 © Grzegorz Grodzicki; 179 © Stefano Girodo; 182, 184-185 © Henrik Moksnes Bitmap AS; 186, 187 © Elin Engelsvoll; 188, 190, 191, 192-193, 194, 195 © Courtesy of Livit; 196 © Genadijs Zelenkovecs / Alamy Stock Photo; 198-199 © aerial-photos.com / Alamy Stock Photo; 200-201 © Abaca Press / Alamy Stock Photo; 202, 204, 205, 206, 207 © Arch EXIST 存在建筑摄影; 208, 210, 211, 212, 213 © Raphael Thibodeau; 214, 216, 217, 218-219 © 11h45; 220, 222, 223, 224-225 © Canadian Adventure Company; 226 © Oliver Lacey / Alamy Stock Photo; 228 © HedgehogHouse.com, courtesy of Aoraki/Mount Cook National Park Visitor Centre; 229 © Jake Stampler / Alamy Stock Photo; 230, 232-233, 234, 235, 236-237 © weekngo.ch; 239 © Jadran Čilić

PLAN YOUR TRIP

The mountains are unpredictable: weather conditions can change, you can't rely on on-site signage and sleeping facilities can be difficult to locate. Also, you often can't book these facilities like you would a regular hotel; nevertheless reservations are recommended whenever possible. Good preparation is essential for a successful mountain trek. Seasoned mountaineers can turn to their alpine club for this. To help all hikers on their way, Luster Publishing has collected some useful links for each cabin in this book with, for example, information on whether and how to book (a bed in) a cabin, or on hiking trails in the area. Please note that some webpages are in the local language or aimed at alpinists, so allow enough time to plan your trip. You can access the information on the Luster website by scanning the QR-code. This list is the result of independent research by Luster Publishing, and is solely based on the publisher's personal evaluation. Nothing was selected in exchange for payment or benefits of any kind.

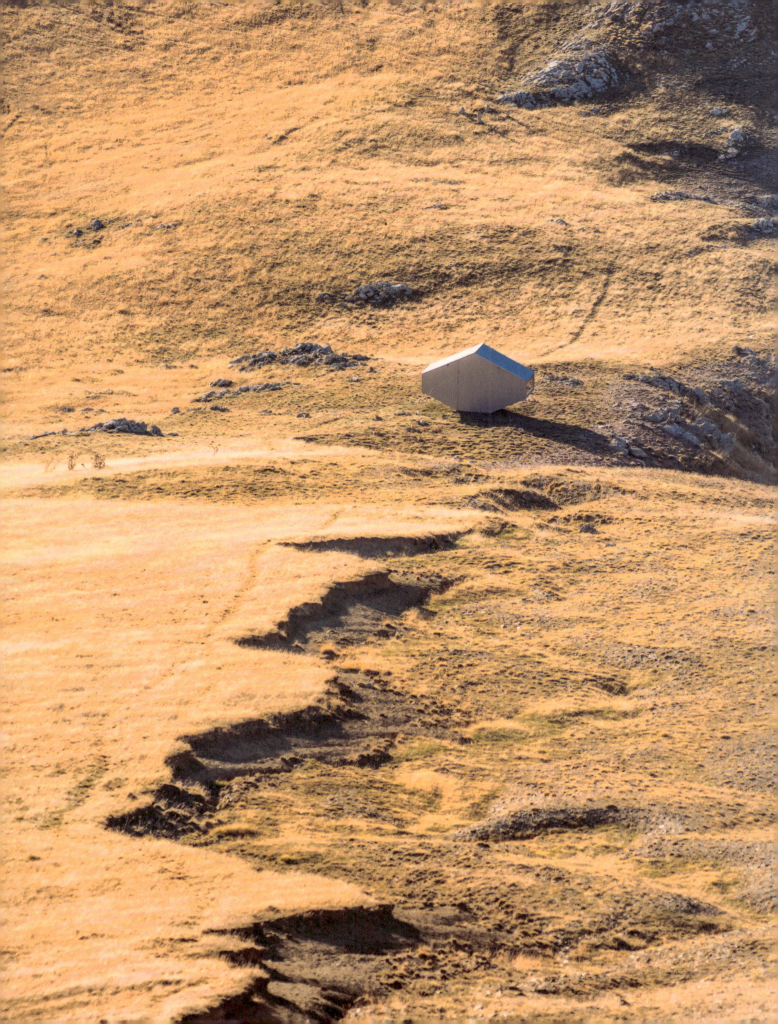

AMAZING MOUNTAIN CABINS
ARCHITECTURE WORTH
THE HIKE

Texts and pictorial research
Agata Toromanoff

Editing
Allison Adelman

Graphic design
Bart Kiggen

Photography
See index on page 238

D/2024/12.005/1
ISBN 9789460583520
NUR 648

© 2024 Luster Publishing

info@lusterpublishing.com
lusterpublishing.com
@lusterbooks

All rights reserved.
No part of this publication may be reproduced, stored in a retrieval system, or transmitted, in any form or by any means, without the prior written consent of the publisher. An exception is made for short excerpts, which may be cited for the sole purpose of reviews.

While all efforts were made to check the details concerning possible stays in the featured cabins as well as how to access them, we recommend double-checking the availability as well as opening times, as they might be subject to change. The levels of route difficulty are indicative and should also be carefully considered and adjusted to each hiker's capabilities and experience. Please note that this information is given as a rough guide, based on data collected from climbers and architects. The publisher and the author cannot be held responsible for the information provided.